"Naturally, people think that when looking at an artist's work his personality shines through. But that's not always the case..."

- Michael Kutsche, michaelkutsche.com

"You need time. You know, drawing, painting takes time – that's one parameter. But you need the mental time. To step away from the concept…"

-Loïc e338 Zimmermann

THE ART OF LOÏC ZIMMERMANN

3DTOTALPUBLISHING

3DTOTAL PUBLISHING

Correspondence: publishing@3dtotal.com
Website: www.3dtotalpublishing.com

First published in the United Kingdom, 2014, by 3dtotal Publishing.

ISBN: 978-1909414068

Printing and binding: Everbest Printing (China)
www.everbest.com

Editor: Lynette Clee
Deputy Editor: Jess Serjent-Tipping
Layouts by: Loïc Zimmermann
Lead Graphic Designer: Imogen Williams
Proofreader: Adam J. Smith

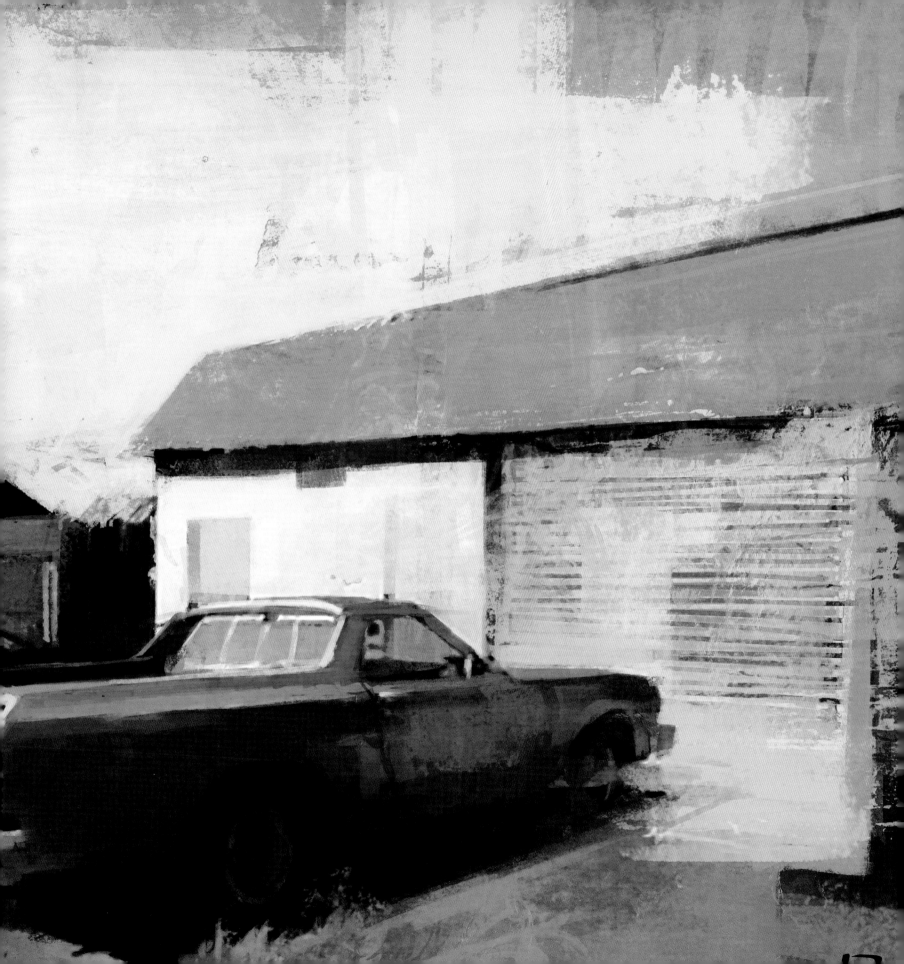

CONTENTS

008 Foreword

010 Introduction

016 Timeline

018 From France...

024 3D

036 Hybrid

050 Silkscreen

056 Illustration

 064 Industry insights

 088 ...to California

094 Mixed media

108 Photography

132 The *Binaural* series

150 Thank you

Free resources: video guide covering Loïc Zimmermann's
digital-painting and digital-sculpting processes to create
hybrid illustrations: www.3dtotalpublishing.com/resources

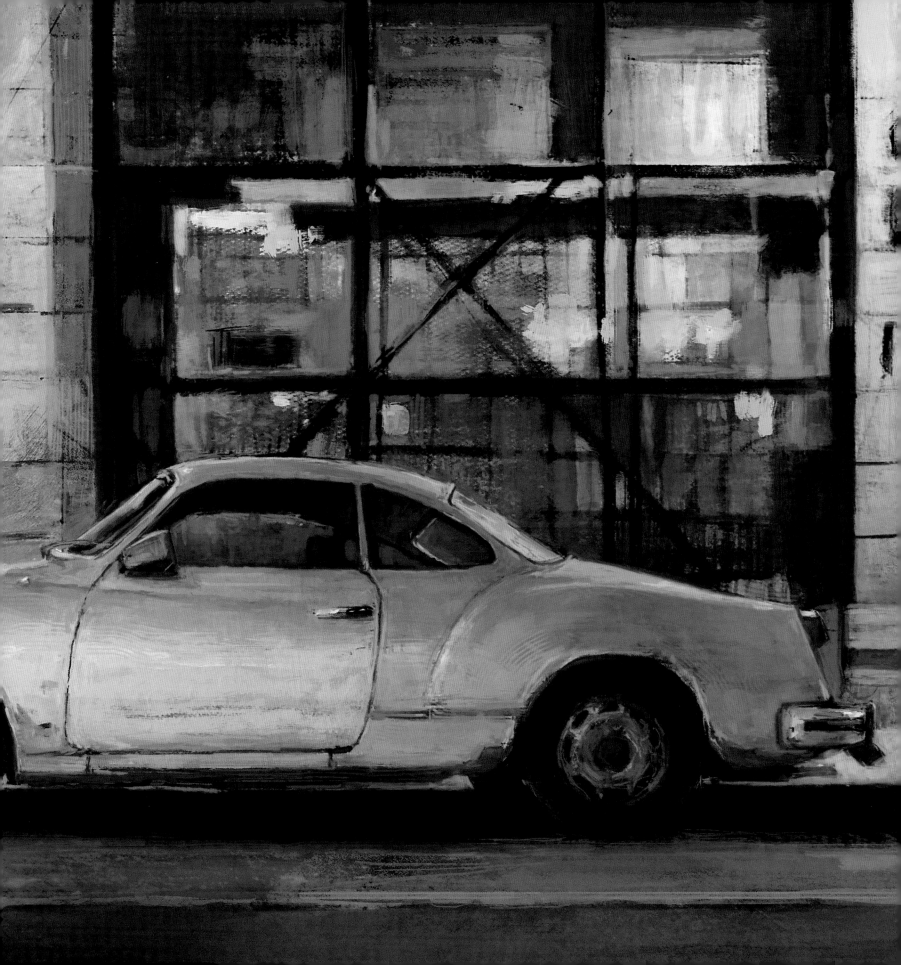

FOREWORD

BY PASCAL BLANCHÉ, ART DIRECTOR AT UBISOFT MONTREAL

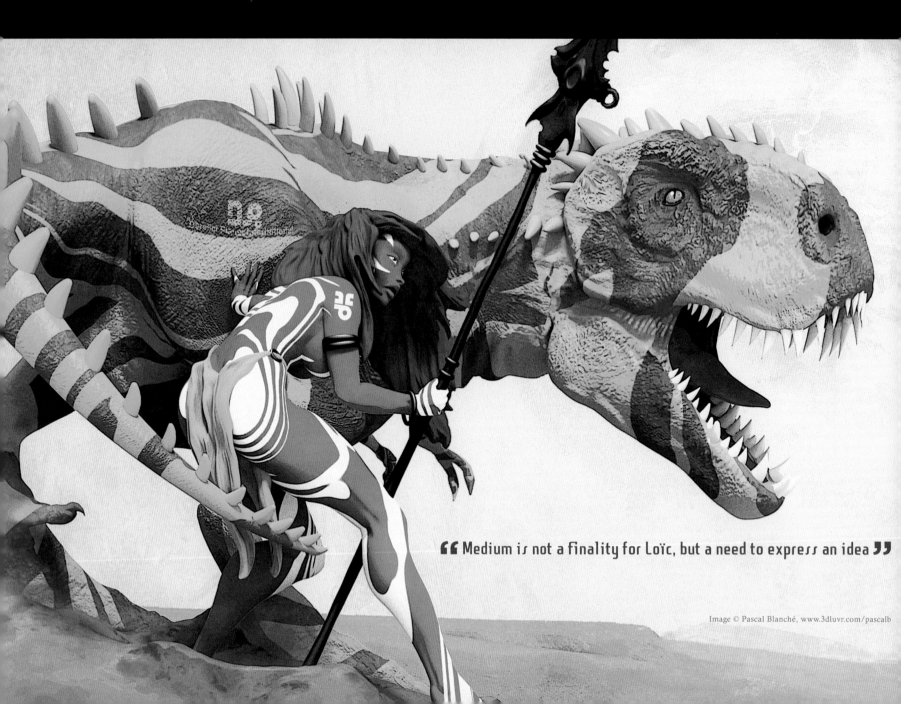

" Medium is not a finality for Loïc, but a need to express an idea **"**

Jump into the gritty yet tender world of Loïc Zimmermann, where reservations are left aside to reveal a dreamy universe of memories and fantasies

I remember when I first saw Loïc's work back in early 2000, I openly said to myself: 'Now that's something I *like*!' It was his series of Z-Mens. If I remember correctly, it was a caricature of an X-Men: half-2D, half-3D and 150-percent powerful.

With the artist community being a fairly small place, Loïc and I first met on a digital art forum. We began to exchange a fair few emails sharing our common grounds, and I could sense in his work the same drive and sensibility that I have when I approach mine – which must be part of the fact that, being from the same French generation, we grew up with the same mixed influences of European BD, American comics and TV anime shows. We also shared similar experiences graduating from the same art academic schools (as in, national French art schools) where we were taught to look outside the frame, put a black spot on a wall and deliberate it for an hour. Guys like us found that we were branded like black sheep back then, but we survived – somehow. We managed to go our own ways, although some of these teachings will always be anchored inside us. We are a strange cross-breed, somewhere between painters and comic-book geeks.

Loïc and I are similar in that we can't put a picture on a canvas (or screen!) without having already considered about 1,000 questions beforehand, covering everything from shapes to inner motivations. But we also know how to not take it too seriously. And that's one of the core reasons that Loïc's work stands out. But that's not the only stand-out quality he has earned for himself! He remarkably goes the full loop: 3D, sculpting, painting, photography, illustration, graphic design, tattoos... Medium is not a finality for Loïc, but a need to express an idea. I feel like I'm talking like one of those art teachers right now, but that's exactly what Loïc – as an artist – is doing. A real artistic attitude is about the journey; trying new roads, climbing mountains when needed, and always going further to express his own view on the world.

His world is gritty, colorful, bold, dreamy and touching. While his graphic influences are multiple and vary with the subjects. When it comes to characters, like in Bill Sienkiewicz and Frank Miller works, there's always the right amount of brutal tough guys with bad attitude, dark humor and feminine sensuality. When it comes to environments, his works always remind me of the urban landscape painter, William Wray. And even if the styles vary depending on his mood and the chosen medium, every picture conveys a story and seems to be part of a same whole world – a noir film world with bold splotches of colors; Loïc's world.

What I love the most about Loïc's work, though, is the way he puts his heart and soul right into his pictures. Everything you'll see on the pages of this book is what Loïc truly is. Without any reservations, Loïc exposes his childhood memories, his loves, his blues, his dreams and fantasies. Loïc's unique vision is living inside this book, and you may even see him around the pages from time to time, in self portraits and photography, inviting us to also jump into his fantasy world. I'm sure there is a place in there where we can finally meet and have that beer together. I think it is about damn time, too!

INTRODUCTION

" It's not just about forms, it's a living thing; it's a vital part "

e338 in conversation Part 1

3dtotal is well-versed at introducing all manner of publications for arty readers, but what happens when that introduction is *about* an art talent as immense as Loïc Zimmermann? Well, we figured we couldn't possibly say it better than the man himself – with a little help from his comrade, the award-winning German artist, Michael Kutsche. This insightful interview between two incredible minds will inspire, motivate, and make you hungry for the pages that continue. Let the banter commence!

Loïc Zimmermann: I went to Berlin for the first time in September to visit Michael. I had been to Germany maybe a couple of times, but never to Berlin. I told him that I didn't want to visit the regular landmarks – the touristy stuff, obviously – I want to see Berlin the way you see it when you've been living there. Which is what you've been doing over the years. And see more little details – the little things that people don't think of.

Michael Kutsche: Sometimes I like just stumbling into stuff.

A meeting of minds: award-winning artists Loïc Zimmermann and Michael Kutsche discuss art, life in the industry - and we discover where the heck 'e338' comes from!

LZ: Yeah, randomly!

The random factor of not necessarily having a plan – and being able to appreciate things when they happen, or when they happen at the corner of the street – 'Hey, what is that?' And just going for it...

MK: It's also a wider part in creating art, right?

Someone asked about how long you can keep the length of the leash you have to keep yourself strapped to – because there are certain projects where it's clear from the start that venturing in too many different directions isn't cost-effective in the end. So then, sometimes there's a certain routine that gets into the workflow, but of course, when there's time, it's always nice to venture towards a unique look at the problem at hand, or approach the task from new directions. And yeah, there are all these certain techniques on how to trick your own psychology…

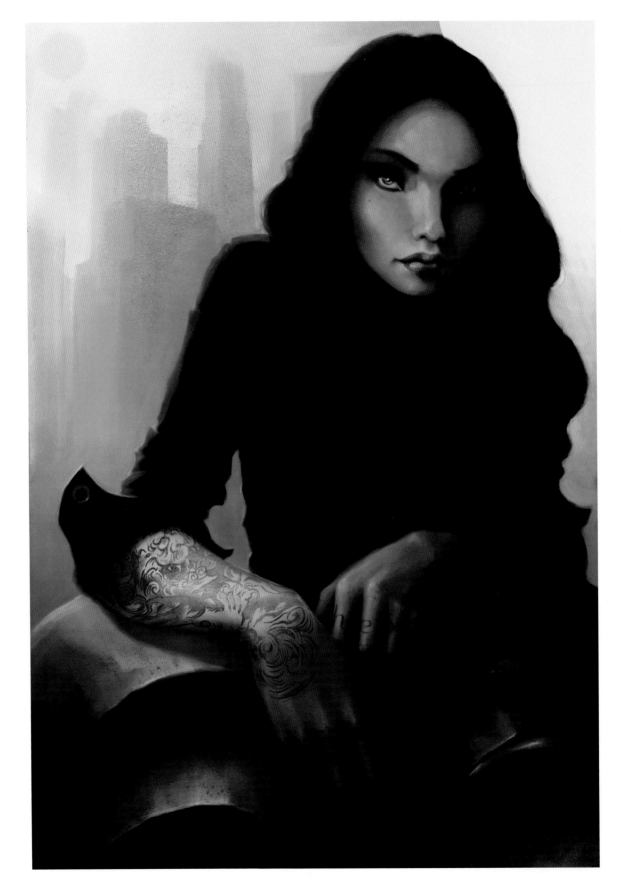

LZ: Yeah, like with those random shapes – the chaotic thing and how you interpret them… It's like when you're a child and you're looking at clouds – you see shapes and you see creatures, animals, scenes… That seems to do the trick for most people when they feel a bit uninspired. Just throwing stuff on the canvas and hoping to read something and just get there. Yeah, I really like that.

At some point – I think it was two or three years ago – I really wanted to combine illustration and concept art; I really thought I could make that happen at work, and not necessarily have this photorealistic style to please the client. I really tried, and I'm really done with it [laughs] – it was too much pain in the end.

MK: Stamina, right?

LZ: I'm trying to just – well, not do what I'm told because they really don't tell you anything since they don't know what they want. It's still my job to come up with options. But I don't put the same amount of passion, let's say, into the technique itself; I just try to make it work. Whereas for my own work, now I've actually taken back all that energy, all that drive for improvisation, and developing it, and I'm learning as well…

MK: Totally! But you're talking more about personal work here, right?

LZ: Yeah, at this point, yes.

MK: Yeah, I mean, you know, sometimes there's almost like a whole roadmap. My work mostly starts by getting a script, and the script usually dictates the original style, or there's a certain atmosphere you'll get from reading the script – even though it'll change a lot of the time – and then you have a whole list of characters. And sometimes you have like an extra task – which I create for myself – which also helps, because it's not just only about the character design, which is what you think is the actual task because I'm a character designer, but there are a lot of different things, like the lighting you choose. And there are already storytelling elements, even if there's just the one character standing in the center of the frame.

LZ: Well this story is when *you* design a character; each of them comes with a background, and the background is not arbitrary, and the lighting isn't arbitrary either – you kind of situate that character in the world. He's not just like, 'Hey, I look cool!' I think you actually really make it work with the story. With one image you're trying to say, 'Okay, that guy fits here'. It's the same way that a DP is going to choose a specific light for a unique character, or for a bad guy, or for this moment of the movie…

MK: You would think it's not purist enough. Like there's a reason why sometimes 3D models have to be shown in a certain lighting situation with a certain material so that you can just concentrate on form. But with a finalized design, you want to see it not just on a plain background – I mean, from a technical point you could do that because you have to do a lot of versions and iterations anyway, and it's a lot of work. But if you think about some background situation or some environment or some atmosphere, I rather go the extra mile because I feel it's more fulfilling in the end because I can look at that series of pictures and it makes me feel that it's already part of the world – almost as if the world is reflecting in the character's eyes, as if it's kind of flowing through his organs. Because it's our environment that creates us, so in that way it feels like more of a complete image for me, instead of having them on a plain background.

Usually I think of my job as not just designing, but it's also part of the storytelling, because sometimes the script writers look at the designs – and actually sometimes, for example Michael Chabon who was writing the script for *John Carter*, he dropped me an email sometime in the middle of the project and he was like, 'Yeah, I put your *White Apes* image up on the wall and it served as an inspiration for me because it kind of has the thrill that I'm seeing in the project. Sometimes if I'm lost in the story I look at the image and it keeps me going.' So it's informing back and forth.

LZ: And that must be very fulfilling for you?

MK: Yeah, it's satisfying. It's not just about forms, it's a living thing; it's a vital part. It somehow transcends into storytelling already – because you have to think about all that stuff while designing. It's not just about, 'Oh, this is a cool shape, or this kind of looks modern.' And it's not just about style; it has to have some substance underneath.

LZ: Well this is where our jobs are totally different [laughs], because you design ahead and with all those things in mind. Which is something I love about your professional work. And I am at the very end of the chain, designing for VFX, meaning when everything has been selected design-wise – and built – and shot. I do more problem-solving at the end…

MK: Yeah, it's almost like figuring it back, at the end. Because you on your side, you also have this understanding of how all this connects together. And sometimes it's almost like there's a little virus, or a little screw in the clockwork, and no matter how shiny you polish everything or how many layers you put on top of it – it's like standing on a rotten construction, where the foundations aren't there to hold it, or something.

LZ: Ah, well that could be true for most of the projects I work on [laughs] – it's like a giant tower but they forgot about the foundation. Again, I may sound cynical – I am, I am cynical – but in the meantime I find a game in it; this has been designed and there are strengths and weaknesses, and there's this particular design that doesn't work. So what now? What I need to do is to say: 'Okay, this is what we have here, and what we have there, and I have to create a net out of all of them and then come up with an answer in that existing world.' It happened on *Thor: The Dark World*. There was this one environment that they didn't have the time to design. It was based on the whole culture that they created for the Dark Elves, and it ended up being a great work because I really liked those designs…

I went to art school and I didn't learn anything craft-wise, but I did a lot of studies of paintings – like how does the painting work. And that's exactly what I did: I traced down on the costume of the characters and the weapons and the ships and everything and said: 'Okay, these are the design decisions they made.' There's a pattern when a design is properly made – there's something that's happening over and over again. And out of that, I extracted that vocabulary; basically it's a language. And I came up with a design for that environment; I added history to it, time, I added my own little touch – and that went well. The client was really, really pleased, because there was an understanding. I wasn't trying to make a revolution, but…

MK: So like filling the gaps…

LZ: Yeah, it's like you've got the beginning of a sentence, and the end, but something is missing – you're not going to change the sentence, but there's fun in that. That problem-solving element is great.

What does e338 stand for?
e338 is the acid in Coca-Cola, which Loïc used to drink by the gallon – back in the day…

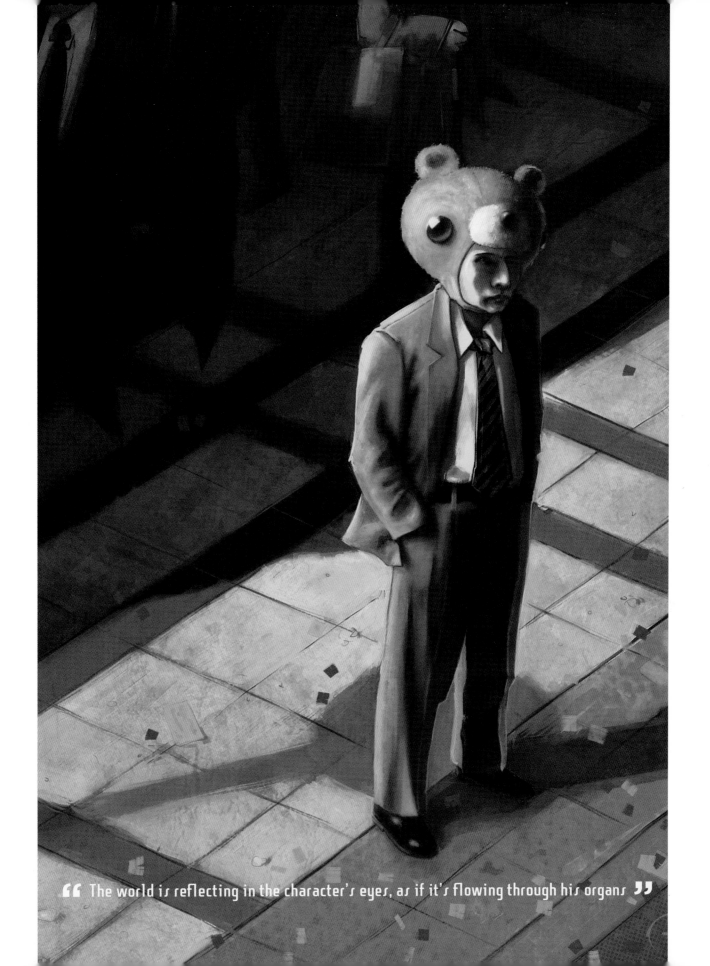

The world is reflecting in the character's eyes, as if it's flowing through his organs

1974. Born in Reims, France.

1980. Pneumonia. One week in hospital.

1981. Eats way too much when Mitterand is elected.
Way too young to understand.

1982. First encounter with an Atari 2600.

1984. Summer camp learning electronics, coding, radio
hosting and kissing girls in the dunes.

1985-1991. School/hell/purgatory. Hates every second of it.

1986. Sees a commercial with a 3D robot. Brain explosion!

1986. First encounter with an Apple Macintosh.

1987. Paints hundreds of screens for two video
games on Amstrad, never to be released.

1988. Iggy Pop live, and the world will never be the same again.

1991. First job as an illustrator for magazines.

1993. First rock band. First apartment…

1994. Begins art school in Reims. Power Macs.
Photography. Label 5 (gee).

1994. Death of Kurt Cobain.

1996. Graphic design school in Troyes. Switches
to PC. Family explosion.

1997. Graduates with major.

1997. Starts teaching computer graphics.

2000. Soccer team wins something… never liked soccer.

2001. Buys a factory, builds apartments, stops purchasing
CDs and spends his time and money at Home Depot.

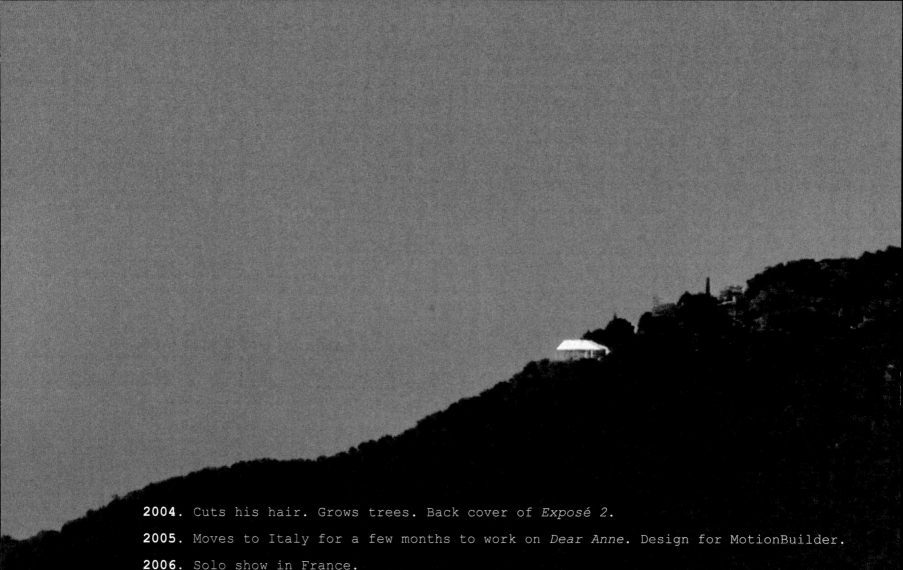

2004. Cuts his hair. Grows trees. Back cover of *Exposé 2*.

2005. Moves to Italy for a few months to work on *Dear Anne*. Design for MotionBuilder.

2006. Solo show in France.

FROM
FRANCE...

“ Salvation eventually found Loïc when he began to mix 3D and paint-over techniques ”

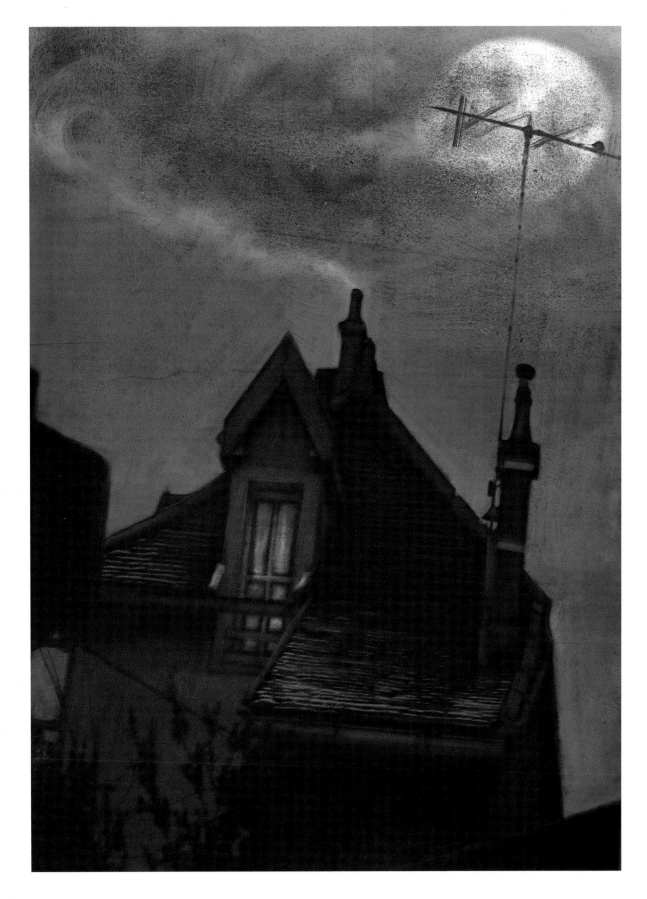

Back in the days: a personal account of the calm before the storm – working remotely in France for Quantic Dream on *Heavy Rain*, finding illustration gigs and project-planning tattoos

Immediately after graduating in graphic design in France, Loïc went straight back to school – only this time as a teacher. Although this was a fun gig, he quickly realized that he'd need something else in his life. And that's when he started work on several personal art projects by night, developing little animation tests (that would never, ever get done). After a couple of years of teaching, he made the decision to quit and took a position at a small VFX company in France.

With 3D being such a demanding mistress, he ended up leaving most other media on the sideline for a while. He did a lot of urbanism and architecture, some motion graphics and a few short films. Yet, he began missing illustration more and more each day, and the little time he gave to drawing suffered a lot from a lack of practice. Salvation eventually found Loïc when he began to mix 3D and paint-over techniques. It was a slow process at first, but the technique offered him a certain peace of mind.

As life continued and art was made, Loïc bought himself a house, left his job shortly afterwards and consequently found himself fairly broke. He had to work extremely hard as a freelancer in order to pay the mortgage and survive. Meanwhile, his ever-increasing presence in the digital art community allowed him to keep it together.

Loïc would regularly post on several art forums, until one image, *Assassin* (see page 39), managed to really reach other people. Ballistic Publishing picked it up for the back cover of the second issue of *Exposé*, and various magazines around the globe used it as cover art – the overall response on the forums was extremely encouraging for him, too. It took him a while after that to achieve the same level, both qualitywise and popularity wise. It was around this time that Loïc relocated to Milan to join a remarkable team of artists working on the film, *Dear Anne*. It was a feature-length film about the life of Anne Frank. Everyone in the small studio had reached an incredible level, or was shortly going to, and Loïc found it a great

opportunity to learn and improve techniques – particularly in anatomy – while working in a brand-new environment. After eight months on the film, Loïc left the project, aware that it would never go beyond a lovely trailer. He moved to Paris for a while – initially as a supervisor for Sparx Animation – in order to truly experience what 'miserable' was supposed to feel like. He went back to teaching for one month, this time at GOBELINS L'École de L'Image. Here he helped students finalize their short films for the Annecy Festival. This became, by far, one of the most exciting teaching experiences Loïc ever had.

He later joined LuxAnimation to work as a texture artist on *Dragon Hunters*, a European CG feature film, art-directed by Guillaume Yvernel. This gave him the great inspiration to lean towards more creative tasks, and eventually concept art. Soon after, Quantic Dream hired Loïc as a senior character artist to work on the upcoming hit, *Heavy Rain*. This kept him extremely busy for a year and a half. The production was very structured indeed, under Thierry Prodhomme, one of the sharpest supervisors Loïc has ever worked with. He learned a lot about processes, technical (game) constraints as well as very challenging subjects – he found that, funnily enough, ordinary people are way tougher to pull off than superheroes!

Around the same time, Loïc decided to move forward on his tattoo project. After meeting a tattoo artist and discussing with him the details of the process, he realized that the methodology was actually very similar to the way textures were handled in CG. With this in mind, he went to the Quantic Dream office in Paris and had them scan portions of his torso and arms. Following that, Loïc worked the way he would on any given digital-double: step by step until he ended up with a clean CG version of himself. With that, the design of the tattoo could finally start.

After putting so much work into designing his tattoo, he thought he might as well push the render even further to promote his work as a character artist. And with that, the project went viral – there were articles about him all over the place, reaching not only the CG audience but also tech-geeks, and obviously the tattoo community. One of those articles ended up on Luma Pictures' VFX supervisor's desk, who could see in Loïc something that could benefit the company: an artist comfortable with both 2D and 3D and a tendency to go beyond his comfort zone.

A few months later, Loïc was leaving France for California…

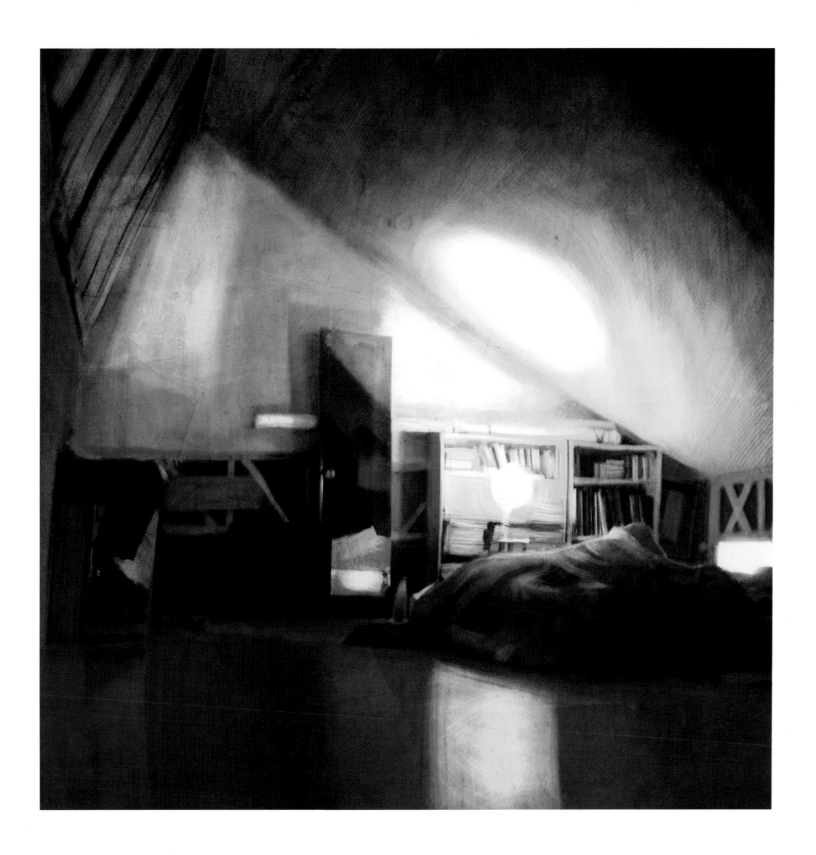

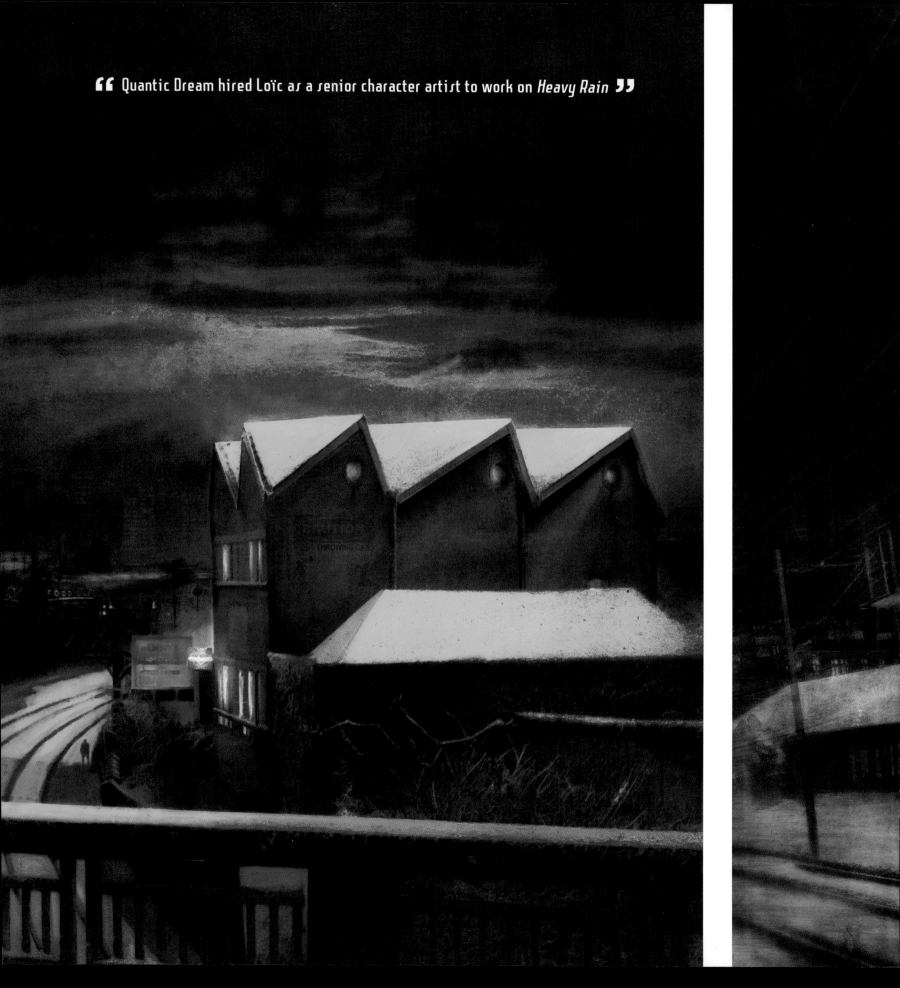

"" Quantic Dream hired Loïc as a senior character artist to work on *Heavy Rain* ""

3D

" I never had to deal with polygon limitations before. It helped me a lot "

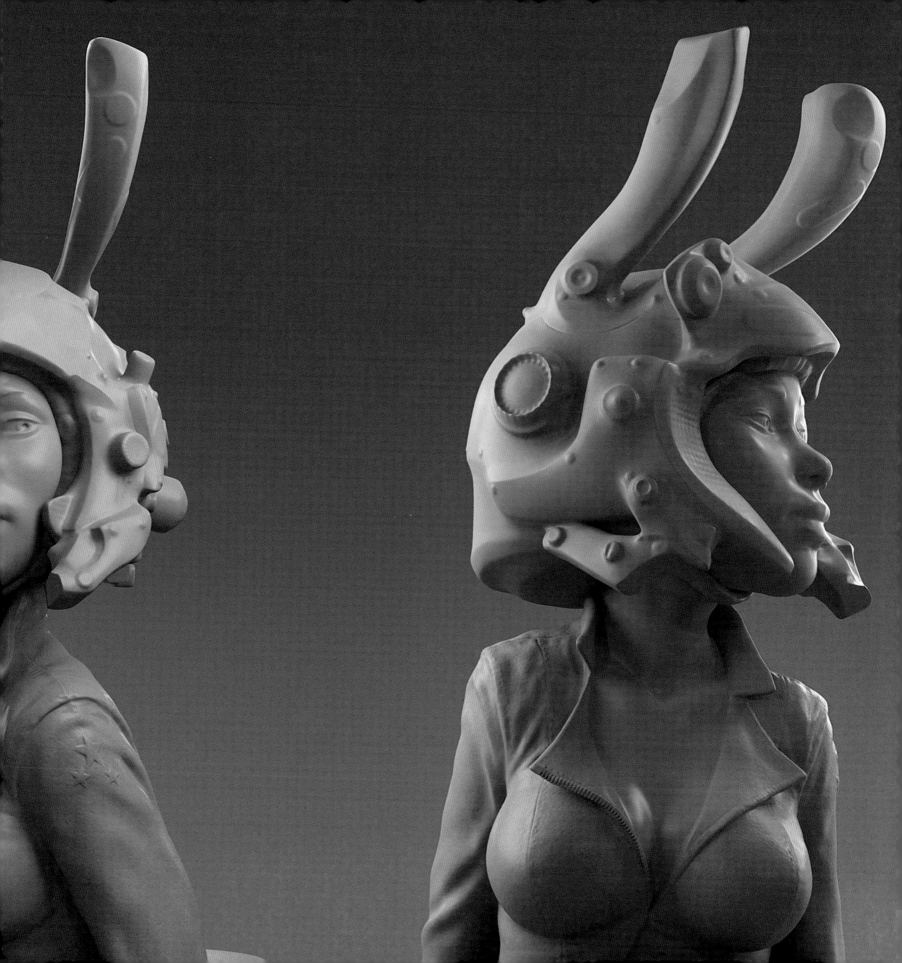

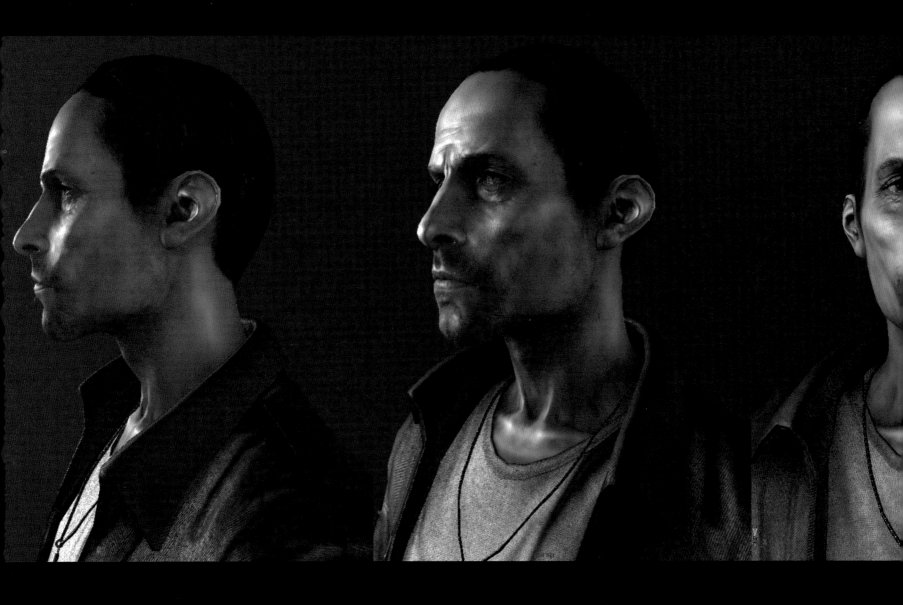

Creating digital doubles for video games
and self-promotion: an insight into the
skills involved in crafting characters
for Quantic Dream - and for scaring tattoo
artists with new levels of detail

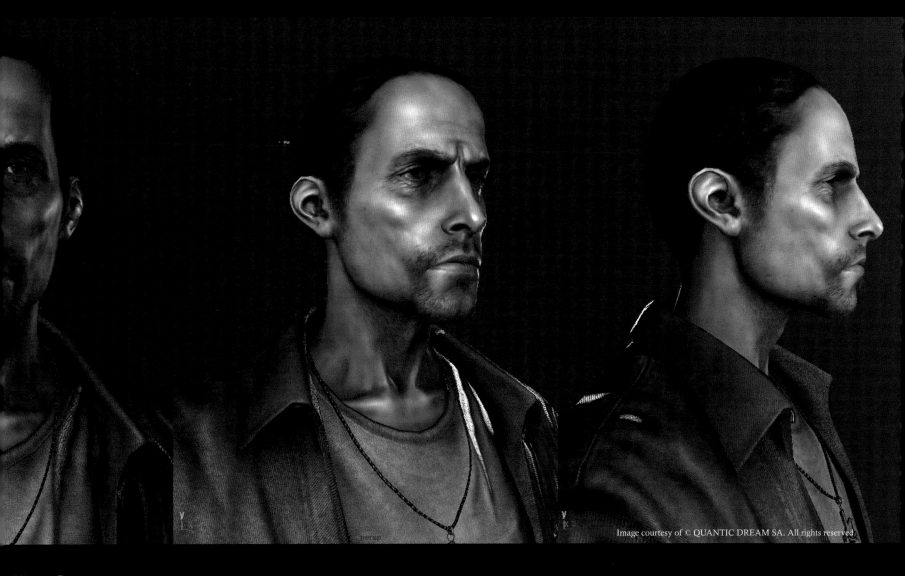

Heavy Rain

Loïc met with the folks at Quantic Dream right after signing with Sparx Animation. They were warming up prior to getting started on *Heavy Rain*, and they had just released their demo using what would be the base of their development for the game. "I was really impressed, and deep in me I was sad to be under contract and unable to join them for this," Loïc recalls. "A year later, we would meet again and after a couple of tests, we started what would become a fairly long collaboration."

"My job was very technical," he explains. "The design part was taken care of in-house. For each character I would receive a package with some concept art, visual references for clothing, photographs from the actor and a facial scan. I had to follow precise instructions, from the polycount, the size of the textures, to the naming convention and the structure to adopt in my scene. If I struggled a bit at first, I ended up adopting this system. It was a very efficient way to work.

"The characters we had to deal with were – for the most part – regular citizens from the city where the story was taking place. It was very unusual since characters for games are often the hero archetype, very – if not overly – designed. Breathing life into those was a challenge each and every time. And modeling for games was a challenge for me as well; I never really had to deal with polygon limitations before. It helped me to focus on the silhouette and how to be efficient.

"For a few characters, I got lucky. Because the actor selected didn't quite work for the character – although their work for dialogue and mo-cap was great, they simply didn't have the right look – I had to improvise a bit. This was my favorite part, and where I was actually the most comfortable. Having my input on the design made a big difference, and based on what I had seen from the game during my visits at the studio, I knew that the bar was set pretty high. All the people involved were doing a stunning job.

"I kept working with Quantic Dream over the years on a couple of other projects, including the *Dark Sorcerer* demo released in 2013."

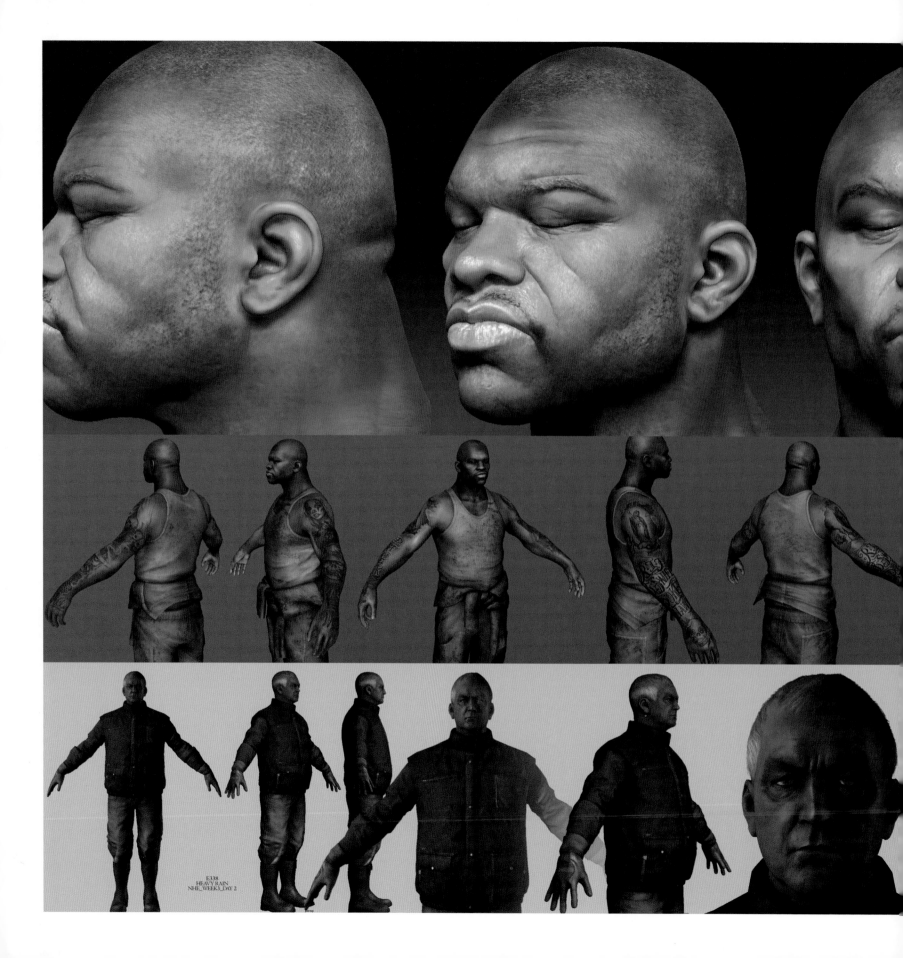

E338
HEAVY RAIN
NHE_WEEK3_DAY 2

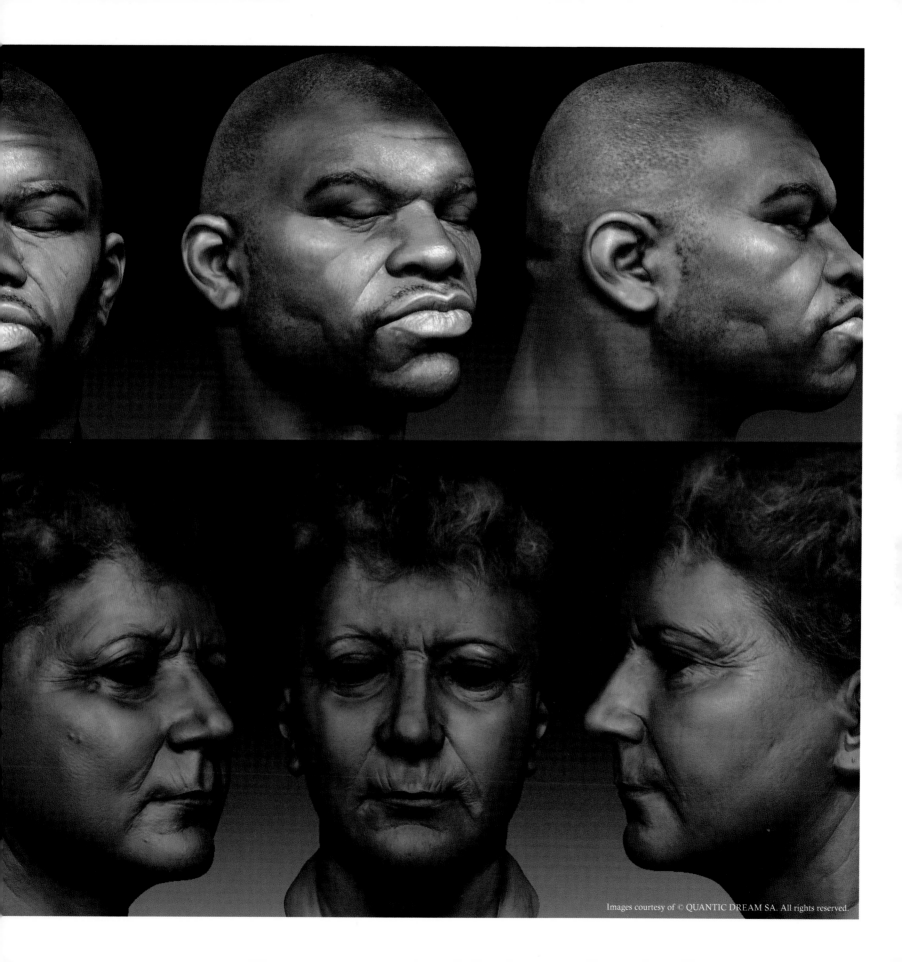

Longmen's Fall:
The Tattoo Project

Loïc had been working on *Heavy Rain* for about a year when he decided to pay a visit to a tattoo artist based a couple of hours from where he used to live. He saw the artist's work on a few friends and liked the sharpness of his line work. "We talked for a bit and I quickly explained that I wanted to design a sleeve of my own," Loïc remembers. "We looked at books and eventually he showed me some big pieces he was working on, drawn on layer sheets. I was facing those designs and suddenly I realized that this was going to be a fun process. Those images – especially a full back tattoo – were looking like unfolded textures in CG. I had seen those before but it's really at that moment when it clicked in my head."

"I left the parlor, went back home and called Quantic Dream," he continues. "A few days later I was in Paris, and Thierry Prodhomme was driving the scanner used in production for the cast of *Heavy Rain*. Back then, they were using a scanner that could only grab small portions of the body, so I left their office with a dozen fragments of my torso, head and arms on a flash drive. I assembled them all and from there it was nothing different from my work on *Heavy Rain*: creating a clean digital double. After I was done with that part, I threw some UVs out there and defined the area that I wanted to tattoo.

"I knew I wanted a half-sleeve; I knew it would reach the clavicle, cover the right part of my chest and end up right below the elbow. The UV layout was cut to minimize the stretches and was very influenced by those designs I saw at the parlor. The design process could start. I drew some simple shapes, broad figures, and checked out how it looked on the geometry in Maya. Then there was a long series of back and forth between the two until I was satisfied with the visual.

"I realized that the UVs could be improved, so I used a warp function in Maya in order to transfer the design from one layout to the other. I could have stopped here – it was good to go for the tattoo already! But having done so much work, I thought I could push it a bit further and put it online as an example of my 3D work for digital doubles. After all, *Heavy Rain* wouldn't be released for a couple of years and it couldn't hurt to create buzz online…"

>> If you work on characters, understand the basics of animation and rigging, as they will inform the way you should model to properly deform – and make the other guys in your team happy!

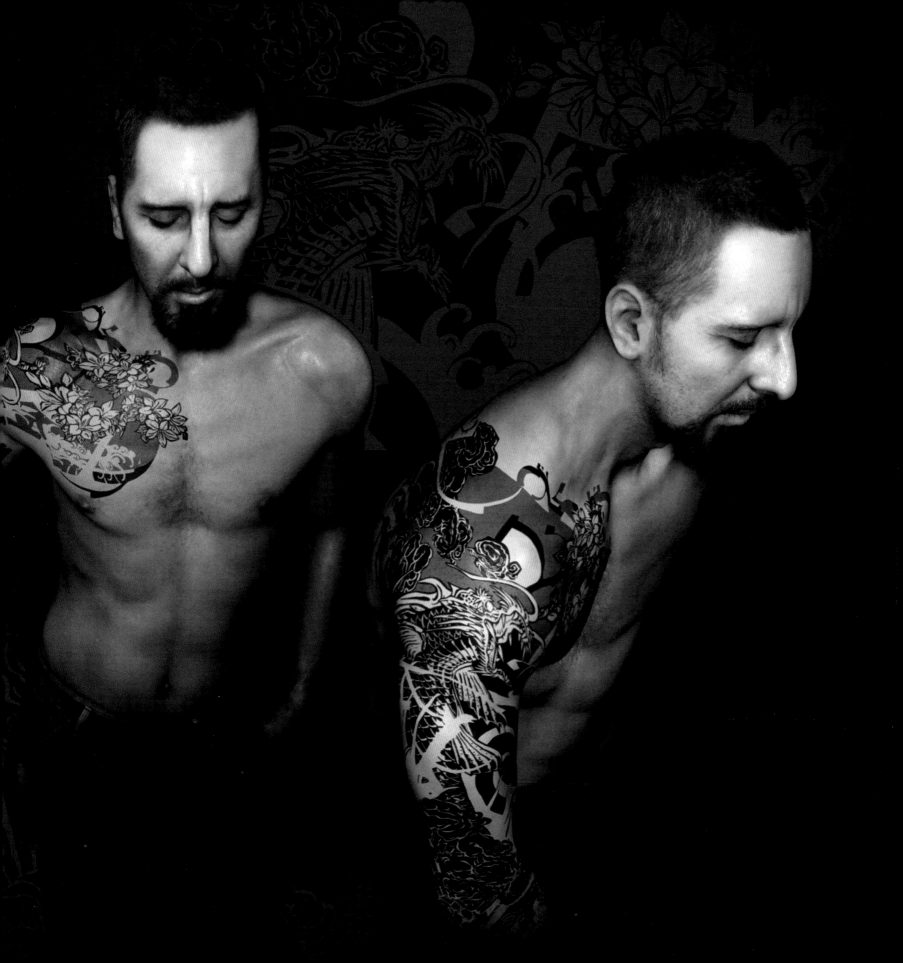

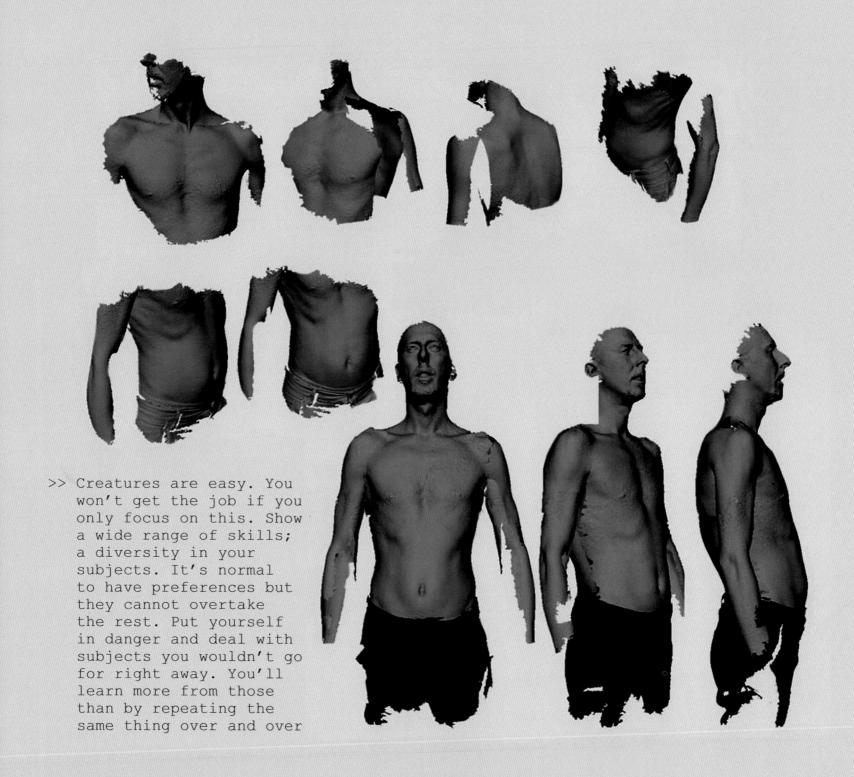

>> Creatures are easy. You
won't get the job if you
only focus on this. Show
a wide range of skills;
a diversity in your
subjects. It's normal
to have preferences but
they cannot overtake
the rest. Put yourself
in danger and deal with
subjects you wouldn't go
for right away. You'll
learn more from those
than by repeating the
same thing over and over

❝ Thierry Prodhomme was driving the scanner used in production for the cast of *Heavy Rain* ❞

> **❝ Those images – especially a full back tattoo – were looking like unfolded textures in CG ❞**

"I created my textures by stitching a bunch of reference photos together," Loïc goes on. "Again, this was a very similar process to working on doubles for games – at least up to that point. The plan was to render images with mental ray and pretty much use everything I had learned on previous projects. The skin texture was split into different maps to trigger sub-surface scattering, sub-dermal, masks, specular, bump, and so on.

"Then there was the work in ZBrush to create the high-frequency details of the sculpt, and export my displacement maps. I used the native hair system in Maya to take care of the beard, hair and eyebrows, and I used patches with alphas for the eyelashes. Seeing the design on a shaded and textured geometry gave it a different impact and it helped me make some little adjustments. I still had a bit of time; my appointment was only set later that month.

"I rendered a turntable using an HDRI and a few stills. I sent them along with the high-res image of the design to the tattoo artist. And… he freaked out! Usually, people come to a parlor, bring or picture or order a design, suffer a bit, and then they leave, more or less happy. The pressure put on him was intense, since he had to reproduce an intricate design already – and on top of that he was facing a hyperreal simulation of the final look of the tattoo. There was very little room for improvisation or mistakes.

"We had to do some adjustments on the shoulder area. Even if my unfold was clean, it didn't work in that section. We traced reference points and I adjusted the design later on. The process took 35 hours for that piece alone. Then many others followed. I improved the method over time by tracing guidelines at the parlor and using them as references in the 3D mesh as well as in Photoshop. The best of both worlds! I designed three other pieces with this technique, but for the most recent one I didn't even bother, since it was a fairly simple chest piece.

"And it keeps evolving."

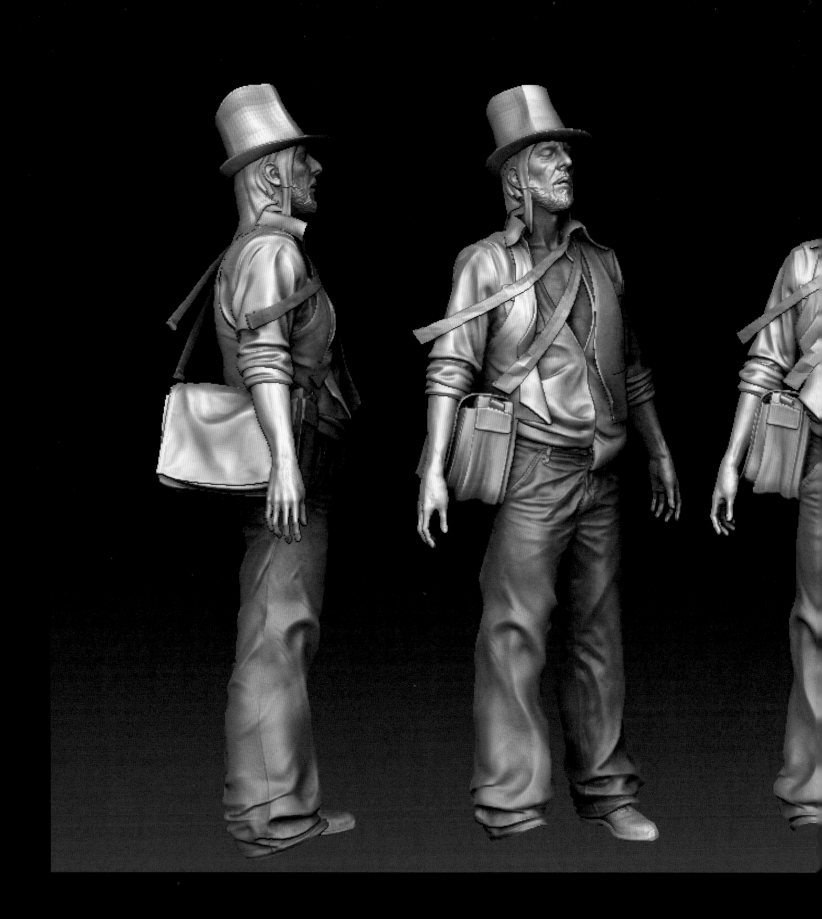

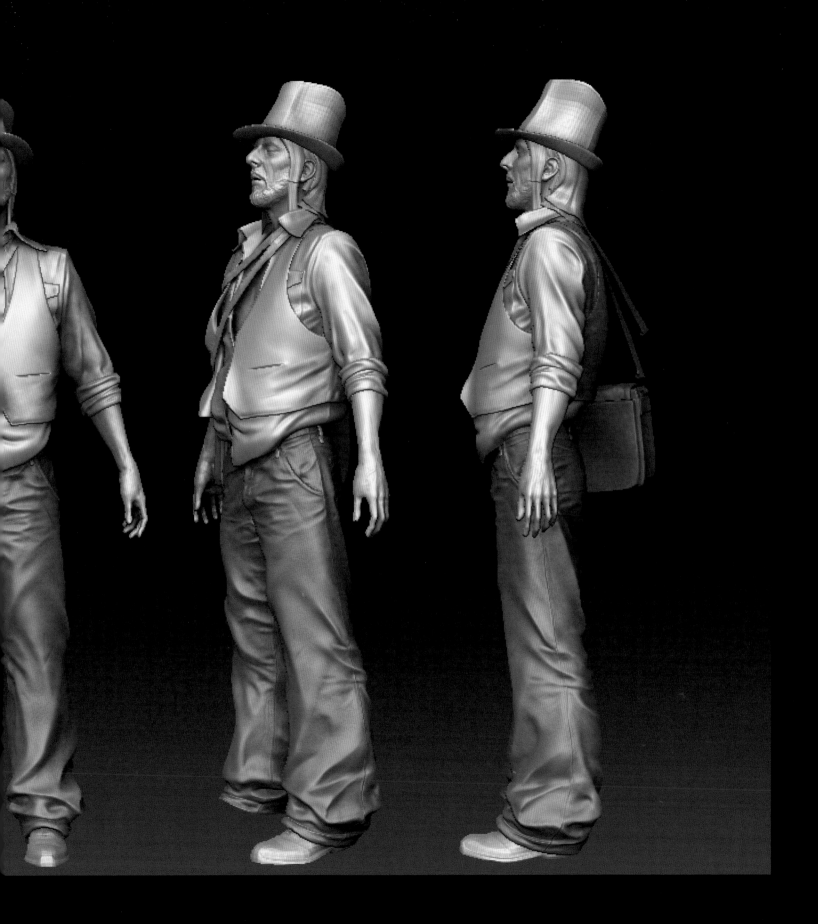

HYBRID

❝ I changed my process and simplified it: less 3D, more 2D ❞

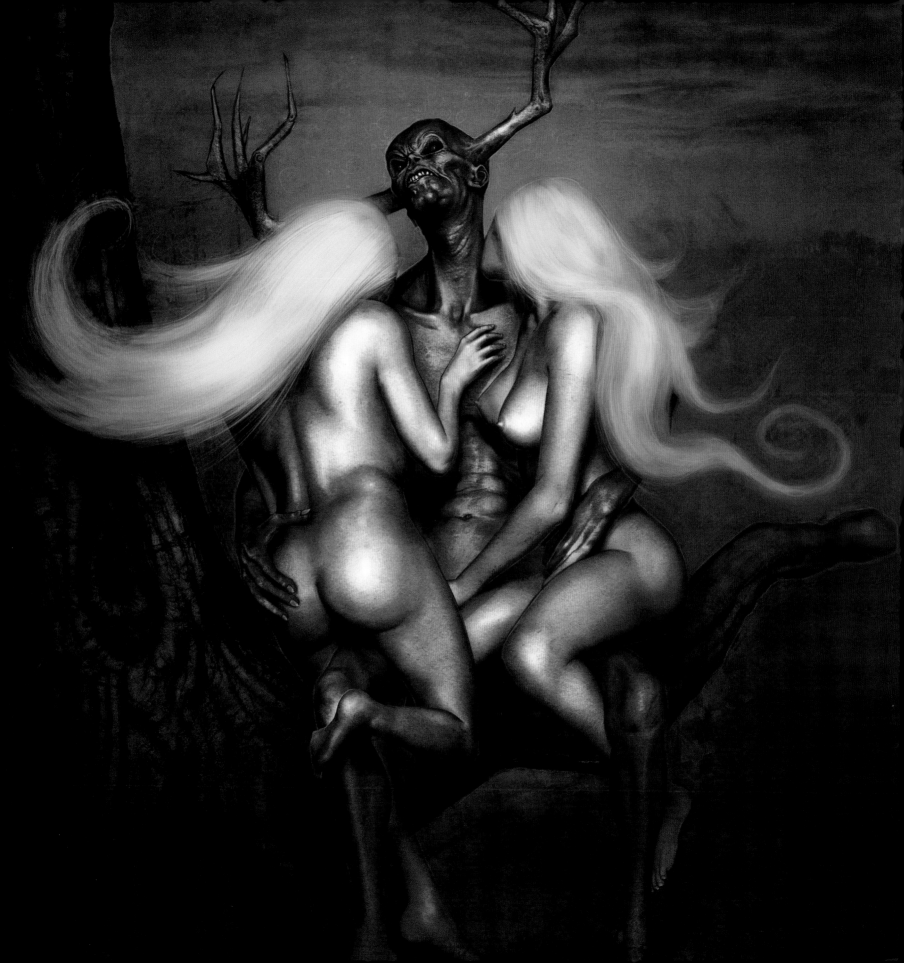

" Modeling remains my favorite part of the process when it comes to 3D **"**

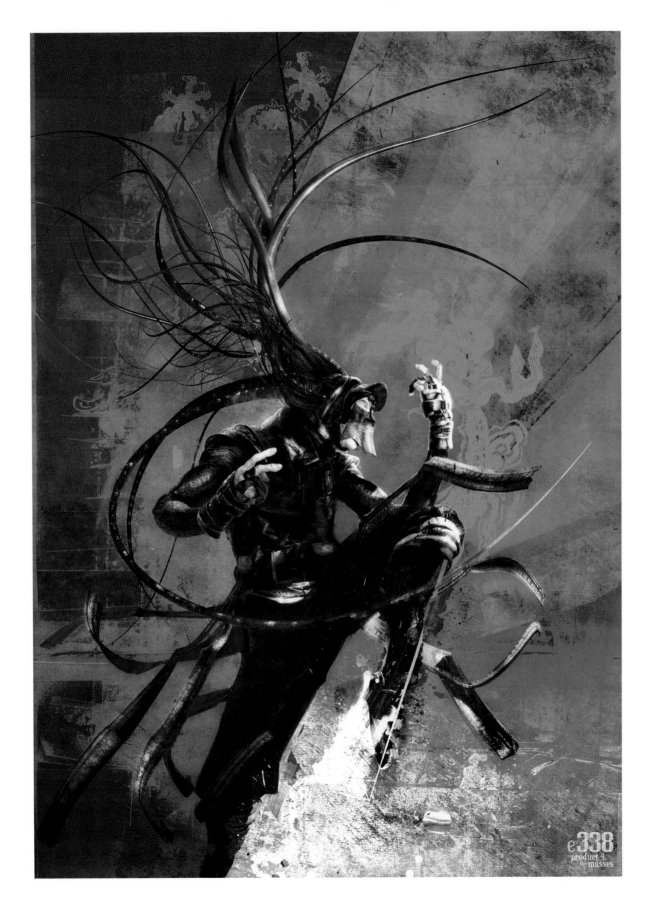

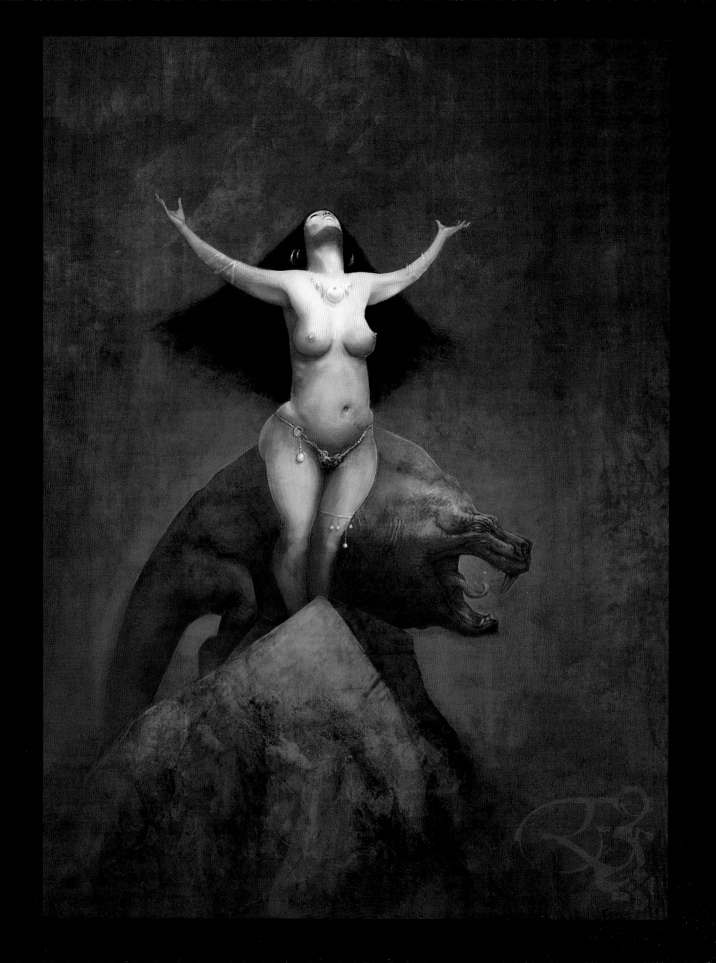

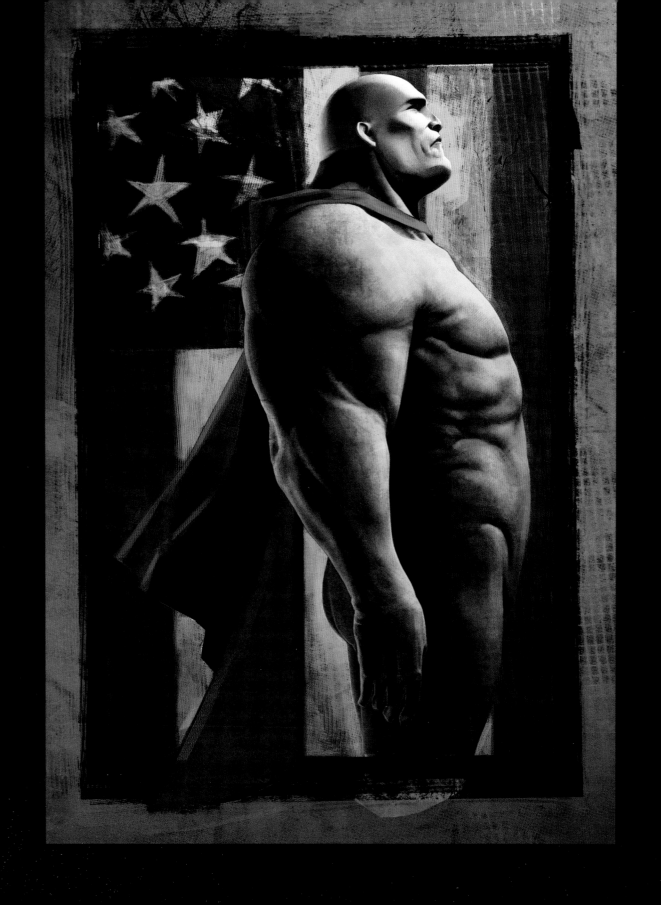

After using 3D for production and animation for years, Loïc decided to try it as a starting point for his illustration work. During his graduation program, 3D quickly became part of his graphic design experiments; the modeling tools were much more rudimentary when he started, but over the years they have become faster and more intuitive.

"While my modeling skills were improving, my illustration ability suffered from a terrible lack of practice," Loïc recalls. "I thought it would make sense to actually create and pose geometry with a simple render as a base for creating my images. After a few tests, I found a process that I really enjoyed and that would serve me for years to come.

"If at first I was still doing shader development and proper renders, it eventually evolved into more rudimentary scenes with detailed geometries – a direct repercussion of the introduction of ZBrush into my process – and no texturing at all. A simple occlusion pass combined with a solid key light would basically give me what I needed to get started and, after all, modeling was – and still is – my favorite part of the process when it comes to 3D. The technique kept evolving.

"While I was working at Sparx Animation, I met and became friends with Matthieu Goutte – who was already a very talented rigger and has become nothing less than a monster at it since. Based on a very simple scene that contained male and female geometry that could morph between each other, Matthieu built an auto rig that would generate, position and skin a simple skeleton based on any sculpt I would create out of that geometry, giving me the ability to pose my characters at any given time. This was before ZBrush's Transpose tool, and it made my life easier for a few years.

"It was also during this time that I made *The Bus-stop Boxer* illustration (see page 45). What's fairly unique about this one is the amount of time I spent tuning my shaders. This was following my work in Milan and I was very impressed by the quality of the renders that our supervisor, Jonas, was doing there. I thought I could benefit from this time-consuming experiment. After all, wasn't I commuting three hours by train every day? This in return gave me a lot of quality time with my beloved laptop. The shader was using SSS in mental ray; there was displacement, final gather, and an insane amount of textures. Pretty much all the things that I would keep using over the following years for production, and also what I had been using to create my images in MotionBuilder the year before.

"After that image, I changed my process and simplified it: less 3D, more 2D. The biggest game changer was obviously ZBrush. Not only was the sculpting part more entertaining with it, but the ability to get all those details directly into the mesh was the perfect way for me to reduce the amount of texturing down to zero. I was able to just focus on the part that I enjoyed the most and over-paint everything I wanted directly in Photoshop.

"For a while, I kept exporting my scenes back into Maya for rendering, using basic Final Gather. Then, out of laziness, I started to render several passes directly in ZBrush – although I always hated the cameras in that one. These days though, I'm debating bringing 3D back into the mix – after six years in quarantine – and I'd probably consider KeyShot for rendering, or any 3D application with a very simple render engine. mental ray was a pain to use back then, and even if I enjoyed what I could do with it, I hated the damn thing. Using Arnold for look-development in production at work sort of reconciled me with the whole rendering process, but really, in the end, I don't want to be tweaking parameters for hours. The next thing you know, I'll use Marmoset and call it a day.

"I had to step away from 3D since I wanted to improve my drawing. If you have stabilizers on your bike, then you tend to rely on them. And after years of creating digital doubles for video games and films, I really didn't feel like opening a 3D package at home at night. This all led to a focus on illustration and painting.

"The recent *Binaural* sculpt was actually my first personal project in 3D in five years. It reminded me that I like to sculpt out of production constraints. Since I feel a bit more comfortable with 2D nowadays, it could make sense for me to play with that 3D toy again – especially since it has kept evolving. I'd probably pick an outsider tool though and step away from the old classics like 3ds Max and Maya."

How evolving with and incubating tools to form a new visual language would carve a path to a career in the film industry, where 3D and paint-overs make for super efficiency

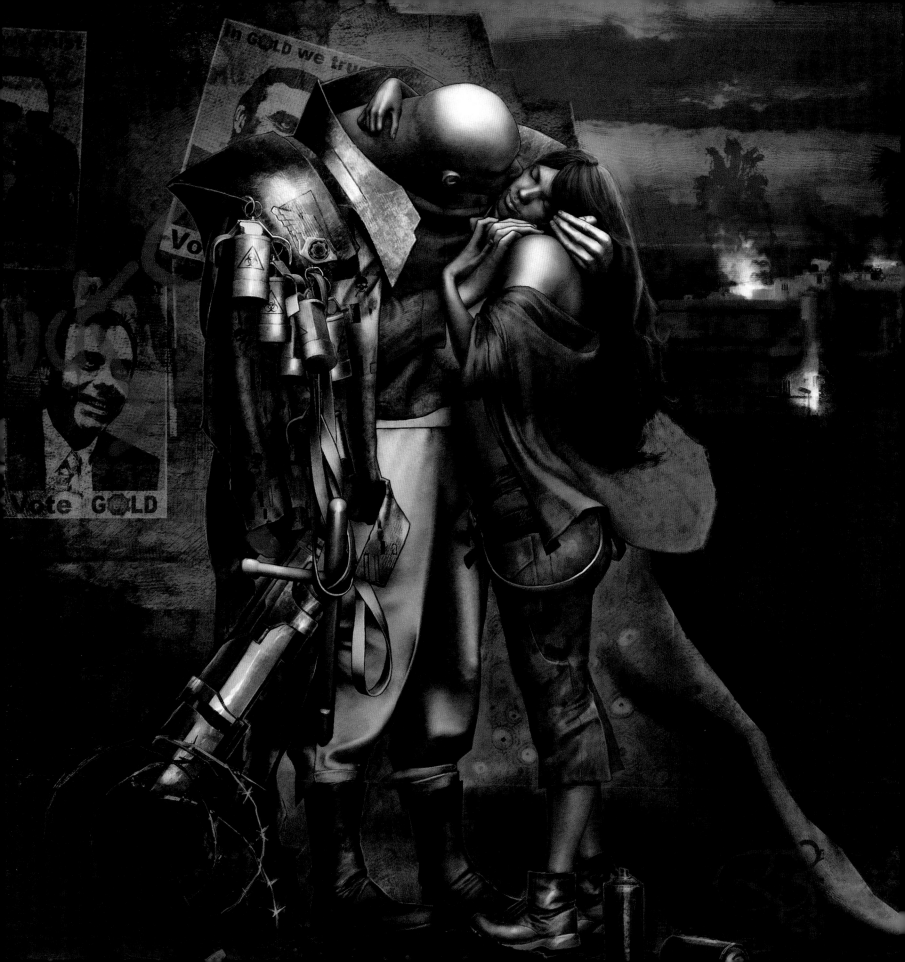

"The process that I used for illustration for years became a great asset of mine at work, since I've gradually migrated towards a supervision position at Luma Pictures," Loïc continues. "Depending on how far we are into production, any of the methods that I have used in the past may come in handy. For example, early on, I could use match-move geometry provided by our team, or pre-viz from a client, and build a detailed image from it that could get the discussion going with the studio. Later on in the production, this paint-over technique becomes a good way to show what we plan on doing so that the time-consuming process of painting textures and fine-tuning shaders can be done with a precise reference in mind. Often I will make one image as fast as I can, then let the artist match it, then make another one more refined based on their current work, and gradually refine till final. This doesn't feel as rewarding as cranking a killer image right away and letting people work on it for weeks, but it's very efficient.

"I also use very fast paint-over images to give my notes during my modeling reviews. This gives the artist a one-to-one reference of what he needs to address, with a clear definition of the volumes and shapes I'm after. You can always talk for hours but over time this method has become our favorite, especially since I'm much faster at it now. Obviously, the last application for it would be for matte painting. In which case, I try to work as clean as possible so we can use the high-res concept directly in production with Maya and NUKE, for example."

" The biggest game changer was obviously ZBrush "

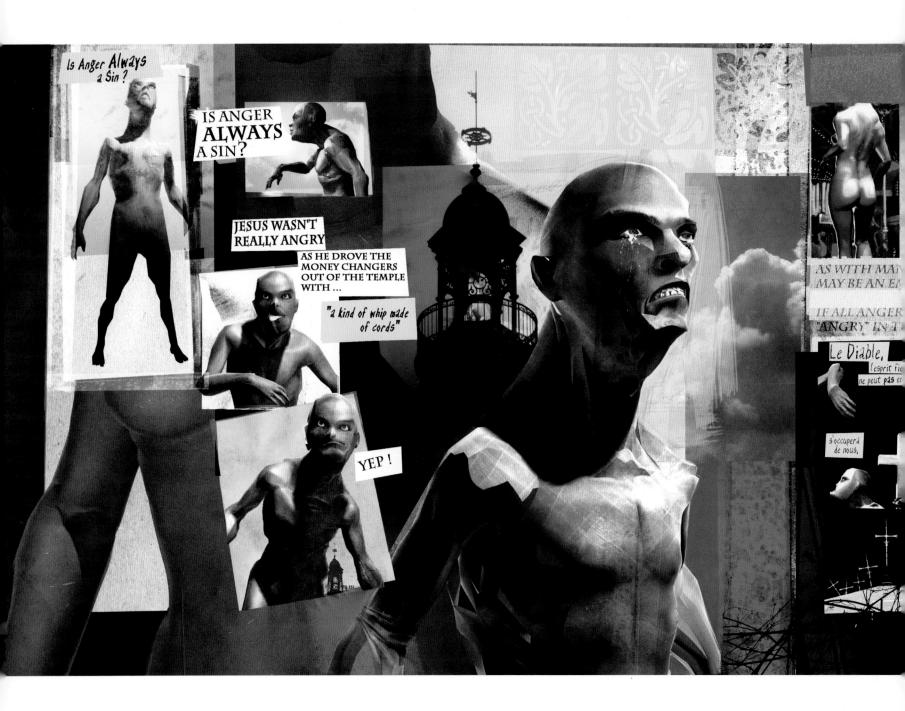

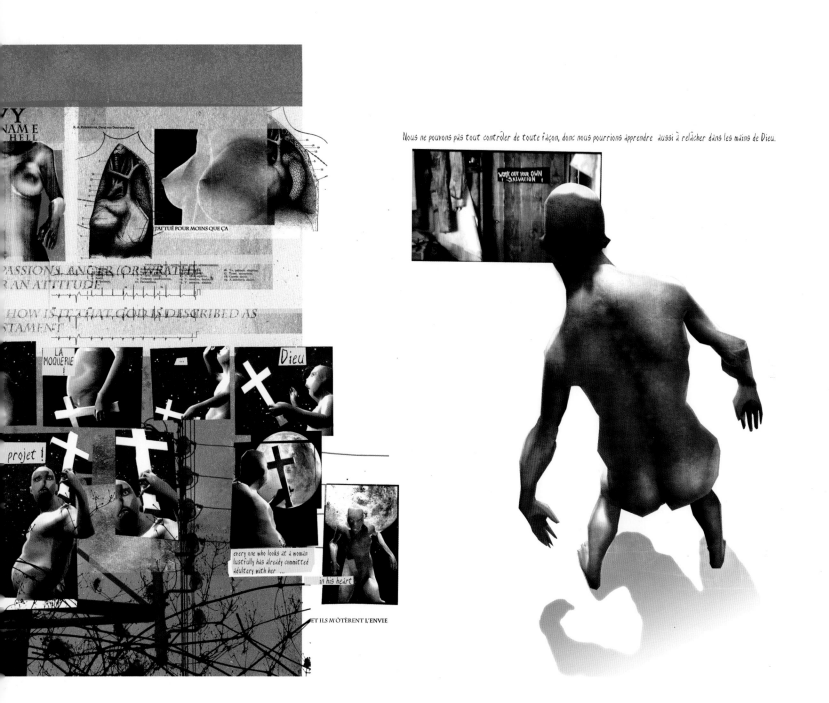

Nous ne pouvons pas tout contrôler de toute façon, donc nous pourrions apprendre aussi à relâcher dans les mains de Dieu.

" Depending on how far we are into production, any of the methods that I have used in the past may come in handy **"**

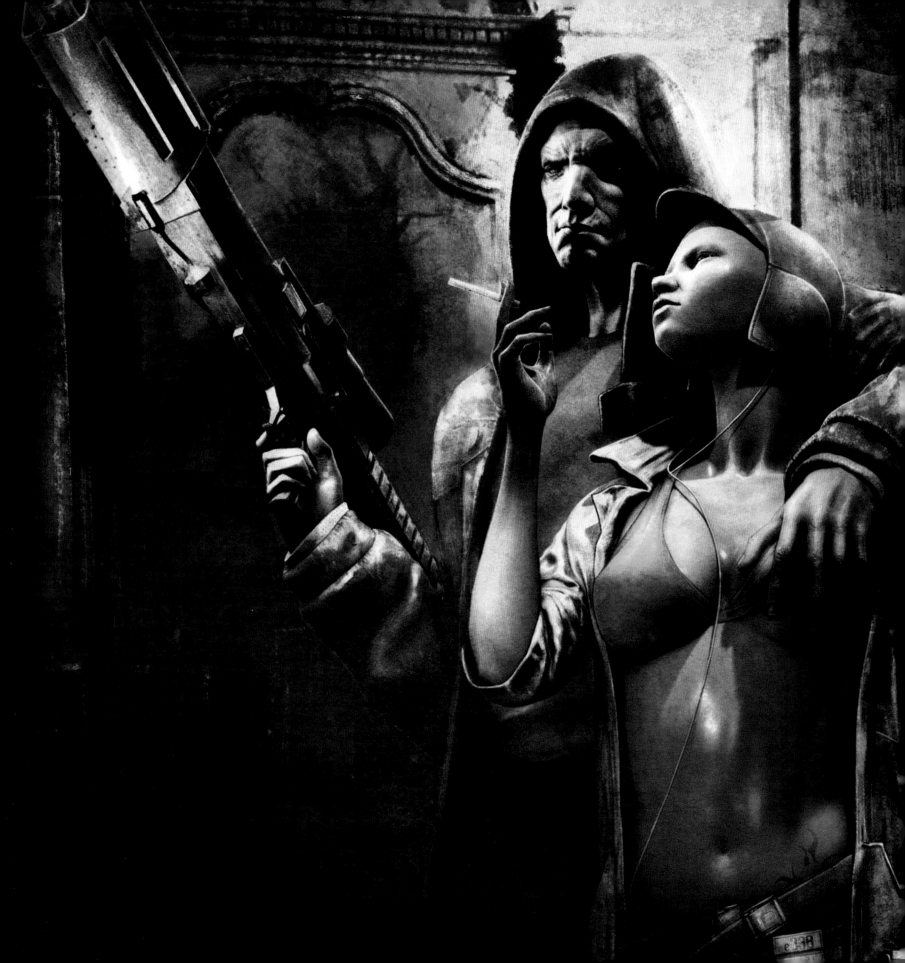

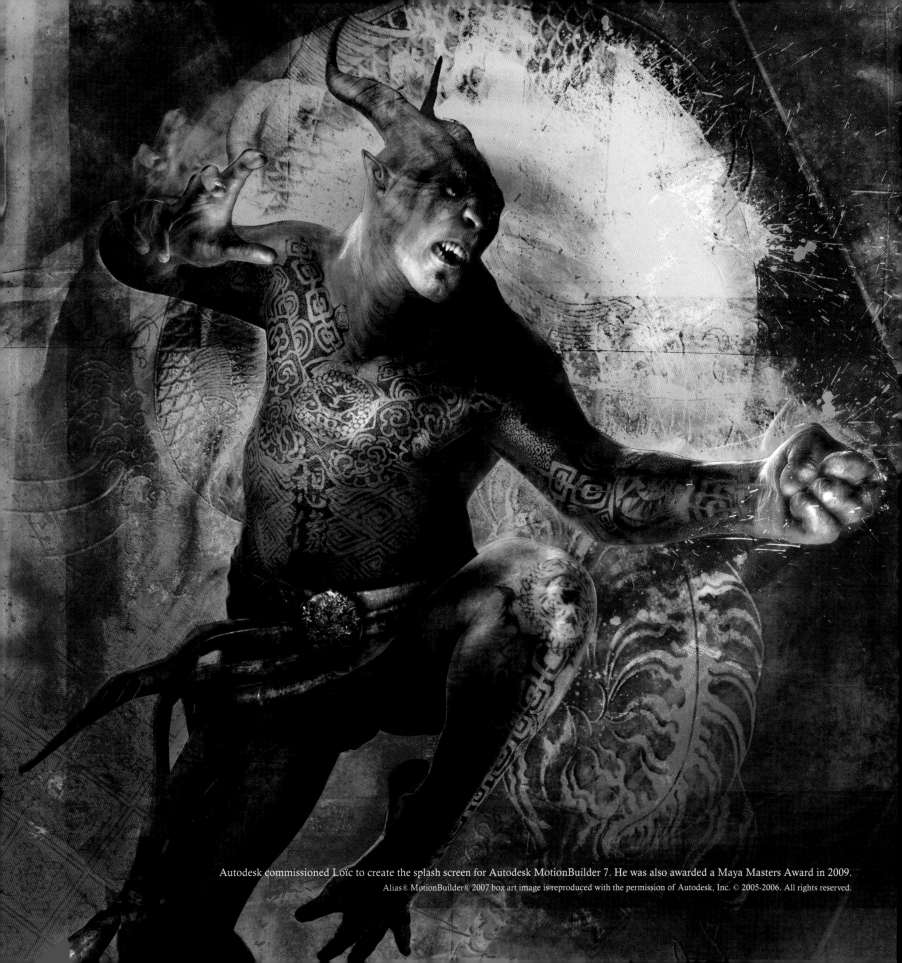

Autodesk commissioned Loïc to create the splash screen for Autodesk MotionBuilder 7. He was also awarded a Maya Masters Award in 2009.

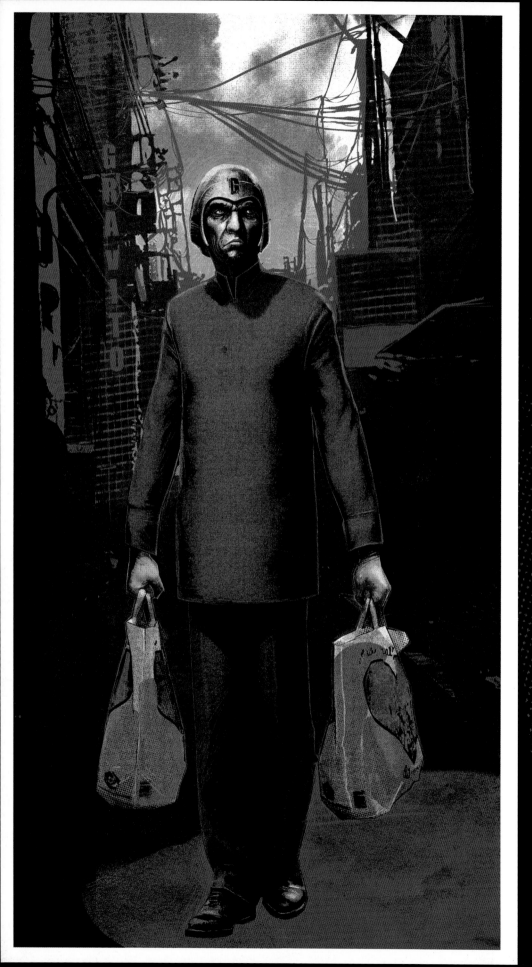

SILKS

Reorganizing chaos into layers: Loïc discusses the hands-on process of silkscreen printing in comparison to digital illustrations that allow for a more frenzied approach

Designing for silkscreen is a very interesting and challenging process. While Loïc tends to be messy in his use of layers – over time they've become more of a history store than a clean way to organize illustrations, aside from specific concept art/matte painting works – this is something he can't afford to do when it comes to silkscreen.

"The way it works is that for every color you want to put in your image, you'll have to create a film, and later on a screen," Loïc explains. "It's called 'color separation' and it's a fairly common process in the printing world. It's easy when you have a few colors only; all that really matters is to make sure you have a bit of overlap in your layers so that a micro offset in the screen won't create too big of a gap when you print.

"In the case of *Roy Nexus 6* (see page 55), for example, the process was a bit more challenging. With its nine colors, each of them in a specific order, some will effectively cover others more easily – from experience, the more you know about how the colors work together, the more predictable the results are."

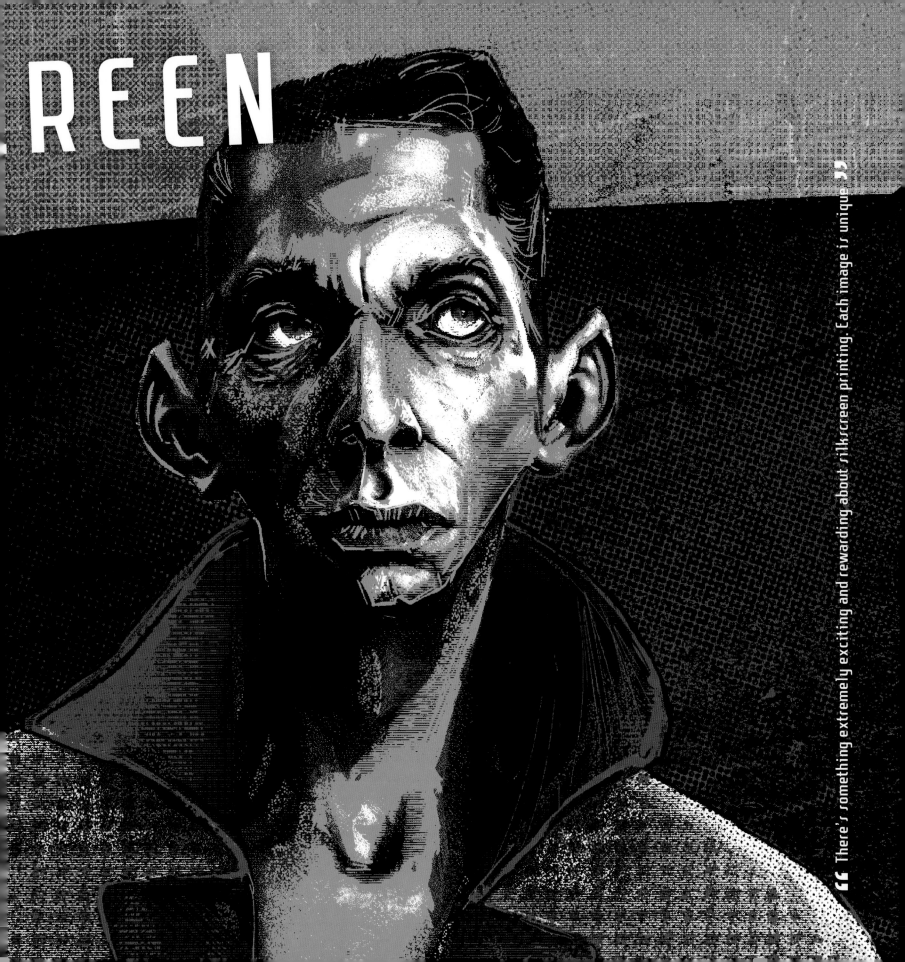

REEN

There's something extremely exciting and rewarding about silkscreen printing. Each image is unique 〞

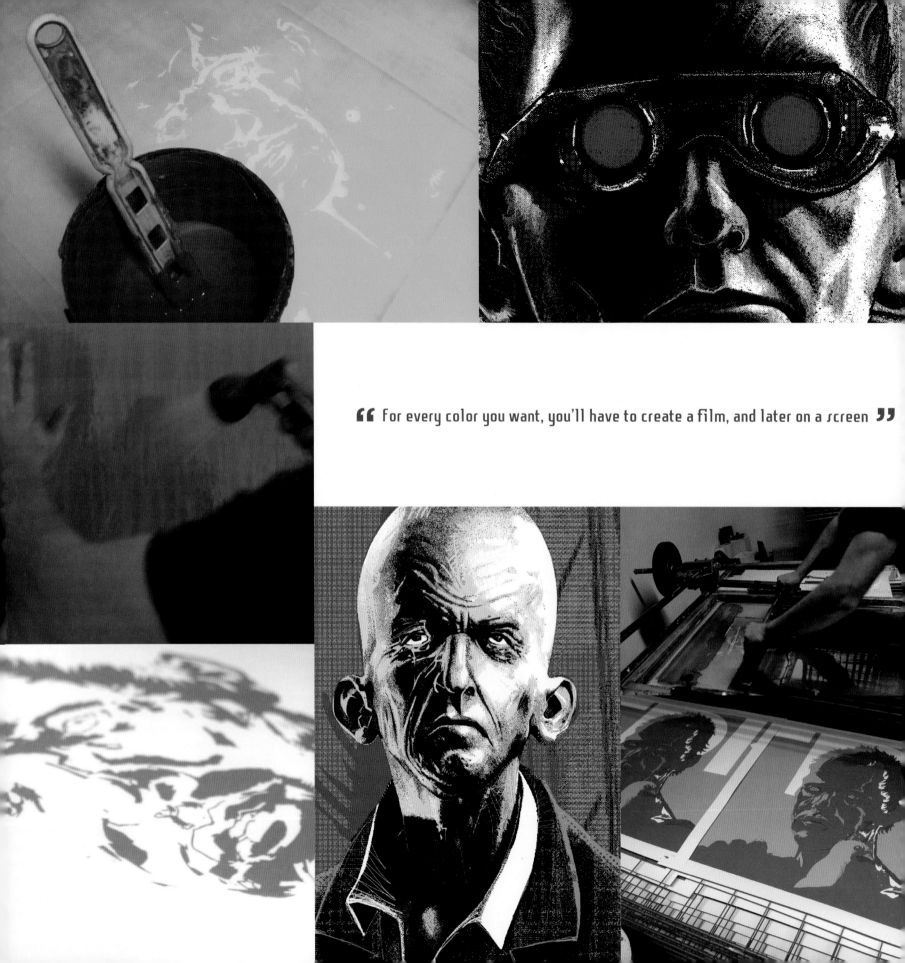

" For every color you want, you'll have to create a film, and later on a screen **"**

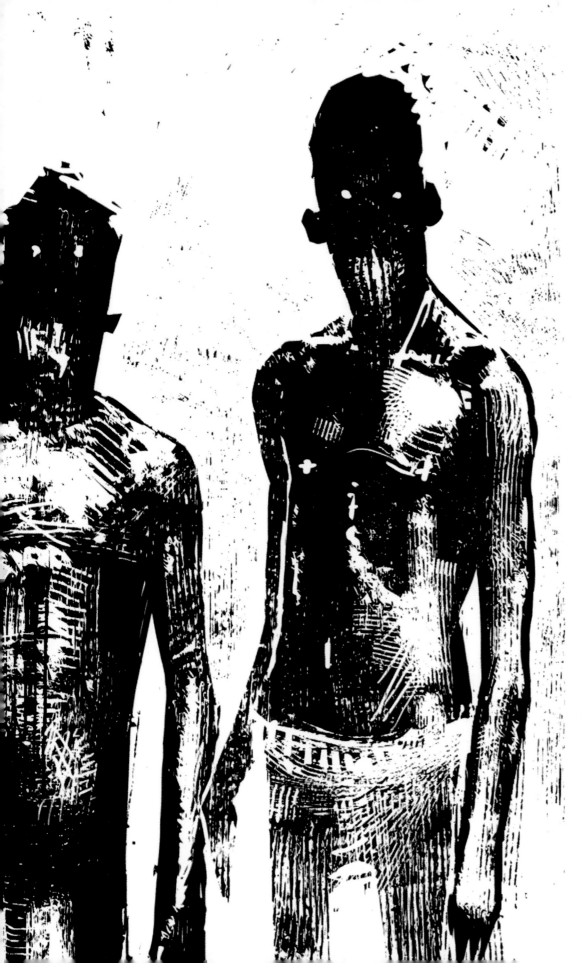

"Then there's the resolution and the amount of details you can put in," Loïc continues. "In a sense, this is closer to tattooing: a thin black line on a clear background can be pretty much as thin as you want, but a white line – negative space – on a darker area will have to be slightly wider since the colors can end up bleeding a bit.

"The fabric acts as a matrix for your image. A detailed work is equivalent to around 130 DPI or so. Coarser fabric will give you the equivalent of 72 DPI. These don't translate as screen images though, and resolution is not everything.

"There's something extremely exciting and rewarding about silkscreen printing. Each image is unique, especially since they're hand-printed when I work with Olivier Marescaux (**www.oliviermarescaux.com**). Little changes will occur, details will appear slightly sharper here, looser there. We're talking about subtle differences, obviously.

"I really enjoy working with this media as an output. It's very traditional and comes with a bunch of challenging constraints – and this can explain why the images I design for it are totally different. In a way, it's forcing me to use another set of skills and focus on my line work. This can only be beneficial in the bigger picture."

❝ Coarser fabric will give you the equivalent of 72 DPI... ❞

Brandon Mouche

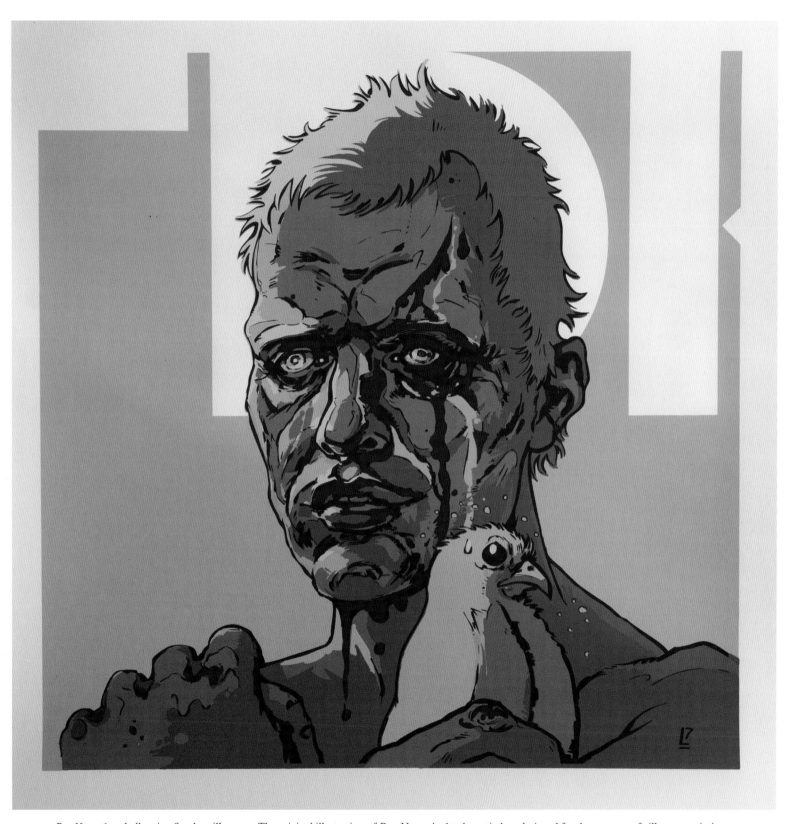

Roy Nexus 6, a challenging 9-color silkscreen. The original illustration of Roy Nexus had to be entirely redesigned for the purpose of silkscreen printing.

ILLUSTRATION

It starts with only a few hundred pixels - 338, most of the time - allowing great speed and simplification

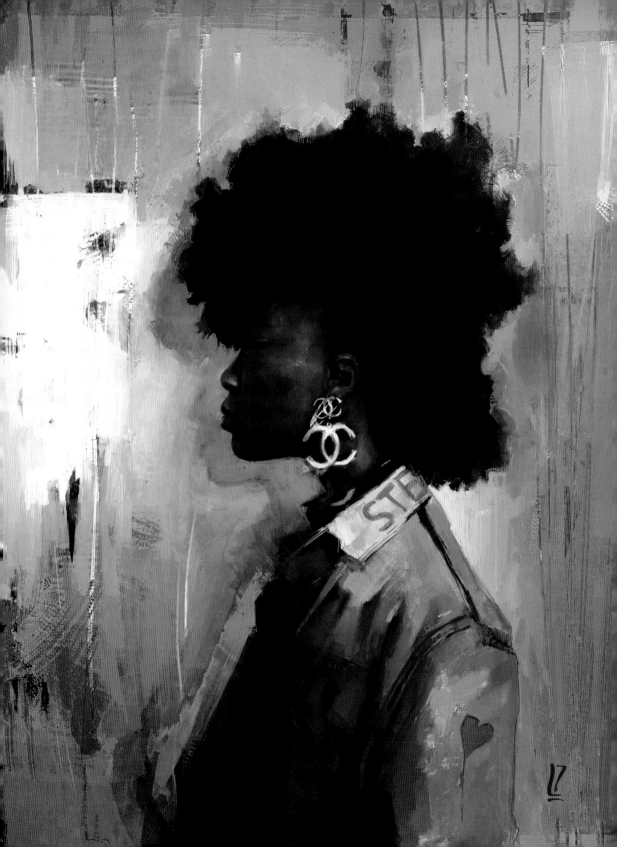

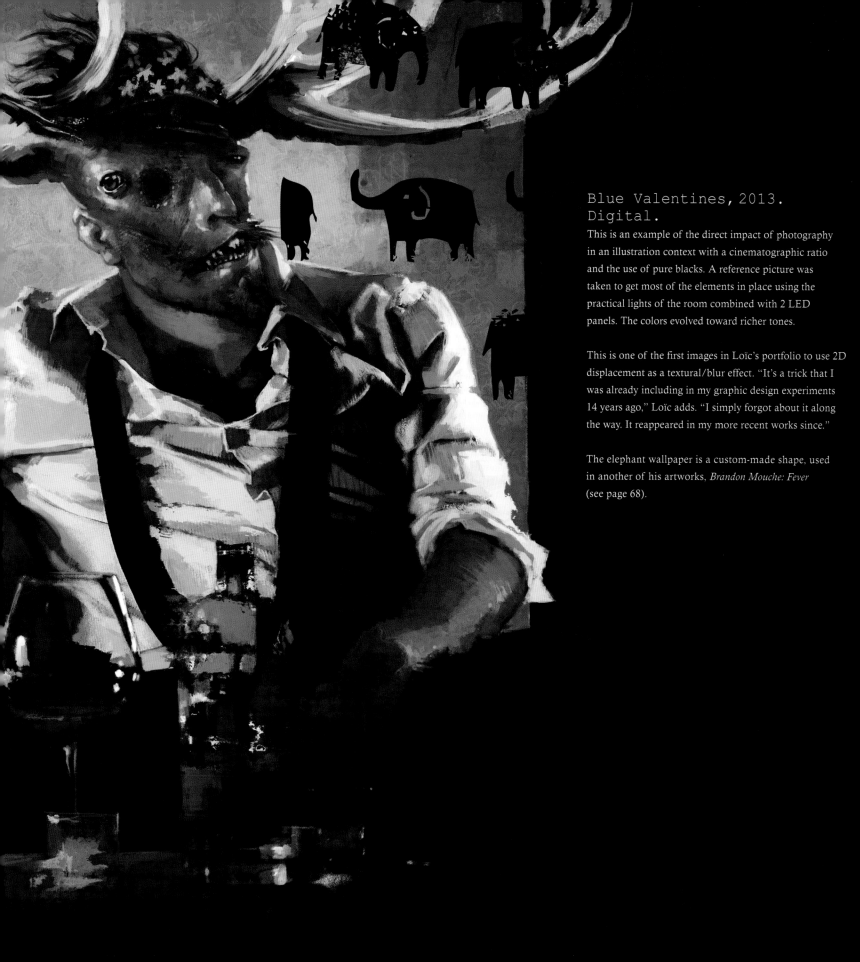

Blue Valentines, 2013.
Digital.

This is an example of the direct impact of photography in an illustration context with a cinematographic ratio and the use of pure blacks. A reference picture was taken to get most of the elements in place using the practical lights of the room combined with 2 LED panels. The colors evolved toward richer tones.

This is one of the first images in Loïc's portfolio to use 2D displacement as a textural/blur effect. "It's a trick that I was already including in my graphic design experiments 14 years ago," Loïc adds. "I simply forgot about it along the way. It reappeared in my more recent works since."

The elephant wallpaper is a custom-made shape, used in another of his artworks, *Brandon Mouche: Fever* (see page 68).

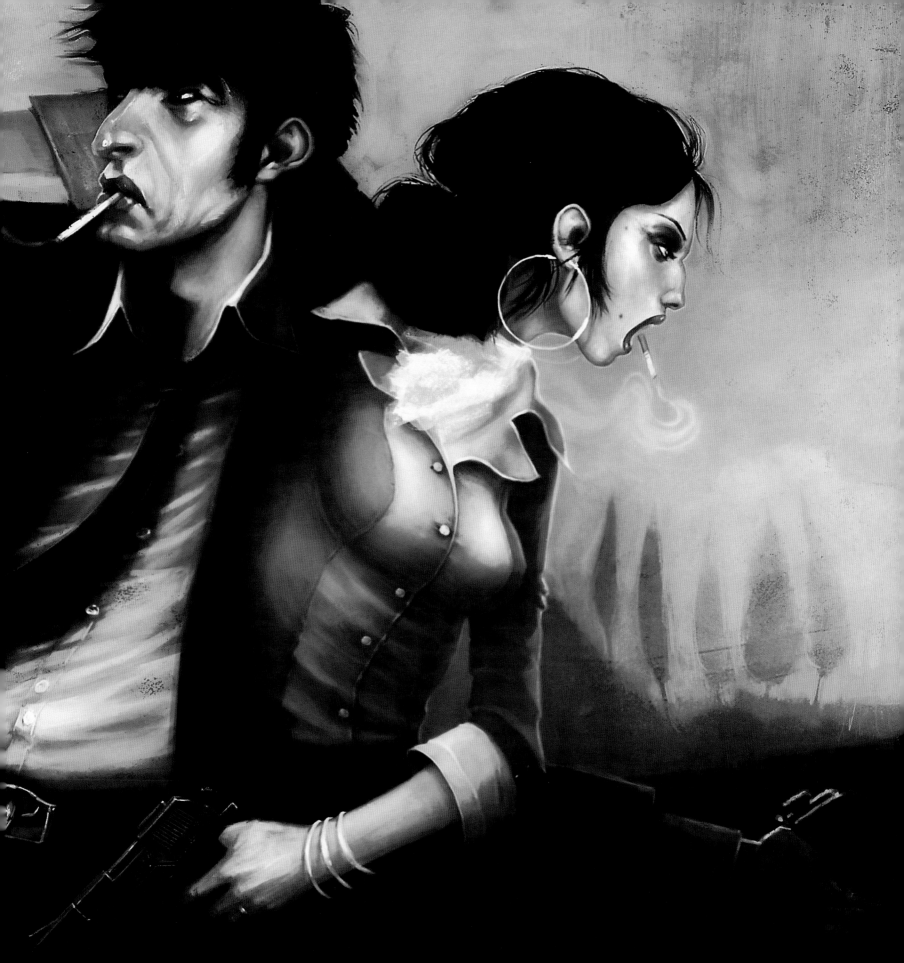

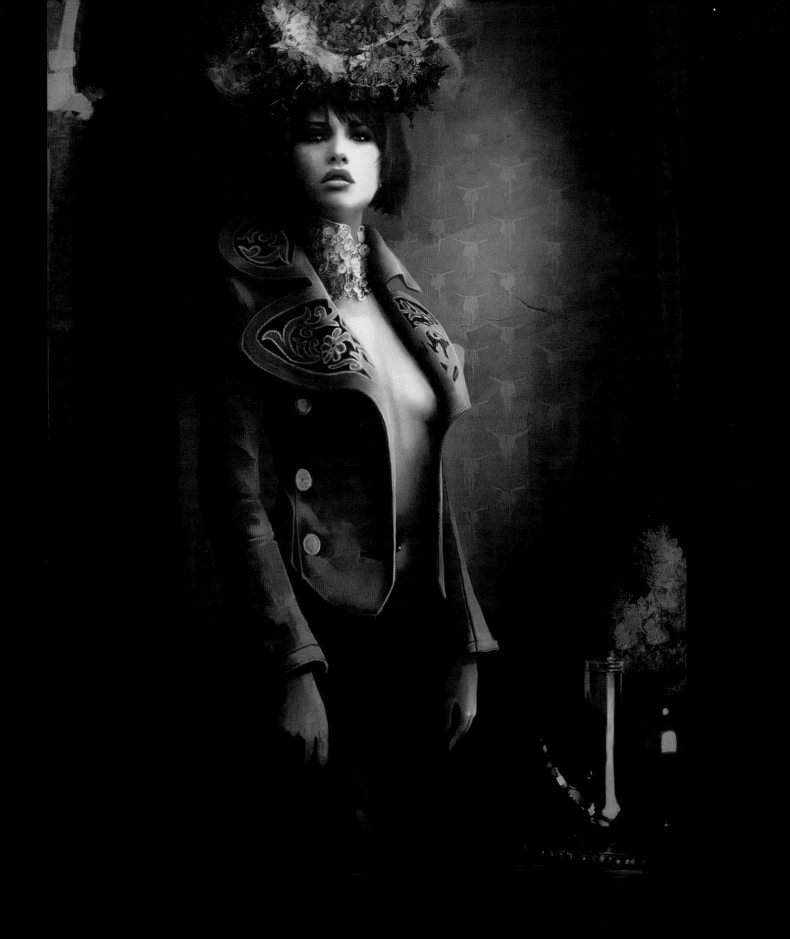

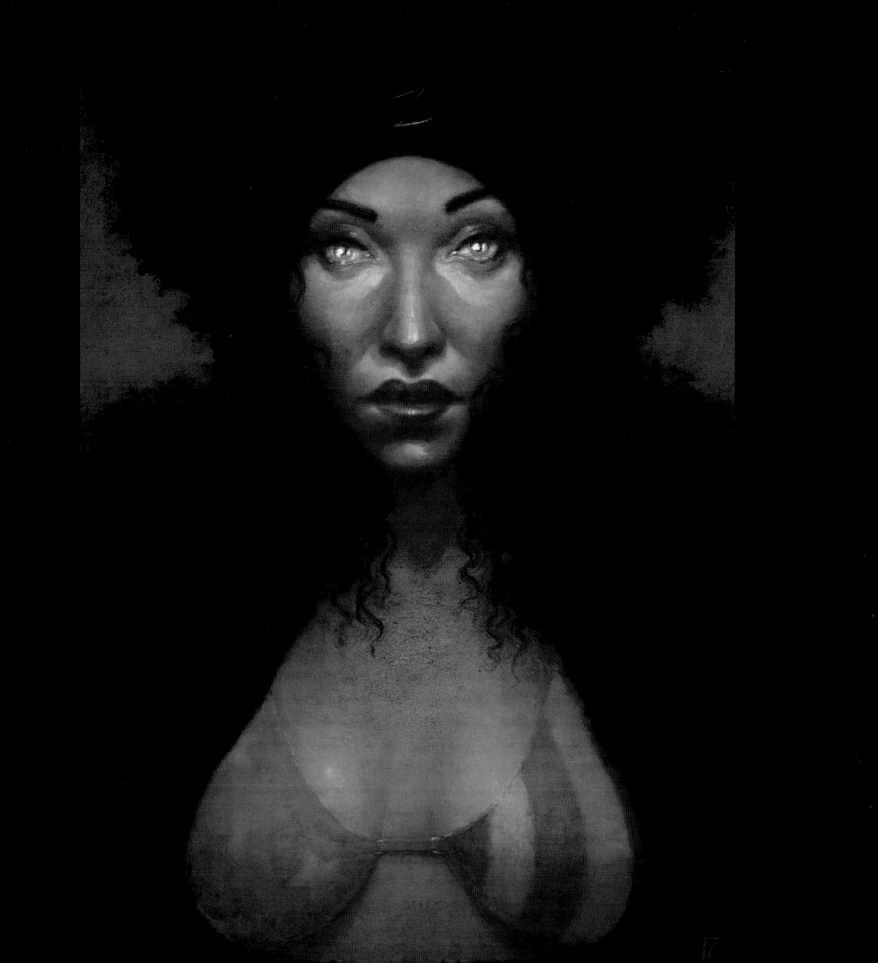

Industry insights

We rate success by a job title or project in a portfolio. Loïc shares an honest account of his lifelong goals as well as the truth about working in the entertainment industry

Of all the people...

I used to think that I knew what I wanted. But the older I get, the looser that concept becomes. Envies, I have. Goals, journeys and aspirations – I have. But nothing is as clear in my head now as it used to be…

For starters, at 10 I wanted to go to art school and do… art. What that was, I have no idea. Over time, illustration became a more precise answer but the artsy things I studied at art school, along with the design classes, only added to my confusion. How could I ever choose from all those disciplines? I liked so many of them!

3D became the logical answer, because it felt like a great way to reconcile everything: a simplified version of the world, a laboratory in which all media would merge. There, in that window, I would bring volumes and colors, light and photographic concepts, graphic design aspirations and animation. Gosh, I would even bring in sound and music!

And this was all true, in a way. But over time, 3D became an ogre, eating everything within reach: other art forms, social life, relationships… And very little would come out of it – at least until I decided to use it mostly for illustration purposes. But that doesn't tell us much about my career, right? So let's try to get a bit more specific here…

Because 3D quickly became my favorite tool during my last years at art school, I decided to focus my efforts on it and build my career from there. Understand it as a 10-year run, approximately. If I still dive in from time to time these days, it is no longer the core of my job but rather an element among others. But during those 10 years, I really covered a wide range of subjects and my job evolved from being a generalist working mostly in architecture and graphic design, to a character artist for games and movies.

The job is the same, really. You have clients, deadlines, constraints, technical limitations, compromises to make, and so on. Your computer crashes – there's always a great tool out there, and a hack to solve a problem.

I used to think that it was different – low-key jobs versus high-profile productions – but really, the only thing that varies is the exposure. When you work for industries, governments or administrations, only a small group of people will ever see what you've done. It can be a bit frustrating when you put your heart into it. You don't get that tap on the back. You do your job and they do theirs, and at the end of the day, no one cares.

On the other hand, working on video games and movies sounds fancier on the paper. But you quickly realize that due to the scale of the projects and the money it represents, there's going to be a lot of politics involved. And if your work does reach a much broader audience, you might not recognize yourself in it in the end. You'll say 'thanks' when people congratulate you, grinding your teeth in silence. In both cases, you will learn much more and much faster by working on real projects than you would by being on your own.

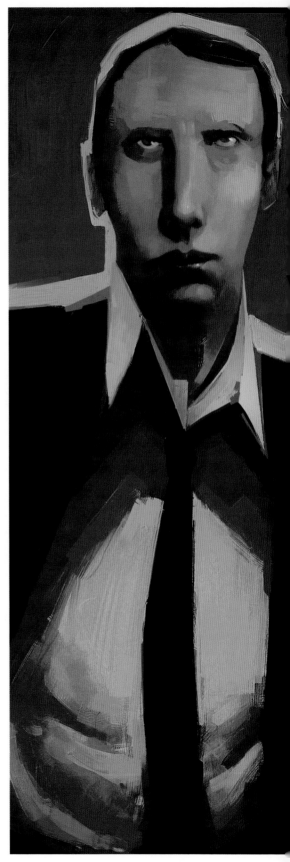

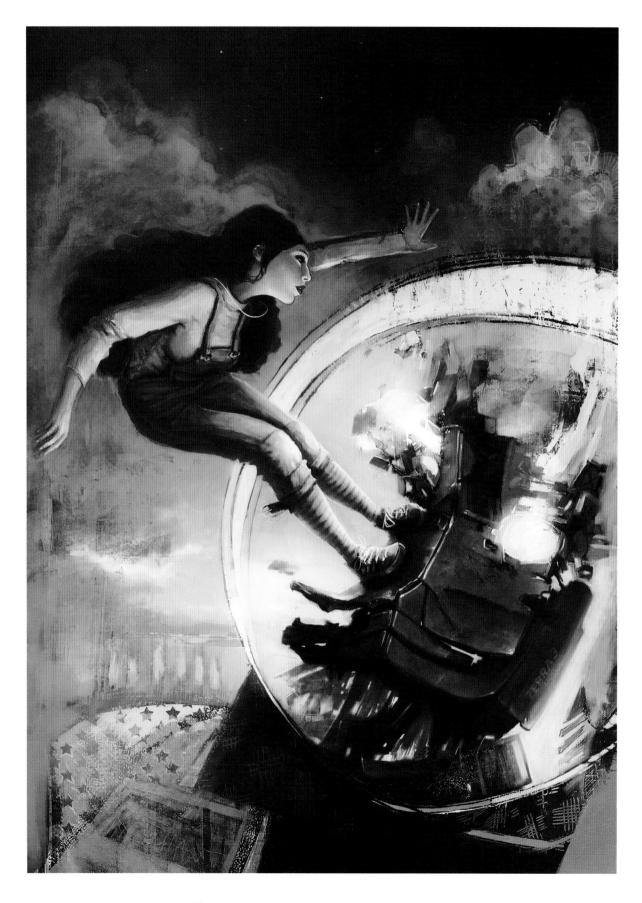

" Minimize the amount of details and focus on the bare minimum. Less is more "

You need a deadline. And that applies to everything. Otherwise, nothing gets done. Ever. I've seen it in my own projects at the beginning and I've seen it around me when people start something and don't put themselves in this situation where they commit to deliver at a specific time. There's always something you can improve; always a little thing here or there that could be tweaked. But in the end, honestly, how big of an impact will this have on your work? 20-percent? 30? Or is it two? It's likely to be the last option, and that alone won't make the work good. But a series of strong decisions will take it to 50-percent, 75-percent, and even 90. Those are the milestones. Those are the things you should keep in mind when you work. Then it's comfort and polishing. It's good. It's very satisfactory, too – like the work of a cabinetmaker when everything clicks perfectly, when the surfaces are smooth and totally lining up. When the tint and the varnish bring the elements together. Although none of this matters if the initial idea, the structure, is not there already.

If we go back to 3D, for example, the myriad of details a tool like ZBrush can lure you to diving into won't make the model a great piece – unless the structure is right. It may sound obvious, but look around and teach your eyes not to get fooled. What happens if you remove the details? Does it still hold up? Does it still have strength? In graphic design, they used to say that if a logo was still readable after running it through an old black-and-white photocopier, you were on to something good. The concept still applies now, although media and reproduction techniques have drastically evolved over the past decades.

Let's extend to other art forms. A great example comes to my mind in the sculptures of Kris Kuksi (**www.kuksi.com**). His art contains a tremendous amount of detail, which appears to be thousands of elements glued together to create intricate pieces, and yet if you squint your eyes in front of them, you'll realize that there's a hierarchy in those shapes. That each piece has a strong silhouette – a mandatory rule in all things design, I guess – and great organization of space. Otherwise it would only be a pile of junk. The details are a major component, but they obey those rules. And those rules serve a subject: theme, structure, form.

The same goes for any project and any artistic endeavor. You have to make sure that there are strong foundations in what you're creating, to progressively detail it to a point where it makes sense to you and your sensibility. Most of the artists I follow and admire try to actually minimize the amount of details and focus on the bare minimum. Less is more. There's an important idea here, I think. And that's to keep an eye on what goes on in other art forms and things in life. Don't get stuck to your screen; don't get caught up in the technique that comes with it; and don't get stuck at work.

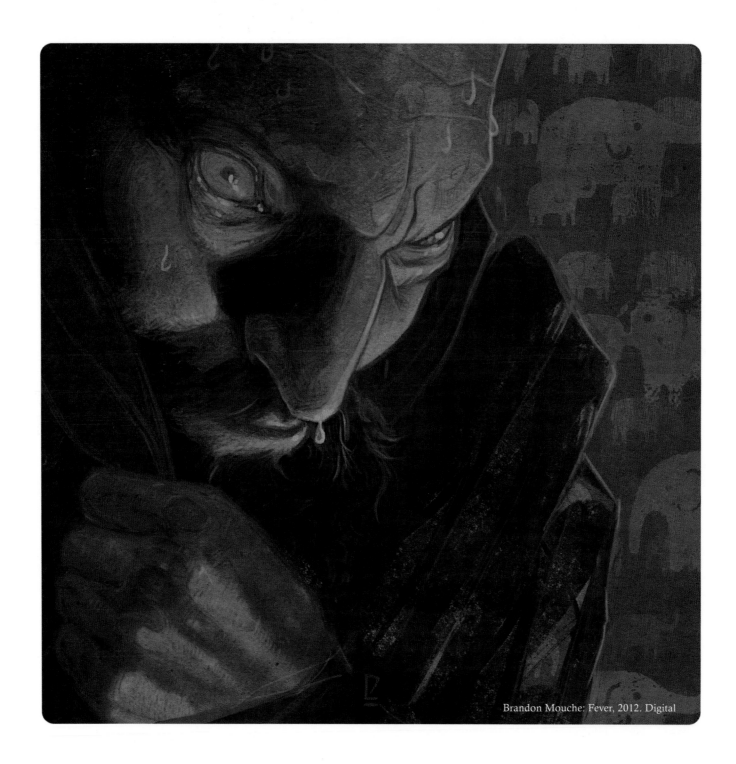

Brandon Mouche: Fever, 2012. Digital

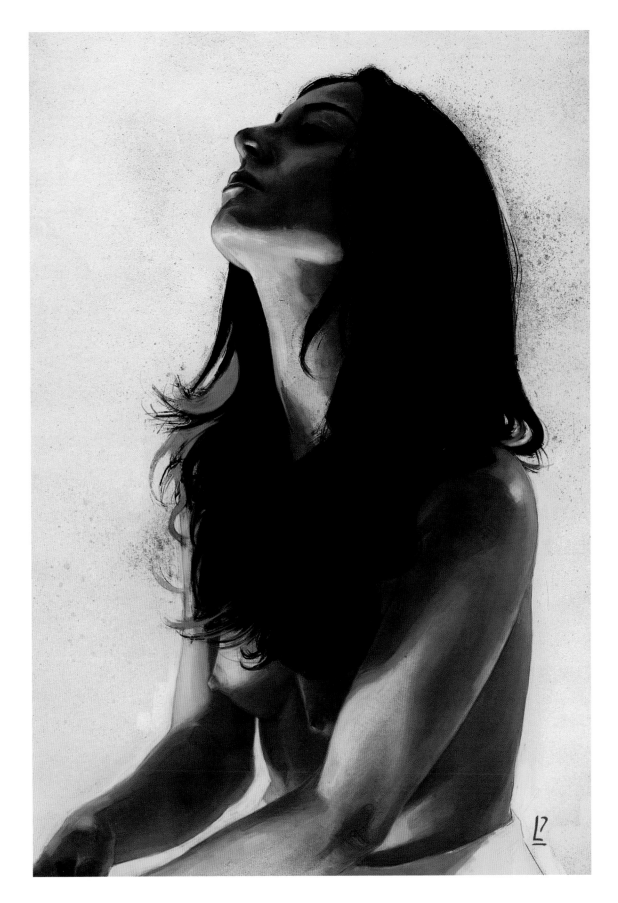

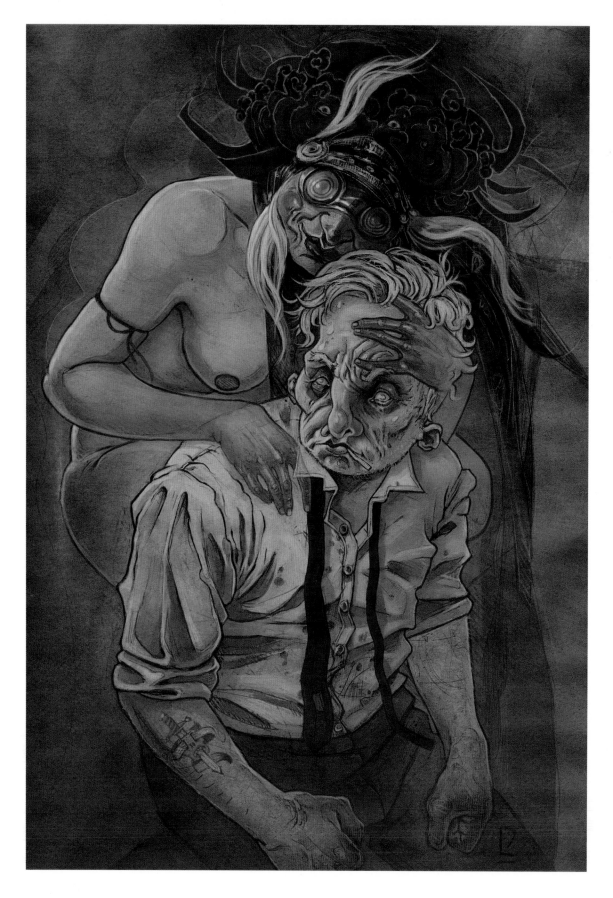

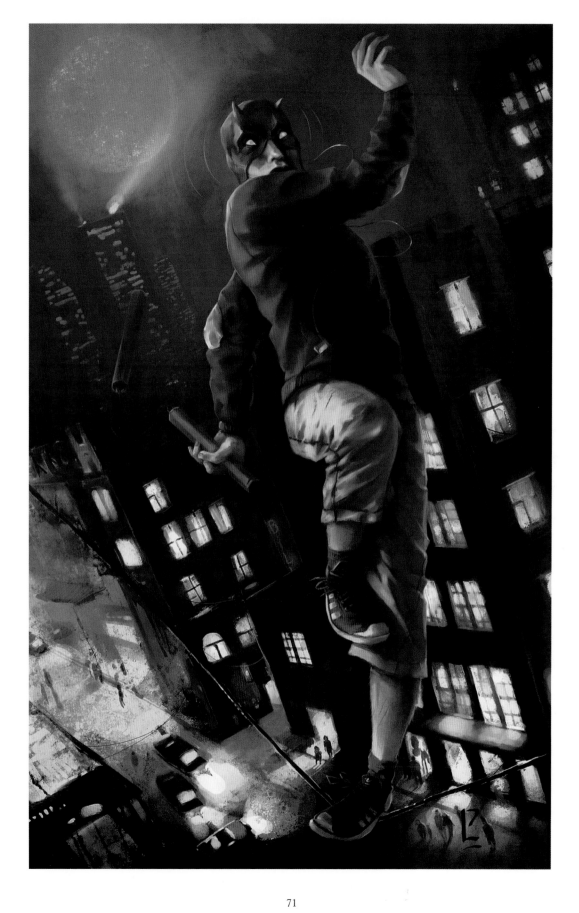

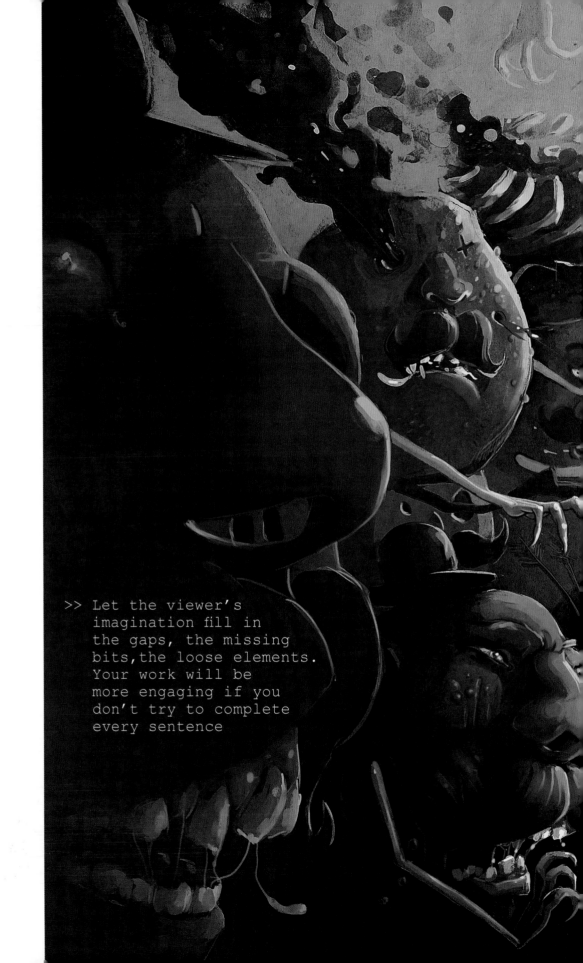

e338 in conversation
Part 2

Loïc Zimmermann: I used to believe that the work and the author were one, and connected; that when you really liked the work you basically had to like the author. And I've discovered – thanks to the social network, Facebook, Twitter, all those things – people share a little bit more of themselves, rather than their work. And I've been disappointed quite a few times [laughs]. Well, now it's not a disappointment anymore – I just know that it doesn't have to be this way.

Michael Kutsche: Yeah, you get like warning signs sometimes, right?

LZ: Oh yeah, you can see how people communicate about something – when they start to talk about their lives and that global vibe that they're going to develop. Facebook is a great example for that: one thing they choose to share beyond their work. And you will start getting a clearer picture of that individual behind the work.

MK: It was a lucky situation with us!

LZ: We were both totally out of our environments and in this place where you have everything to be. When I'm in another place and when you meet people in different places as well – I find that very interesting, how they behave. You don't take anything for granted; everything is new to you – everything is new to that individual. We happen to work somewhat in a similar field, so we know that behind the fun screen of amusement that goes with that work, there's like a dark side, and we know that we can go beyond that.

>> Let the viewer's
imagination fill in
the gaps, the missing
bits,the loose elements.
Your work will be
more engaging if you
don't try to complete
every sentence

The Day Billy The Kid Got
Ambushed by a Horde of
Zombie Potatoes, 2011.

The Jesse James character is inspired by a picture of Bob Dylan, who signed the soundtrack of Peckinpah's 'Pat Garrett & Billy the Kid'. He also had a little part in it. The zombie potatoes reference Playskool's Mr. Potato Head.

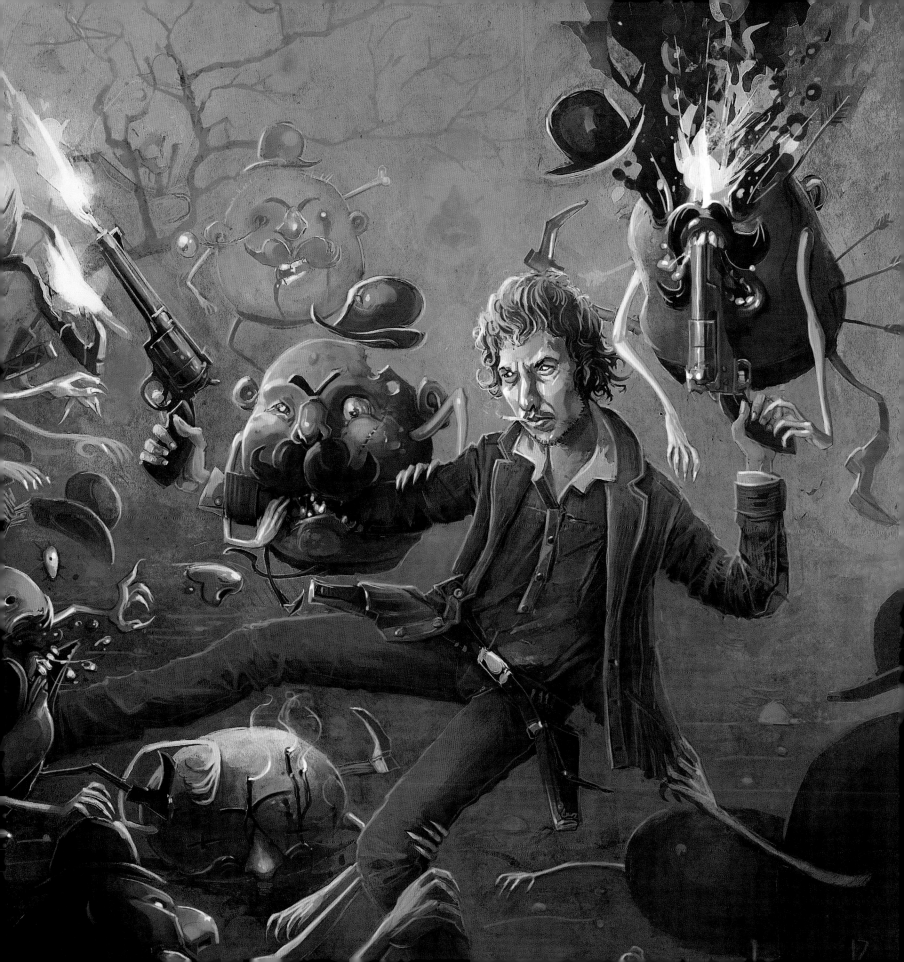

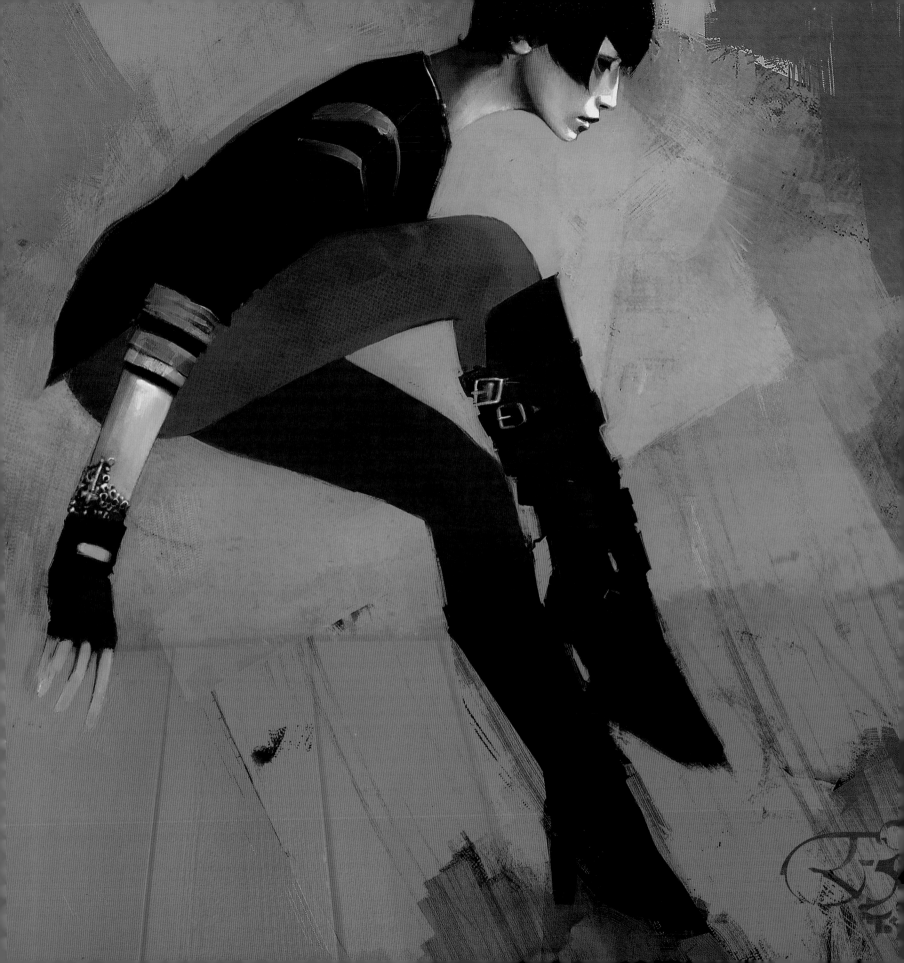

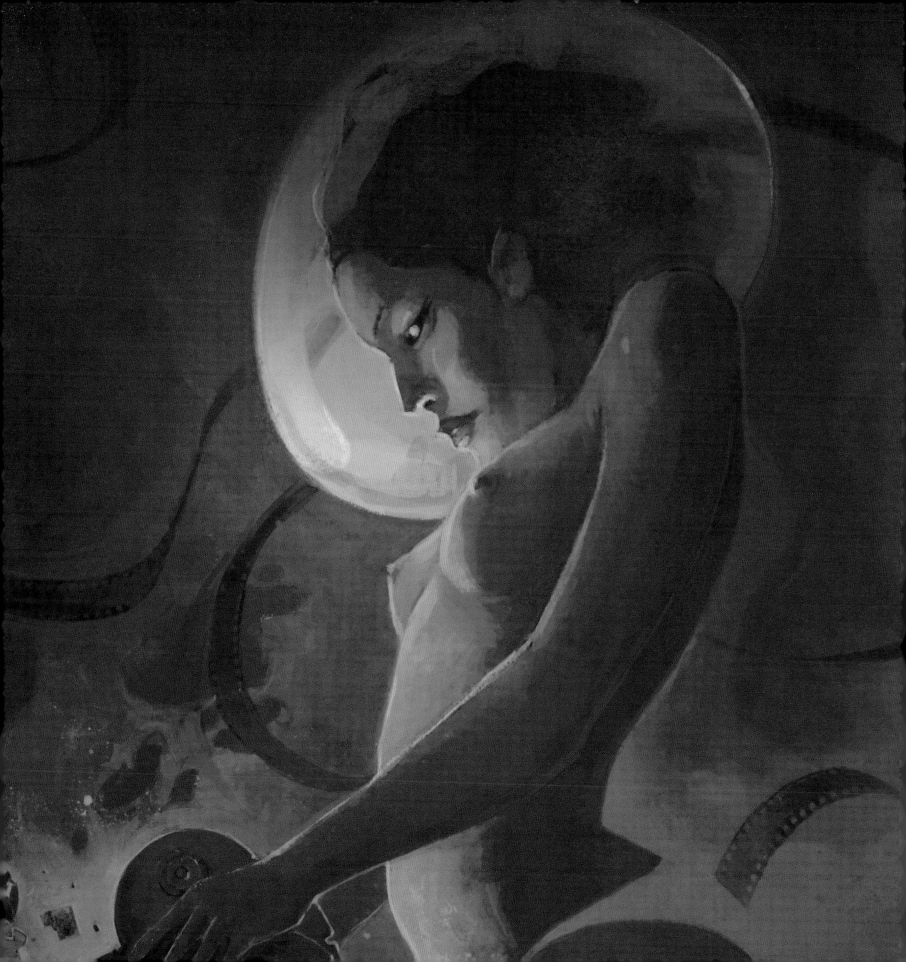

IMPROVIJATION

One idea leads to another. When you add and play with a couple of rules, principles, techniques and you let your imagination go, the result is often more interesting and less contrived than when you have a clear road map. "I'm not good at reading maps anyway," Loïc adds.

"My process, unless I start from a clear sketch – which happens to be very rare – implies collage as the main component," Loïc explains. "Based on the initial shapes, I will modify the composition, change the scale of some elements, overlay textures to lose some of the details and build the material for the illustration. The result is the equivalent of an underpainting. The initial color scheme is only here as something to start building from; hues will evolve as the image progresses; more textures will be added along the way to reflect the gradual increase of the image resolution.

"If it starts with only a few hundred pixels – 338, most of the time – allowing great speed and simplification, the final illustration often reaches 10,000 pixels for printing purposes. Using various color comparison modes, elements are added to the painting for shape or color purposes. Arbitrary shapes appear in the process and they can affect the design of some of the elements.

"The quest over the years has been to reach a certain simplicity and to combine a wide range of sources into a coherent mix. Figurative elements are next to abstract shapes while textures can vary from very organic and traditional to crisp and digital; saturated pixels clashing with smooth, painterly elements. Yet they all work together to let the eye travel. Some shapes are repeated over and over in the image, inspired by stamps, monotypes and other similar techniques – the idea not being to hide the repetition, but to play with it instead.

"The series, TAR (see page 88), really pushed the development of some of those principles, and BINAURAL (see page 132) quickly became a laboratory for the collage experiments. Over time, each series started to bleed onto the other and, these days, they really work according to a similar set of rules – only the theme varies. I noticed that in a much more measured way, they also alter my concept work for visual effects.

"For the past few years, not only have I picked elements from older works, but I have also included fragments of the photographs that I take. The idea is not to use them just for what they are, but to instead create something new and trigger the imagination based on what they can inspire. Perhaps they will drive a shift in colors or values, or be used to displace (2D) some parts of the images, creating an interesting blurring effect. A photograph that doesn't have enough to work on its own can become a recurrent source for illustration purposes, simply because it contains rich textures, or breakup, or shapes."

e338 in conversation Part 3

Loïc Zimmermann: It's something I was unable to do, but I love to do now! It's letting an illustration go for days or weeks or months, or just letting it sleep on a canvas or the computer, to get back to later on – and you are like a barbarian! You don't care anymore! You see what's good about it, wrong about it, what deserves to be destroyed…

Michael Kutsche: That takes a lot of experience as well. Because usually you'd think you have to finish it in one stroke almost, when you still have the stamina. Only with time you know certain things may come later – because there's always the danger of overworking it, right? But like you said, looking at it from a different perspective – and it doesn't have to be working on tiny details, it can be a broader thing like taking away half the image completely and repainting it. 'I don't really like this part and this' – and you're braver to do that when you're not emotional about it anymore.

LZ: And that's the moment!

MK: You're like your own art director – or you're like the creative director who comes over later with a big red pencil [laughs].

LZ: The problem is that when you're constantly working on something, you are the art director, but you're the mum as well. So you care too much about the little baby. And it led me to think: Okay, the way you work, you have one block but you split half, you split half in half – and you will find this is how the image will appear. The thinner the blocks, the more meticulous you become, and slow, and attentive to detail, and you lose the essence. Just like when you do a beautiful sketch and then you start putting the colors down and you lose all the energy. Some people are really good at keeping that alive, but a lot of people fail at that. And I feel that when you actually pause the process, when you actually go for one round of the work – and again, it could be 24 hours or it could be three months. But you get back at it and you have the same type of dynamic: you don't start working with a thin brush, you come with an axe. And I think that this is when you get the best results.

MK: Yeah, the greatest danger is if you forget…

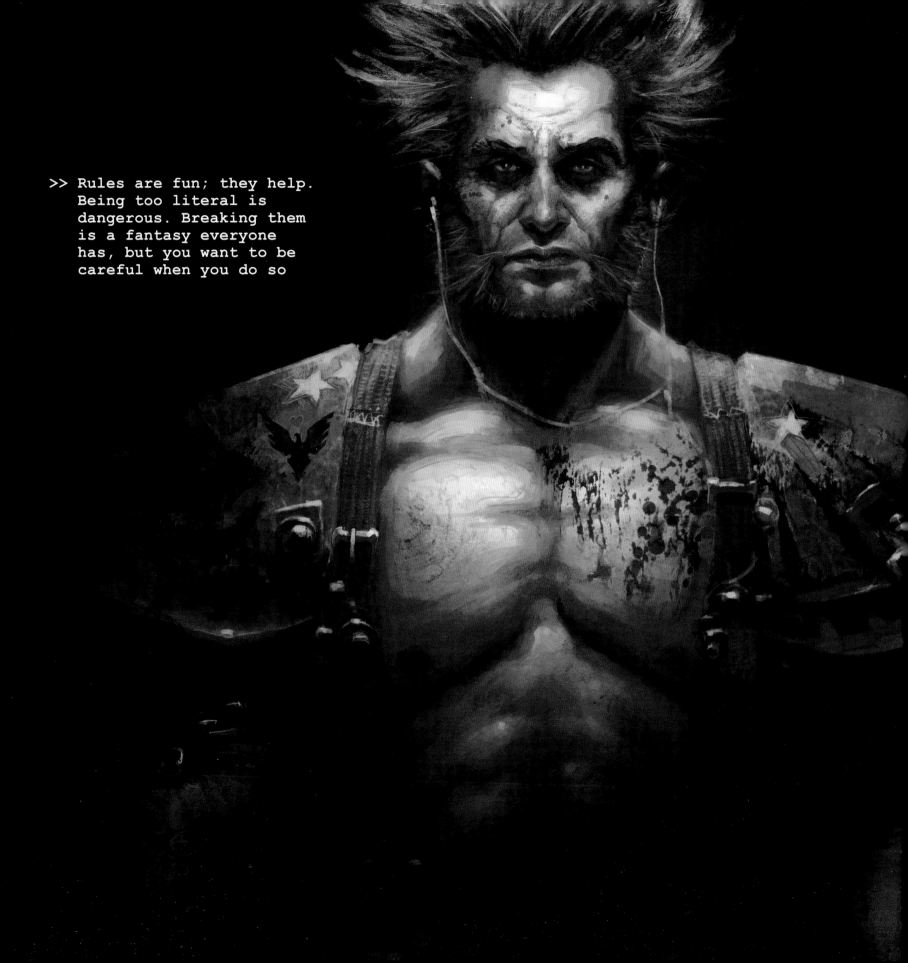

>> Rules are fun; they help.
Being too literal is
dangerous. Breaking them
is a fantasy everyone
has, but you want to be
careful when you do so

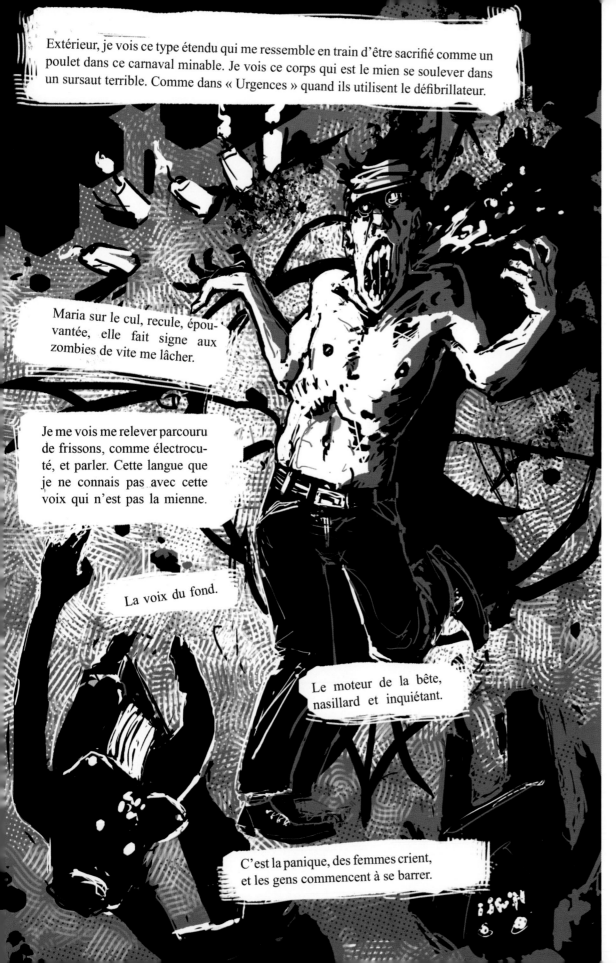

> Extérieur, je vois ce type étendu qui me ressemble en train d'être sacrifié comme un poulet dans ce carnaval minable. Je vois ce corps qui est le mien se soulever dans un sursaut terrible. Comme dans « Urgences » quand ils utilisent le défibrillateur.

> Maria sur le cul, recule, épouvantée, elle fait signe aux zombies de vite me lâcher.

> Je me vois me relever parcouru de frissons, comme électrocuté, et parler. Cette langue que je ne connais pas avec cette voix qui n'est pas la mienne.

> La voix du fond.

> Le moteur de la bête, nasillard et inquiétant.

> C'est la panique, des femmes crient, et les gens commencent à se barrer.

The graphic novel

Coq Le Noir (the black rooster) is a project that went through a complete rebirth several years ago. "Some might say it's a common thing with a graphic novel that decides to deal with voodoo and death," Loïc jests.

The writer, Aymeric Laloux, went to art school with Loïc. They had a band together and even shared an apartment for a year. The place was packed with old buckets of paintings, comic books and magazines, empty burger boxes – and a million other things that really shouldn't have been here, especially sitting on the floor.

10 years later, Loïc contacted his old friend in dear need of some short text that he could turn into a graphic novel. The challenge was interesting: Aymeric gave his copy a few days later, and after four weeks of work, the first version of *Coq Le Noir* was complete.

Olivier Marescaux, the talent behind Loïc's earlier silkscreen prints, financed a small edition, but then the book died in boxes and shelves, only to be forgotten.

Six years later, after Aymeric had just released his first novel through a French publisher, *Coq le Noir* came back to life. Loïc, not totally satisfied with the oh-so-old first version decided to re-work the layouts and half of the illustrations, giving a new kick to the book.

People were excited; the publisher was happy. And then... Nothing. The book was ready to take to the dust again.

Combien, je vais te le dire : exactement cent dix Dollars la piaule. À ce rythme-là, dans trois jours je suis fini, enfin, si la chaleur ne m'a pas tué avant. Et puis qu'est ce que je suis venu foutre ici ?

Mettre un océan entre moi et mes emmerdes ?

Je suis même pas sûr que ça suffise.

Je bouffe deux pilons de poulet piqués au buffet créole 24/24. Dans ma piaule, la clim à fond, je prends une douche, je finis le Temesta et je m'endors en espérant presque ne pas me réveiller, mais c'est sûrement trop demander. Demander à qui d'ailleurs ?

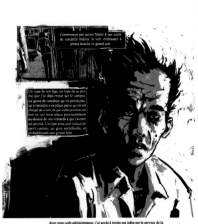

Commencer par suivre Marie à ses cours de conduite hésitants, la voir embrasser à pleine bouche ce grand con.

Un type de son âge, un type de sa promo que j'ai déjà croisé sur le campus. Le genre de sûreté que l'on prend plaisir à remettre à sa place parce qu'on est chargé de cours, et que cette position est tout ce qui nous place provisoirement au-dessus de ces retardé à qui l'avenir est promis. Un type avec une voiture de sport custom, un gros portefeuille, et probablement une grosse bite.

Avec mon code administrateur, j'ai accès à toutes ses infos sur le serveur de la fac, son nom, son adresse, celle de ses parents, son numéro de portable.

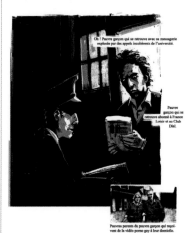

Oh ! Pauvre garçon qui se retrouve avec sa messagerie explosée par des appels incohérents de l'université.

Pauvre garçon qui se retrouve abonné à France Loisir et au Club Dial.

Pauvres parents du pauvre garçon qui reçoivent la vidéo porno gay à leur domicile.

« French ? »

« Mmh. »

« C'est la première fois à Port-au-Prince, hein ? »

« On est obligé d'en parler en pleine rue ? »

« Tu descends à Pétionville ? »

« Ouais, ça se peut, ouais... »

« Suis-moi, on traîne pas trop ici, c'est pas secure. »

« Sans déconner ? »

On monte dans une vieille Ford qui fait office de taxi, départ pour Pétionville, sur des routes de terre que les autochtones abordent avec les véhicules les plus divers et les plus pourris.

s'extirpent du flot des étudiants qui se dirigent vers la caféteria.

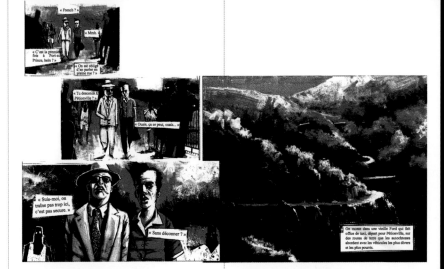

De la fenêtre de mon bureau, je vois l'ennemi monter dans son engin, sans se rendre compte de rien.

De la fenêtre de mon bureau, je vois l'ennemi partir en trombe et perdre le contrôle de son véhicule quelques mètres plus loin, franchir le terre-plein et s'encastrer dans une caisse arrivant dans l'autre sens.

De la fenêtre de mon bureau j'ai l'impression de voir le post-it jaune sur le pare-brise éclaté par la tête de l'ennemi.

« Elle va beaucoup moins bien marcher comme ça, pas vrai, mon garçon ? »

Ouais, tu m'étonnes.

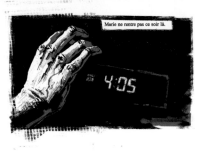

Marie ne rentre pas ce soir là.

4:05

Je la recroise le lendemain, elle débarque avec une copine qui l'aide à faire ses valises, elle pleure, elle est belle. Je lui propose de l'aide, elle part sans rien dire. Je bande. Je suis mal.

Je me réveille en plein cauchemar : je me suis vu attaché sur le sol avec 3 gros noirs qui me menaçaient en criant

« Ago ! Ago ! »

Énorme.

Il est à peine une heure du matin, je mate TV5 en buvant de l'eau glacée jusqu'à ce que le soleil se pointe à l'horizon. Cette île de merde est en train de finir de me rendre cinglé. Je repense à ce qu'a dit Hamilton plus tôt dans la soirée :

« on ne quitte jamais complètement Haïti. »

Je viens à peine de trouver le sommeil quand Hamilton frappe à ma porte, complètement flippé.

« Des types en uniforme montent te chercher, faut que tu bouges ! »

« T'es sûr de toi ? »

« Ils ont sorti ta photo à la réception, fous le camp, je vais les retarder ! »

« Merde... »

« Hé, Hamilton... »

« Allez, tire-toi ! »

« Dis voir, c'est quoi ton prénom, au fait ? »

« Laisse tomber, même ma mère m'appelle Hamilton. Take care, rooster. »

« T'as tué un mec ou quoi ? »

« Un truc dans le genre. »

« Ah. »

« Mais c'était un vrai con. »

Il se fout au lit à ma place,

j'attrape mes pompes, mon sac avant de filer par la fenêtre.

Je me planque derrière les génératrices de l'hôtel en attendant que les flics sortent. Dans cette cocotte-minute au bord de la guerre civile, où personne n'a l'électricité ou le téléphone plus de trois jours consécutifs, où de vieux S5 se la coulent douce depuis soixante ans, moi, je manque me faire poisser au bout de trois jours ! Un vrai bol de coco, quoi ! Bravo la coopération internationale !

Pour fêter ça je pays le resto à l'infidèle. C'est de bonne guerre. C'est une bonne guerre la guerre lasse, comme la mienne, aux aguets... Moi je remonte au filet, l'emporte le tie-break et je baise Marie avec toute la rage que je peux y mettre.

Avant de me prendre 6-0 dans le deuxième set.

Quand je récupère les conversations MSN passées au dossier, elle « conjugal » les unes où je

Pas parce qu'elle ne m'aime plus : ça je le savais, mais surtout parce qu'il la baise mieux. Sans équivoque. Il l'encule, mais curieusement, c'est quand même moi qui ai mal au fion.

Alors, un jour de déprime, un midi une journée comme les autres qui couchait une matinée méridique et obsessionnelle, où franchit la ligne rouge.
Le point de non-retour. Comme quand tu es même et que tu découvres la vérité sur le Père Noël. Tu ne reviens pas. T'as pas trouvé la fonction retour rapide arrière / efface.

De la fenêtre de mon bureau, j'avais repéré sans grande difficulté l'endroit où le belître gare sa Golf, j'avais remué, inséré la chose, répété l'action.

Il n'y a pas grand monde sur le campus quand je me rends silencieux, ma main imite serrée dans la poche sur le manche d'un couteau.

Comme Tim Roth dans Reservoir dogs « Cool, t'es super cool, ils savent pas... »

Saluer un collègue l'air de rien, faire semblant de refaire son lacet et planter la lame dans le pneu comme dans le bide muselé de l'ennemi.
Et signer d'un post-it collé sous l'essuie-glace.

« Elle va beaucoup moins bien marcher comme ça, pas vrai, mon garçon ? »

D'une écriture blanche, en capitales. Quelconque.
Des lettres bien formées qui se traduisent ni baise ni violence, mais qui balancent quand même un truc genre : « Laisse tomber ou t'as pas fini d'en chier. »

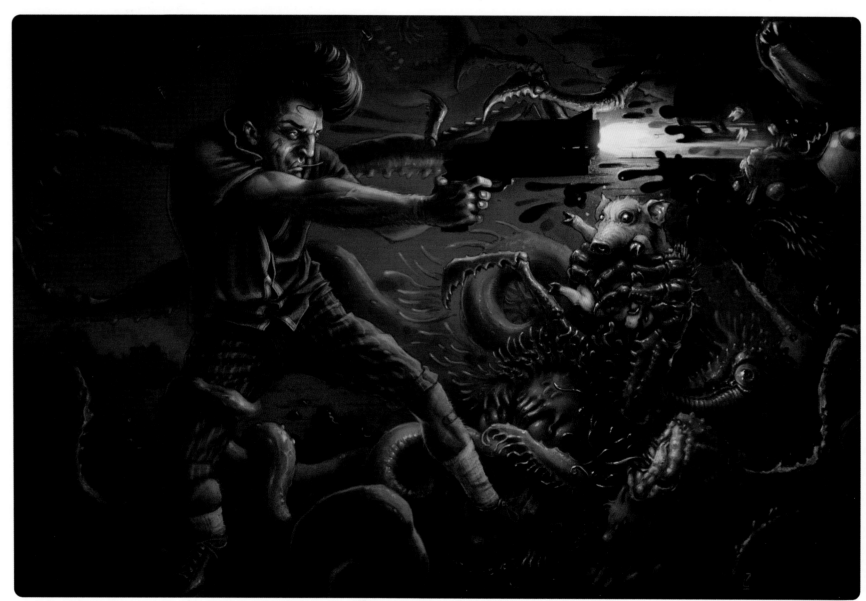

"ETTORE, IL PORCELLINO E LA COSA"

BY LOIC E338 ZIMMERMANN

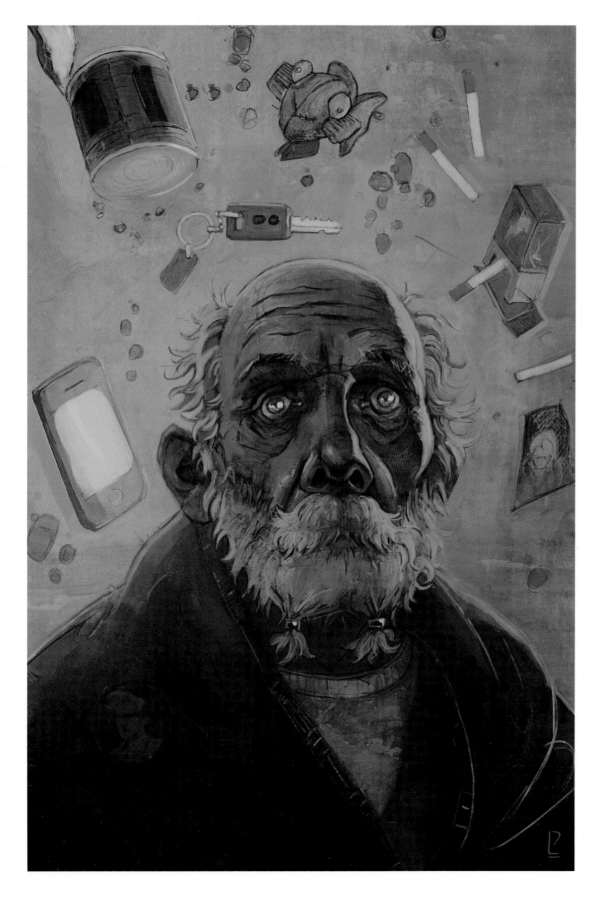

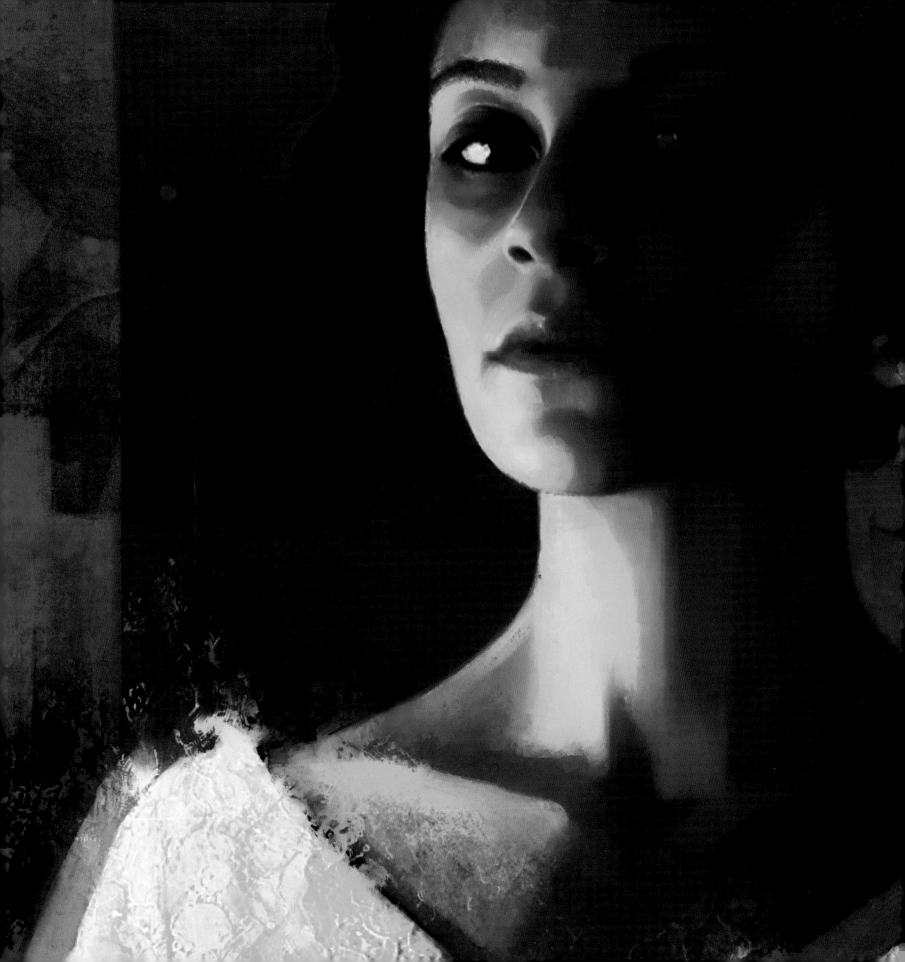

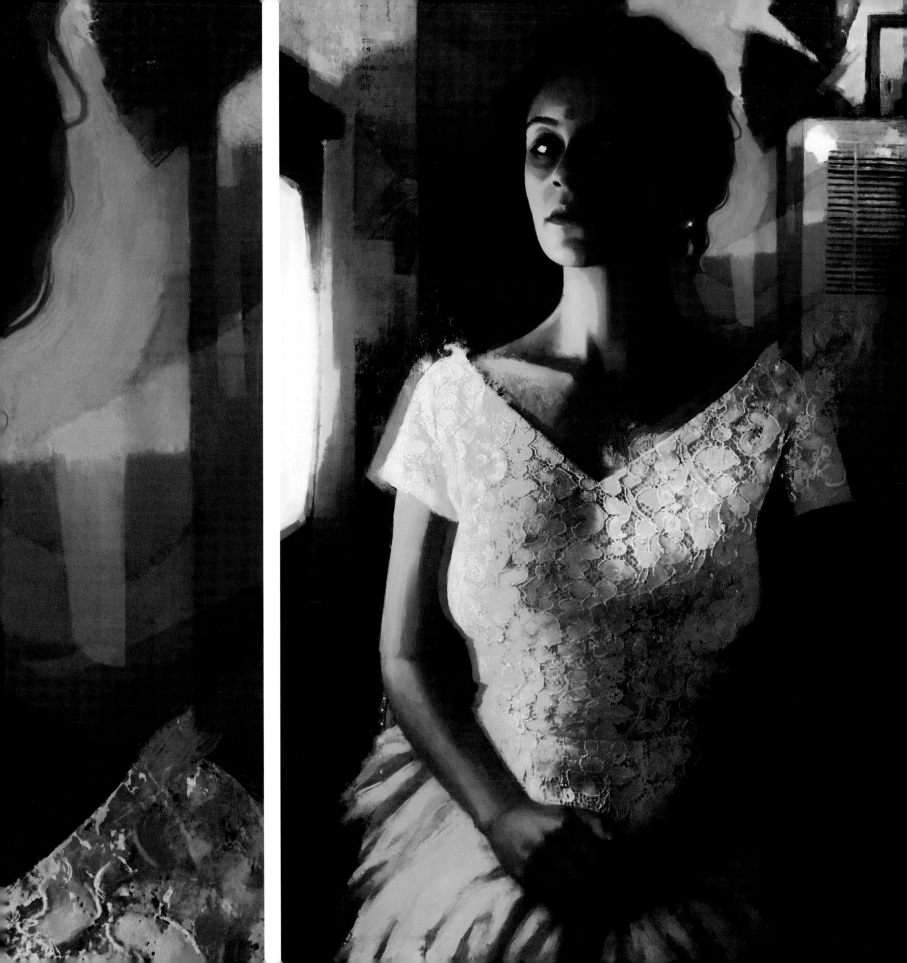

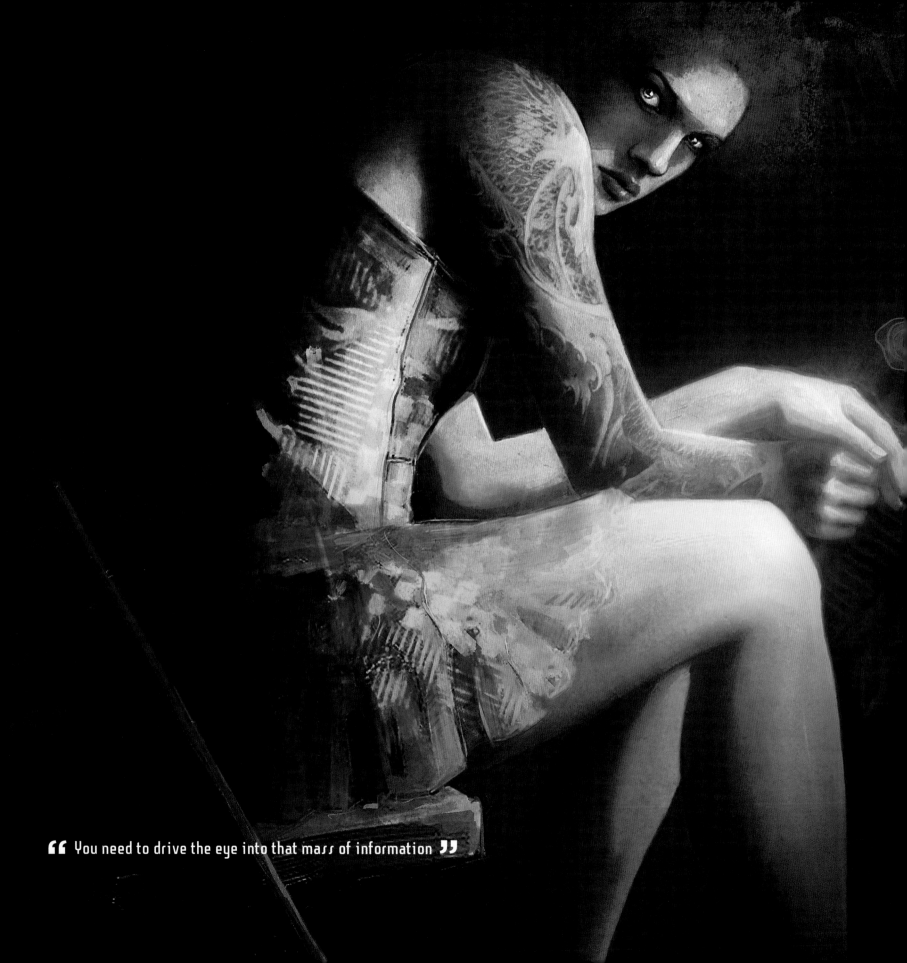

❝ You need to drive the eye into that mass of information ❞

e338 in conversation Part 3

Loïc Zimmermann: What do you want to see about that subject? It's like pure depiction. I'm outside and there's a freaking tree and I'm painting the tree. Or I'm outside and I want to paint the feeling of a tree. Like a Robert Henri type of statement, where you don't paint an elephant, you paint the *weight* of the elephant. And I love that approach.

Michael Kutsche: Yes, there's always this psychological part that adds to it. It's like how we don't read words because we see every letter – we just know the constellation of letters that make this word, and that's what makes us read text in a very fast manner. If you really figure out what every letter would be, it would take a lot more time. And you can use this wisdom when painting naturalistically, but also in very abstract ways – these rules still apply.

LZ: So about, what, the rhythm? Or the details? It's the variety of the elements, basically. Even if you go abstract, everything is wishy washy, nothing gets your attention. You need to actually drive the eye into that mass of information. And you have to establish a hierarchy into the detailing or the looseness or the colors – or whatever value you're using.

MK: Yeah, it's seemingly formless, but it still has the composition of looseness and crispness that makes it interesting to look at, right? It's like a natural flow, where the eye can rest at certain parts and the other parts keep it grounded or more atmospheric… But maybe there are examples that work totally differently, and are interesting because they break all of that and create their own set of rules [laughs].

I think I've seen examples where – I think it was a drawing at the Scope Art Fair in Miami a couple of weeks ago – and it wasn't etching, it looked more like different parts of etchings photocopied and then photo-collaged, but it was very coherent in the end. It looked like a detailed etching of a landscape with cities and clouds… you

know, like the stuff from Gustave Doré, or something like that. And there was such detailed noise going on! It was interesting in its own right, you know? It didn't have any of that which we talked about – there was noise everywhere and there was detail everywhere, but there was so much that it was mind-blowing, you know?

LZ: Yeah, well it always comes down to the same point. You cannot just deny the existence of those concepts – you have to know them to ignore them; it's a choice. You have to understand those fundamental things, and then you can play with them.

MK: Yeah, otherwise it's just lucky guessing.

LZ: It was a comment that I had by an architect in my early beginnings in 3D and it was an environment. And we had to do those fly cams into architectural projects. I was trying to find different backgrounds and different skies, and one time I bashed photos together to make a very nice sunset type of thing, and the client said, 'Well, there's no such thing, those skies don't exist!' [Laughs] Maybe like a day or two later, I was in a car with a co-worker, and the freaking sky – that wasn't a photo-bash – was 10-times wilder than anything I had done. They can go really crazy – it can be surreal – you can have three, four types of clouds!

MK: Yeah, well they don't have a genetic code behind it; they have a set of rules, like they're transformed by wind, but they are all loose particles. They have a logic to them and they react in a different way when there's warm air and cold air, and it creates a pattern – there's a repetition in it. But still, they are loose grains and particles. And the same goes for mountains: they don't have bones and muscles underneath, so there's a way more strict set of rules in characters… When I'm working more on my personal art-related things it's almost like I wash myself clean from all those rules

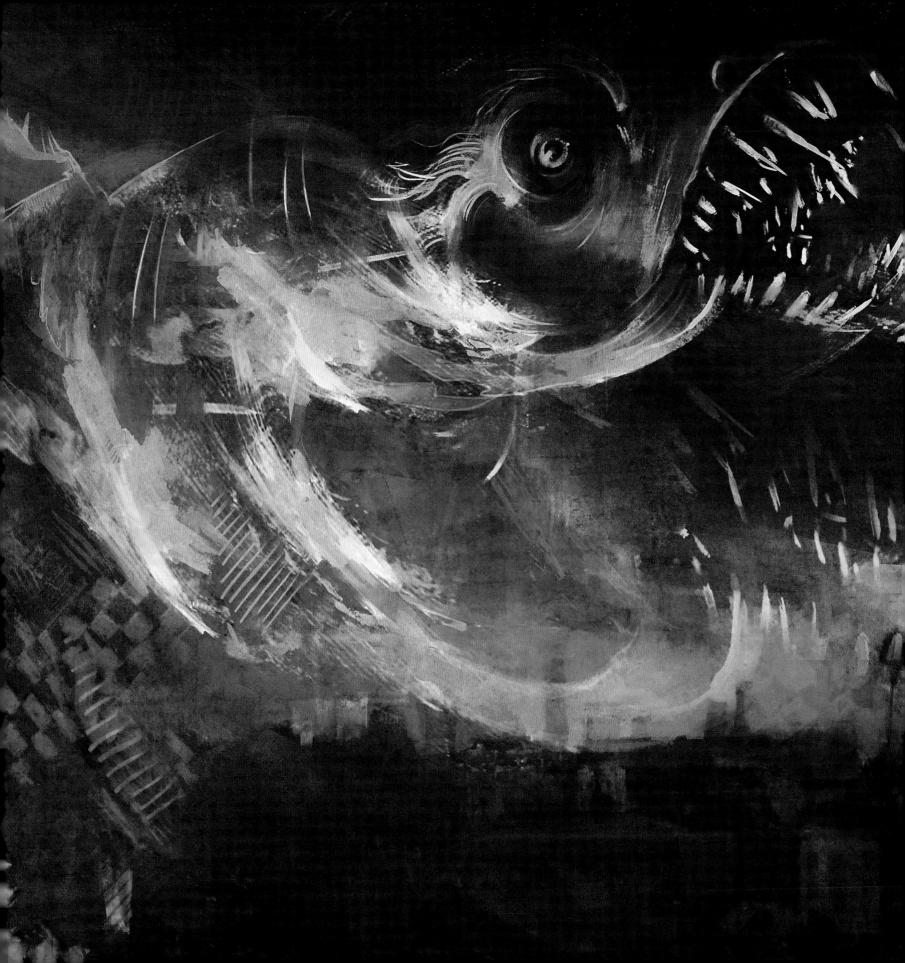

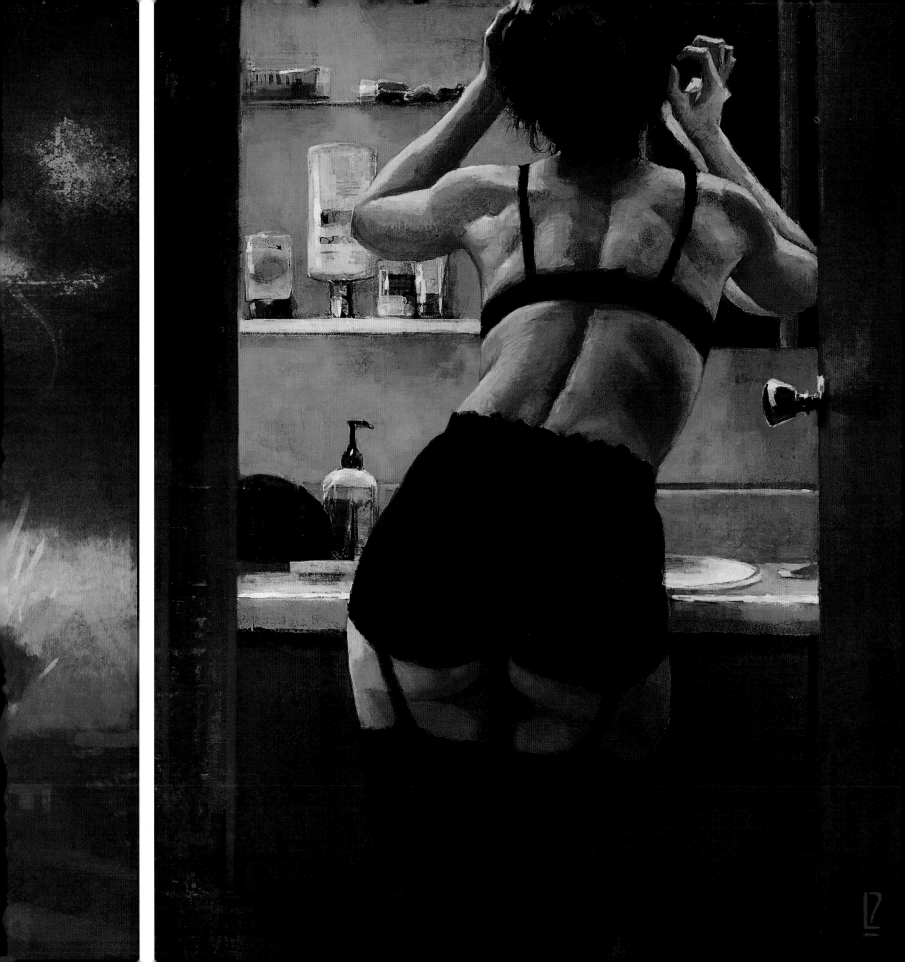

...to California

> We're in December. It's 6PM. The plane is reaching the West Coast after a quick layover in Chicago. A flat, endless sea of flickering lights: Los Angeles. A chauffeur is waiting with my name on a piece of paper; most of the letters are there. A black Lincoln. I sit. The doors shut – it's oh-so quiet.
>
> A quick stop by at the office and then to my hotel in Venice. 9PM. The boardwalk is deserted – spooky! 6AM: The first coffee. Deserted still, but bright; I'm gazing at the ocean. 7:30AM: it's turned into a circus. Venice Beach in its glory! Four months later, in the same hotel, with the same coffee – but this time I'm staying.
>
> It's bigger. The street, the cars, the latte, the portions... Totally disconnected, I start taking snapshots of various situations, aware that this feeling of novelty will soon be fading away. A series of illustrations starts with the envy to document this new chapter of life. Over time, a theme within the theme will start defining itself. *TAR*. With cars being such an important part of the life of an Angelenos, why not portray the city through that angle? The space is flattened down; the colors are much more intense than in the past, and a visual vocabulary starts to build: color bleeding, geometrical shapes, stylization...
>
> This same vocabulary will merge into other themes, including *BINAURAL*, a few years later. These days, the series is taking a new turn. The angles are shifting, the simplification seems to go further and cars start merging with their environments.

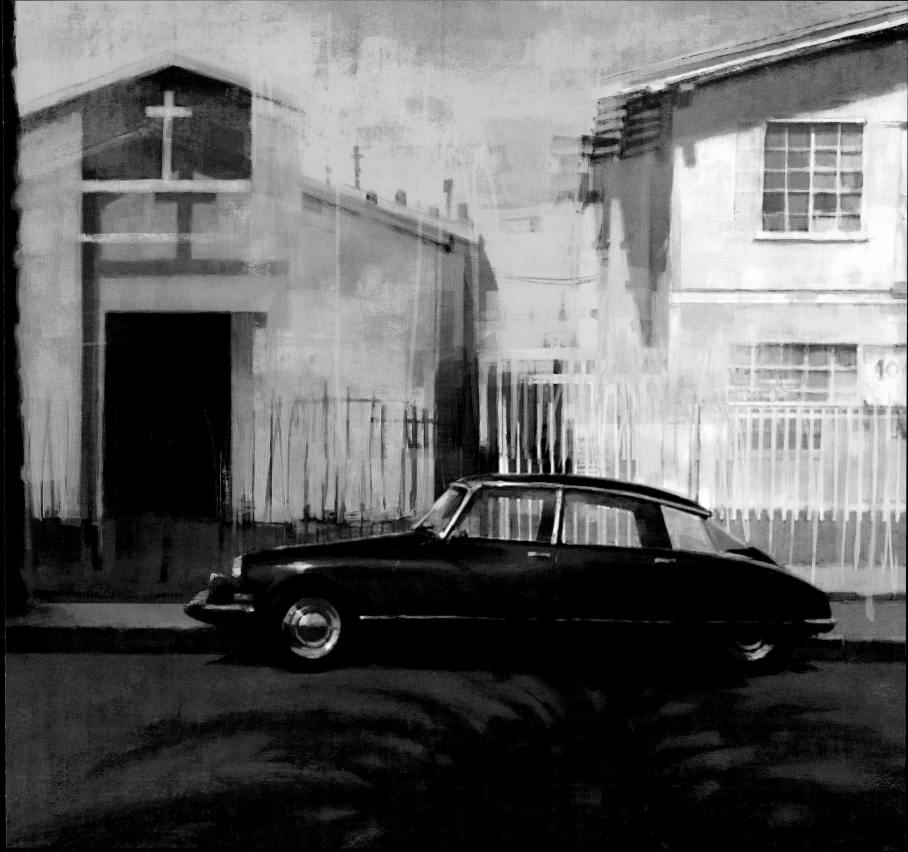

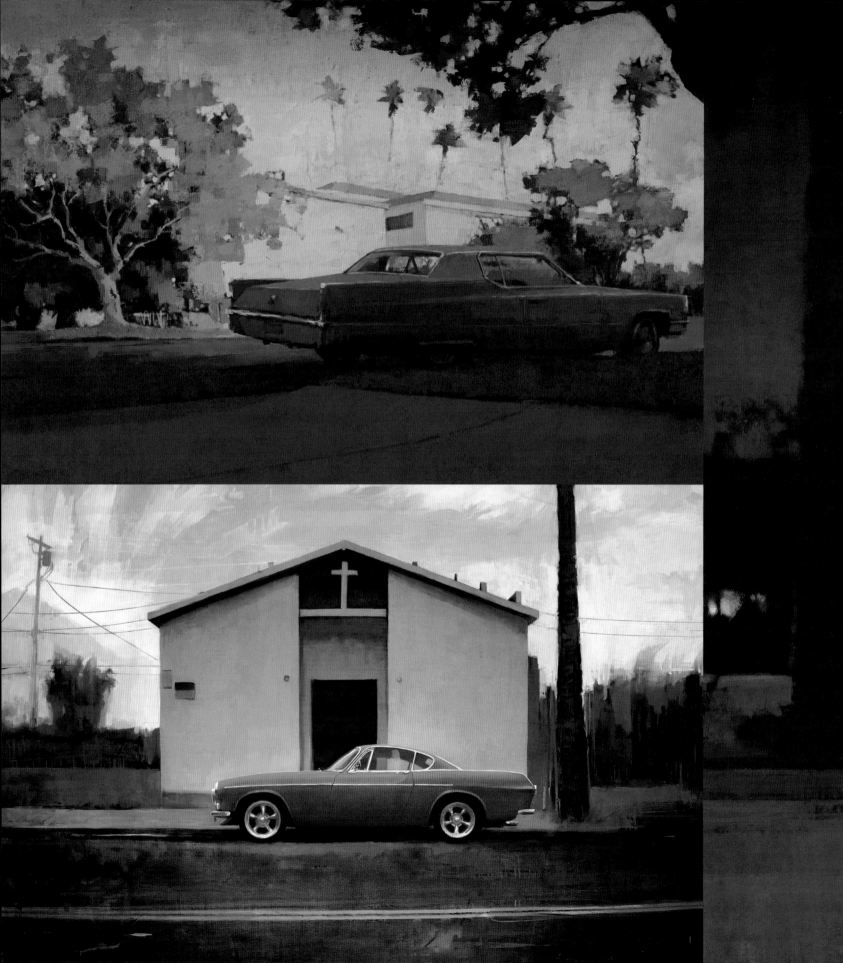

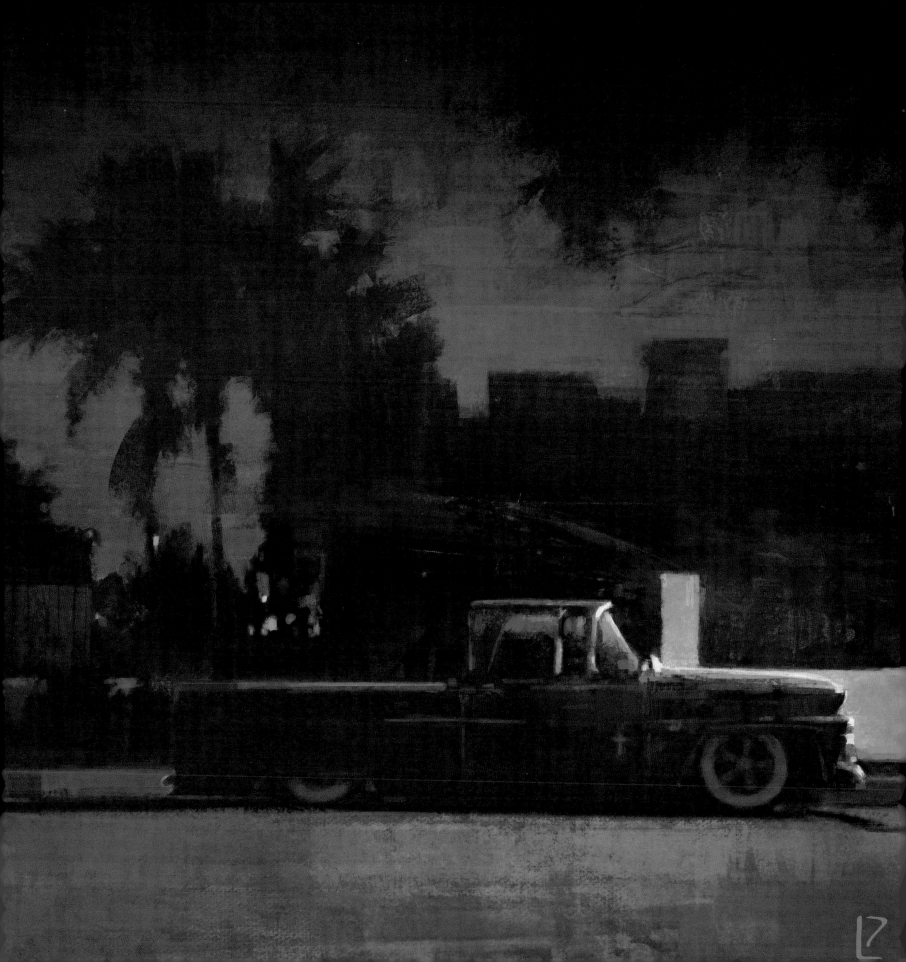

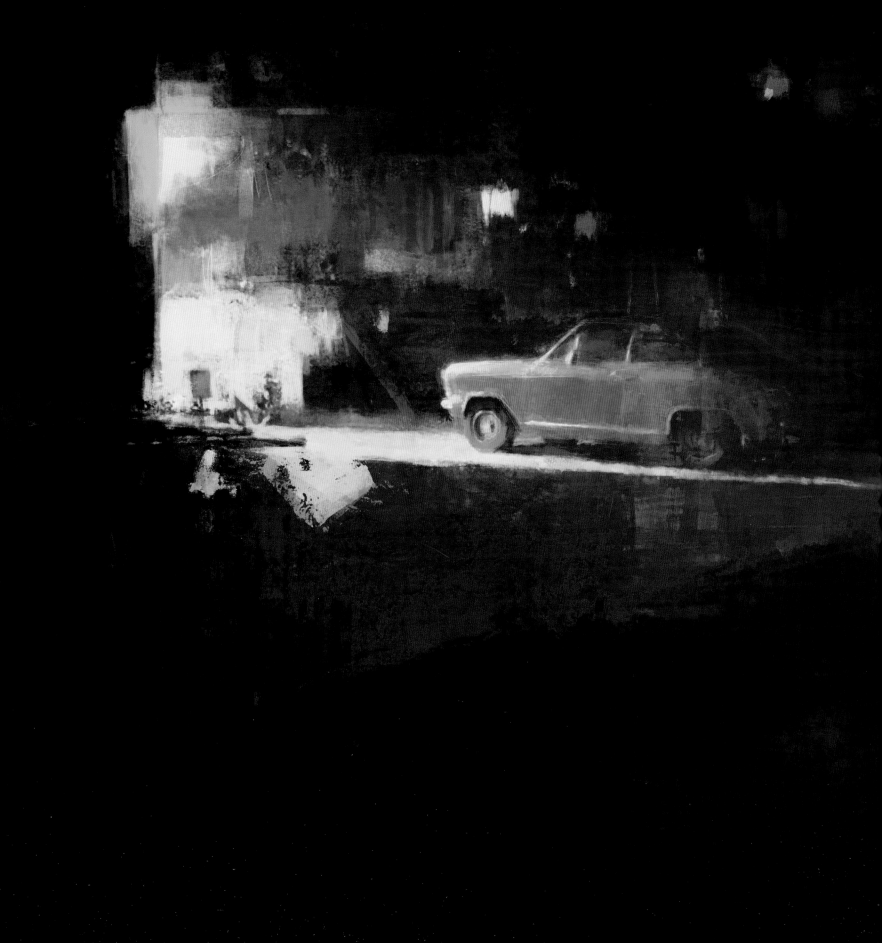

" 6AM: The first coffee. Deserted still, but bright; I'm gazing at the ocean **"**

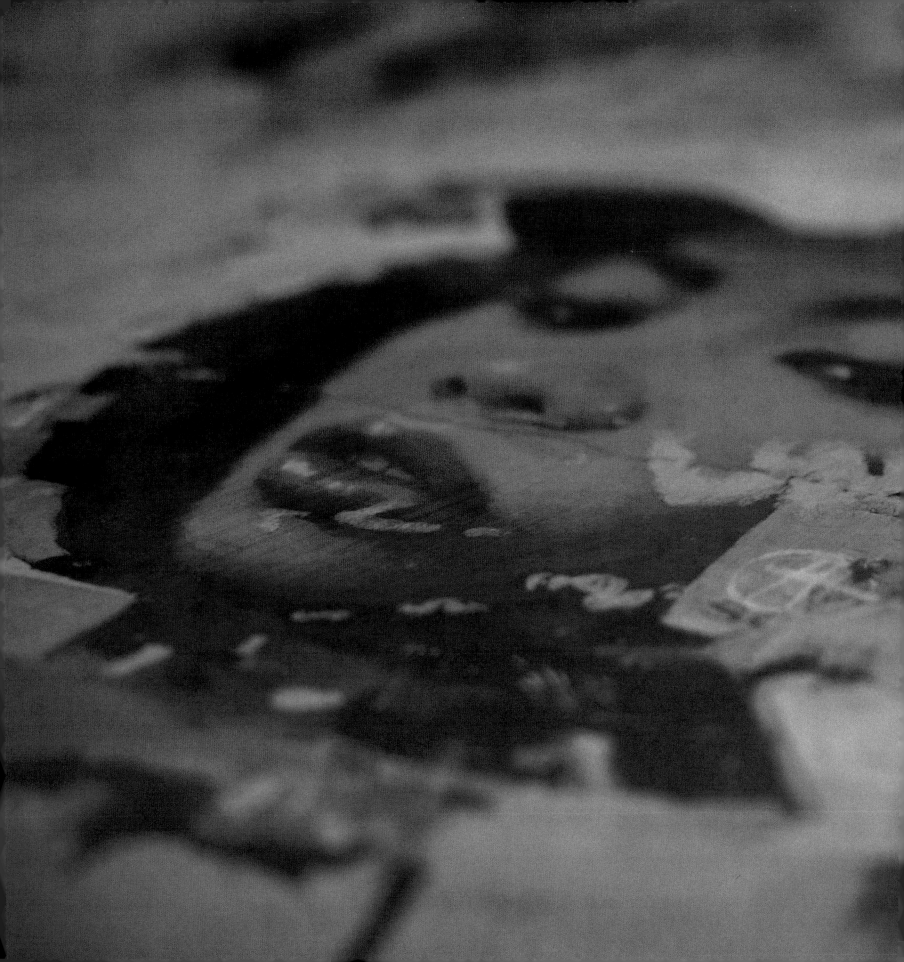

MIXED MEDIA

" When the collage has reached a decent level of complexity, I start painting **"**

Away from the screen and onto the walls of art galleries around the world: Loïc shares the evolving technique that has helped him take his digital illustrations into the exhibition halls

For Loïc's first exhibition in France, he used a combination of giclée prints on canvas and silkscreens as the base material for his mixed-media artworks. The idea was to create unique pieces for each of those images by combining them with acrylics, collages, spray paint and selective varnish work.

"The *Z-Men* portraits used several prints to make the artworks, creating subtle changes in the way the light bounced on them due to the various paper used for printing," Loïc reveals. "The process had to be put on hold for a few years after my move to California due to a lack of space, and a lack of time as well.

"After meeting with a gallery and having my first show scheduled later that year, in 2010, I knew I wanted to get back to these and push them further. My apartment turned into a war zone for several weeks. I had people at the local frame company assembling wood panels for me and a company in east Los Angeles would print the works on the thickest paper they had.

"Then, after collaging those prints together, I started the deterioration process by scratching, sanding, varnishing, burning, painting, and collaging those panels. The images would lose their clean digital quality and gradually become more organic and rich. I would often repaint sections and replace others, making sure the textural work was seamless. In a way, this was the direct continuance of my first experience back in France – except for a few pieces I had pushed a little further.

For those, rather than using the whole original illustration, I would only collage fragments of them and repaint the missing parts. For some reason, the few works using this technique felt a bit more interesting to me. I knew there was something there that I wanted to explore. But, once again, I had a lack of space, lack of time, and apart from a few recreational pieces done over the years my focus wasn't really there either.

"Recently, I decided to get back on track. With the flexibility that is now mine – by owning a good printer with UV-protected inks – I can start experimenting in a more relaxed mindset. It was scary to eventually ruin a print before, as I would have to wait for a few days at least to get a replacement one back. I've also switched acrylics for oils now, since they give me more translucence for overlaying information on top of the collage work.

"The collage work itself has gained complexity as well. Very similar to the digital collages I do on the computer, they often start as an arbitrary placement of shapes and colors, using various papers and cardboards, photographs, fabric and silkscreen elements. Then I bring pieces of a digital image into the composition and also fragments of other images. This is heavily inspired by the look of streets with overlaid commercials and prints on the walls, damaged by the weather conditions, the light, and everything else that can happen outdoors.

"When the collage has reached a decent level of complexity, I start painting. In a way, this is very similar to the way I work digitally. The paint will help unify all those sources and will also complete the elements that have not been printed. And when this stage of work is over, I often go back into collaging again, adding very thin washes of oil to apply a tint over the entire image. The process goes on and on until the image feels balanced and homogenous.

"During the process I often take close-up pictures that will be used later for creating interesting textures in my digital illustrations. It's really a cycle and all things obey the same principles. When you look closely at the mixed media works, you discover some very precise elements that have this digital feel to them – or rather, a pixelization of some lines, or saturated hues and half-tones. I find it amusing to blend the two worlds this way; turning those digital elements into something new. Photography is also working its way into my mixed media art, and I don't hide the strong influence of Rauschenberg on my work either."

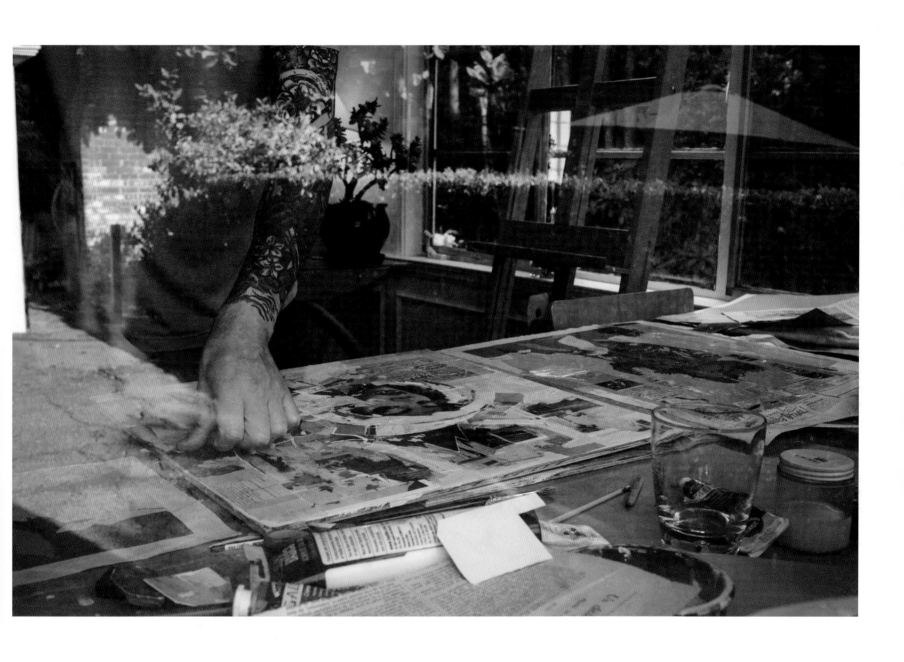

" My apartment turned into a war zone for several weeks "

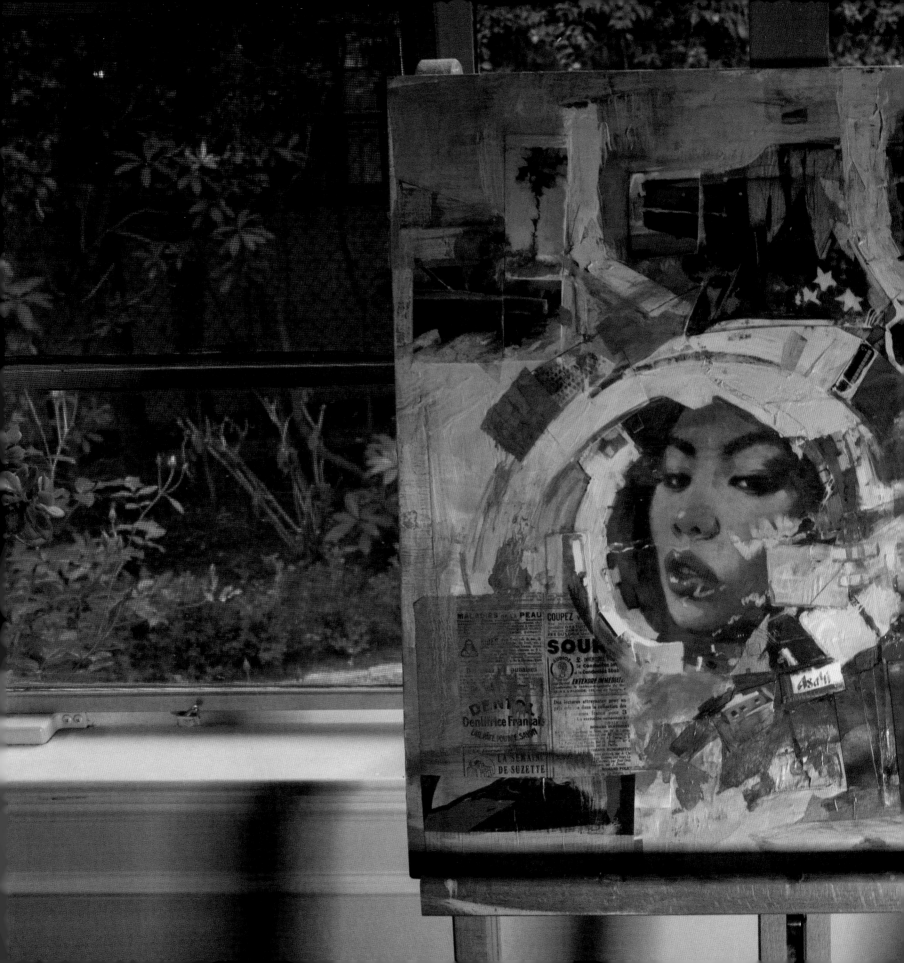

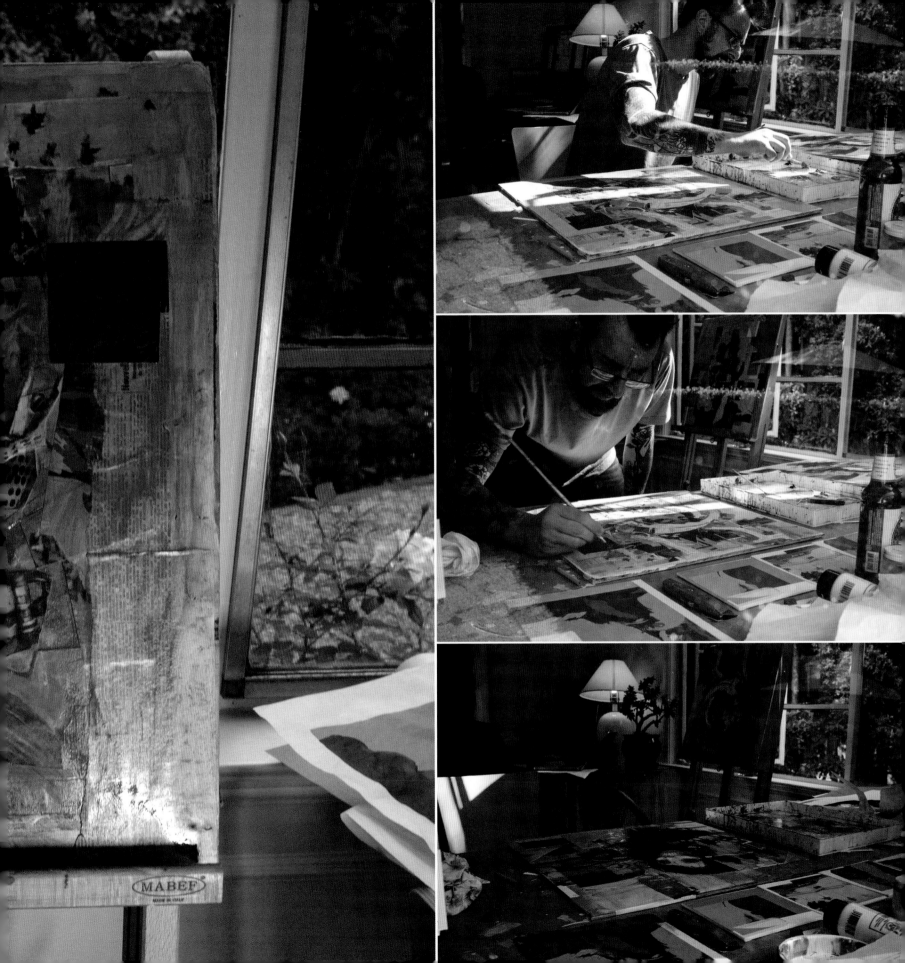

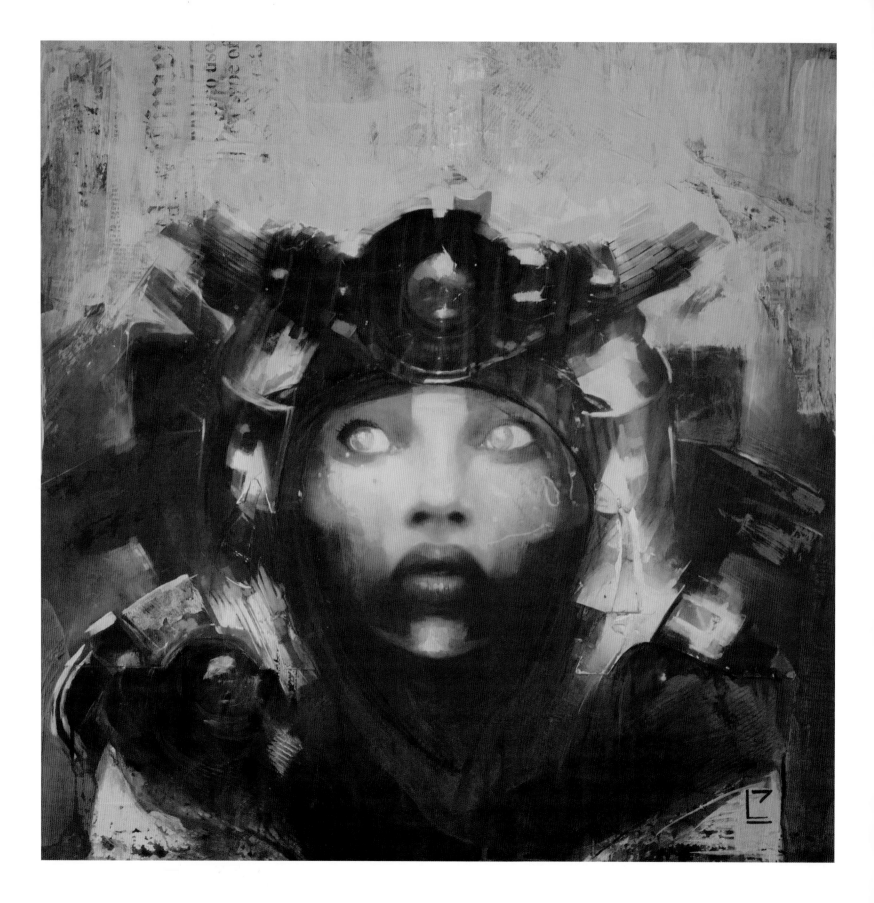

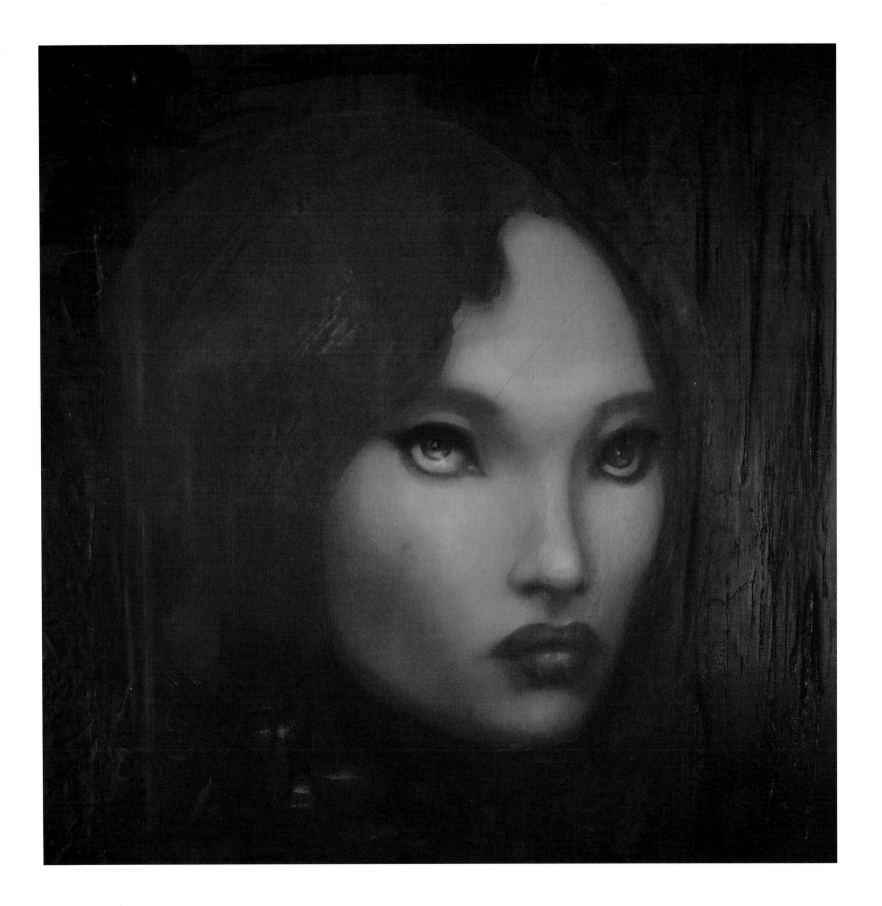

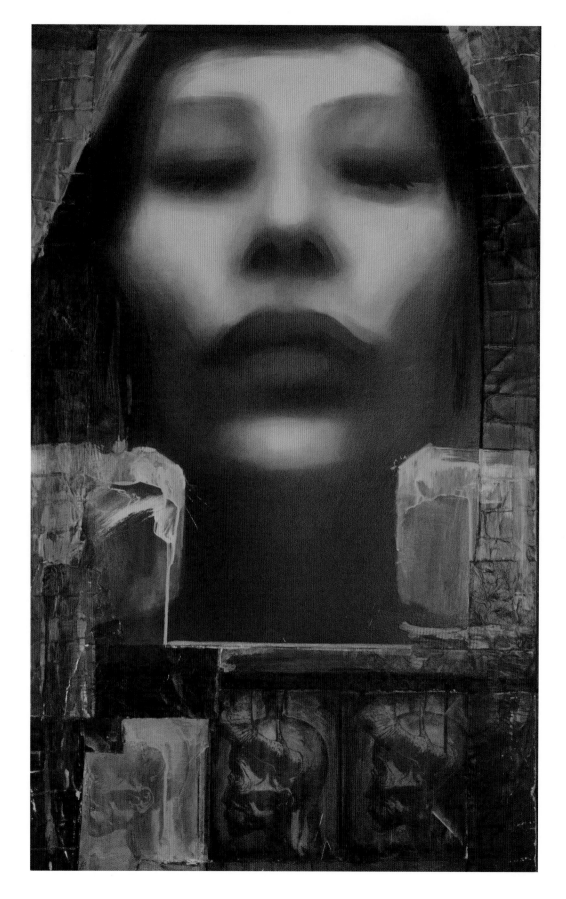

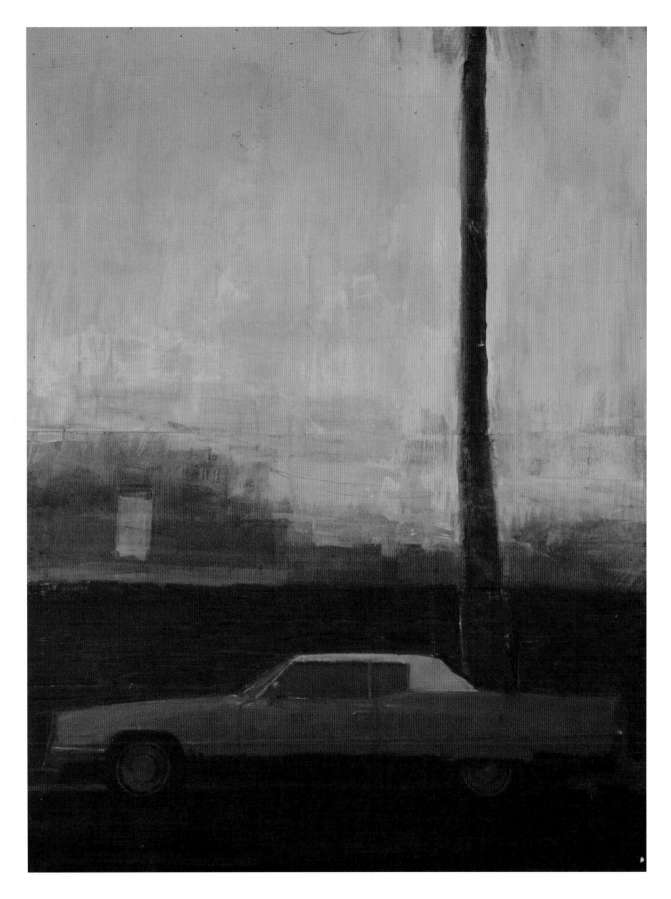

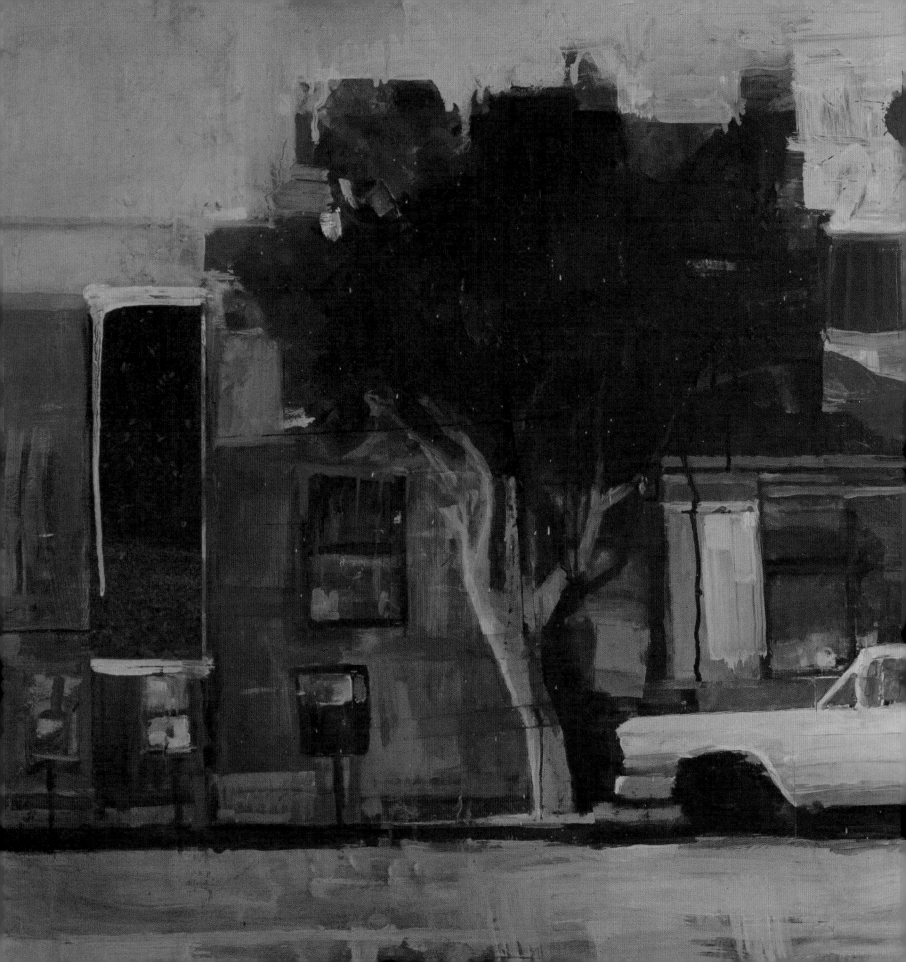

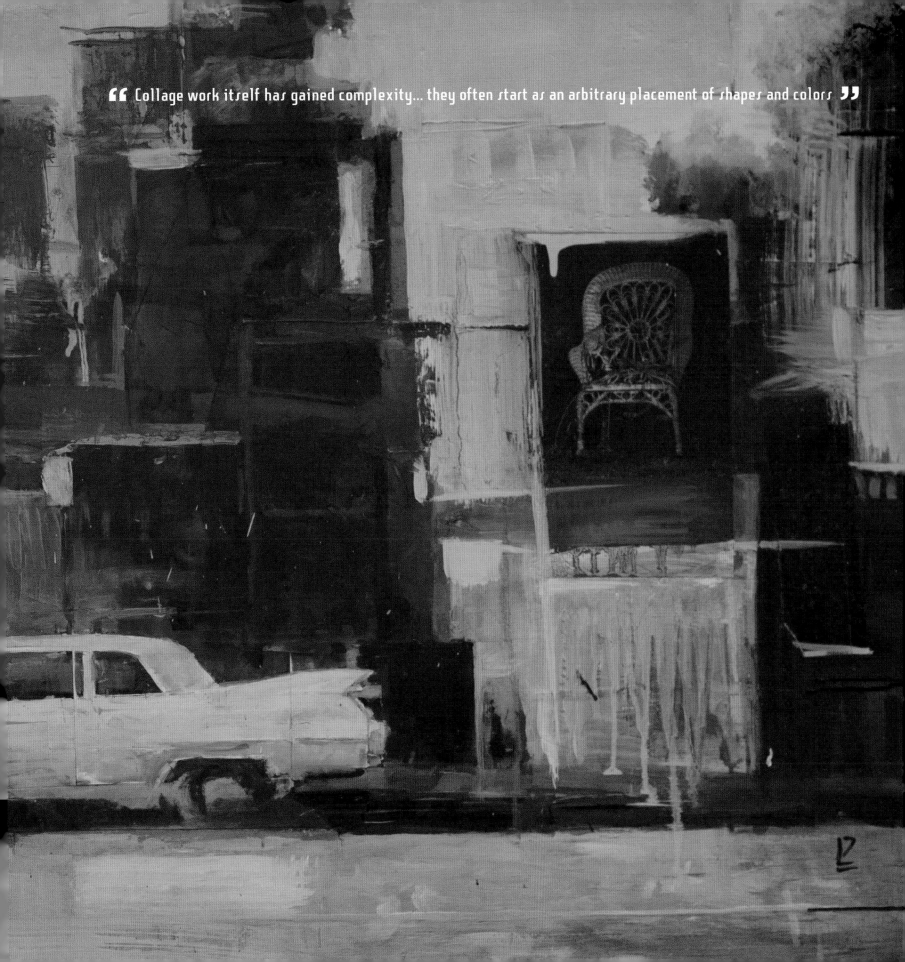

" Collage work itself has gained complexity... they often start as an arbitrary placement of shapes and colors "

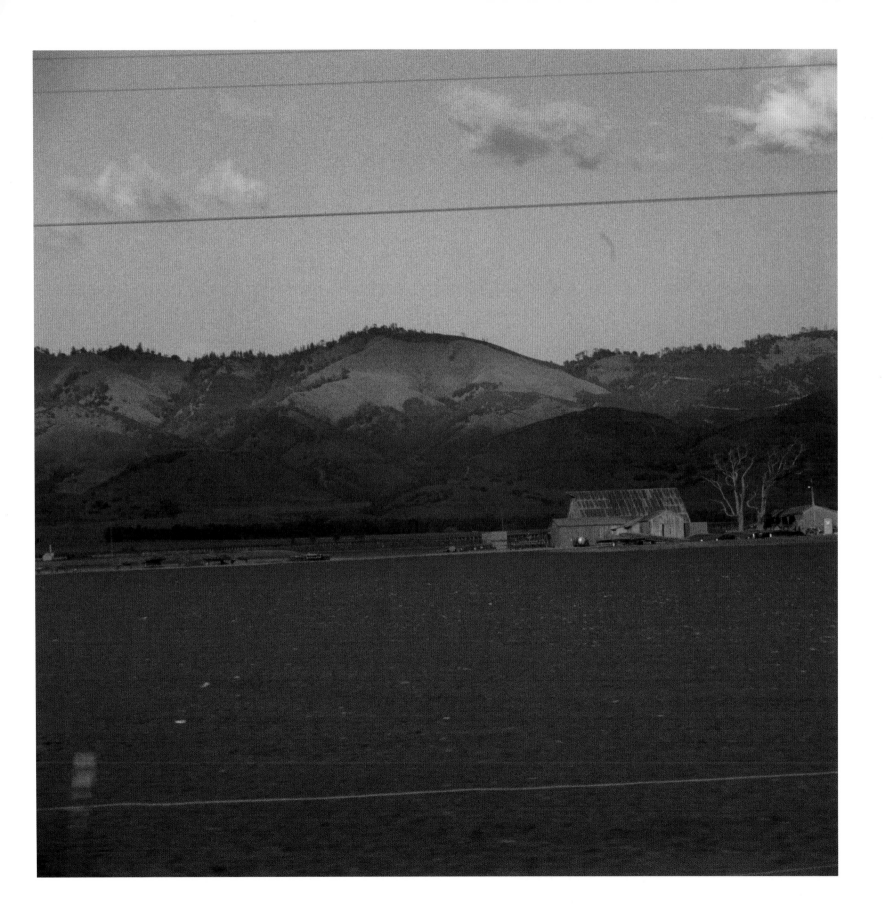

PHOTOGRAPHY

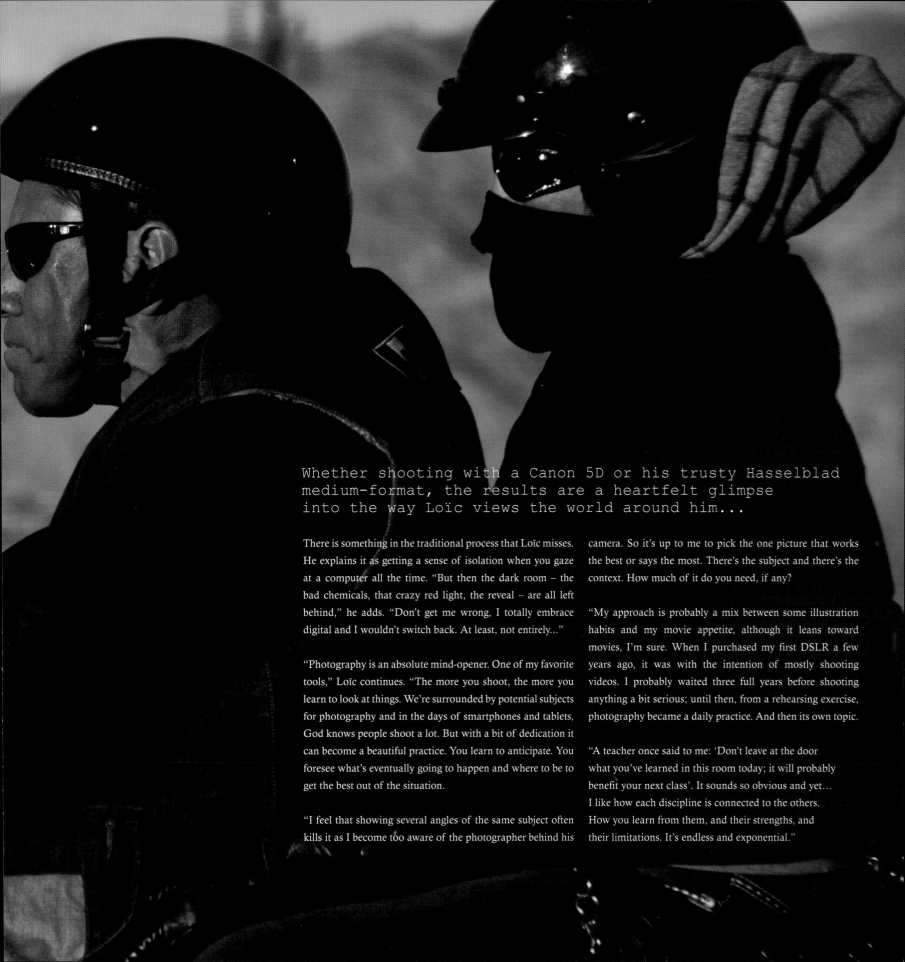

Whether shooting with a Canon 5D or his trusty Hasselblad
medium-format, the results are a heartfelt glimpse
into the way Loïc views the world around him...

There is something in the traditional process that Loïc misses. He explains it as getting a sense of isolation when you gaze at a computer all the time. "But then the dark room – the bad chemicals, that crazy red light, the reveal – are all left behind," he adds. "Don't get me wrong, I totally embrace digital and I wouldn't switch back. At least, not entirely..."

"Photography is an absolute mind-opener. One of my favorite tools," Loïc continues. "The more you shoot, the more you learn to look at things. We're surrounded by potential subjects for photography and in the days of smartphones and tablets, God knows people shoot a lot. But with a bit of dedication it can become a beautiful practice. You learn to anticipate. You foresee what's eventually going to happen and where to be to get the best out of the situation.

"I feel that showing several angles of the same subject often kills it as I become too aware of the photographer behind his

camera. So it's up to me to pick the one picture that works the best or says the most. There's the subject and there's the context. How much of it do you need, if any?

"My approach is probably a mix between some illustration habits and my movie appetite, although it leans toward movies, I'm sure. When I purchased my first DSLR a few years ago, it was with the intention of mostly shooting videos. I probably waited three full years before shooting anything a bit serious; until then, from a rehearsing exercise, photography became a daily practice. And then its own topic.

"A teacher once said to me: 'Don't leave at the door what you've learned in this room today; it will probably benefit your next class'. It sounds so obvious and yet... I like how each discipline is connected to the others. How you learn from them, and their strengths, and their limitations. It's endless and exponential."

"When I leave the house, I like to commit to a couple of lenses maximum," Loïc explains. "This alters the way I'll hunt. If I carry my old manual 100-200 – the only zoom lens I have – I'll be looking for very specific things that I cannot get out of my regular 50mm. And it's not just about the zoom factor but rather how it brings the plans together. It's a great one in New York City, for example. I kept using it over and over when I was there to get a sense of the layering this city has.

"The 50mm is probably the one I'd keep if I was forced to choose one and one only. Great for portraits, and it comes handy for street photography too – although I'd prefer the 35 for that specific matter. The Primes require that you move, walk closer, further and eventually to a point where you get exposed, leaving you with two options: smile and make sure the person is okay with this, or be fast at shooting and or running. Every now and then I'll pick a lens – one that I don't use too often – to practice, to see what's possible with it and get more familiar. Then, when the time comes that you need it for good, you're somewhat ready."

>> When taking a photo,
 move until you get the
 best possible angle.
 All the rules that apply
 to illustration can
 apply to photography
 as well: silhouette,
 light, composition...
 Shooting with Prime
 lenses will force you
 to be more mobile. I'm
 not trying to shoot what
 happens, but rather
 my impression of it

"My main camera is a Canon 5D Mark II," Loïc adds. "I use Magic Lantern for a few specific functions that I really like, such as the intervalometer timelapse feature, which has definitely made my life easier for self portraits. I also use it for shooting video, combined to a rig that, once again, gives me a lot of flexibility.

"I also sport an old Hasselblad medium-format camera and a Polaroid back for experimenting on the side. And I've recently added a mirrorless FujiFilm X-E2 to my arsenal as well. Let's see what happens."

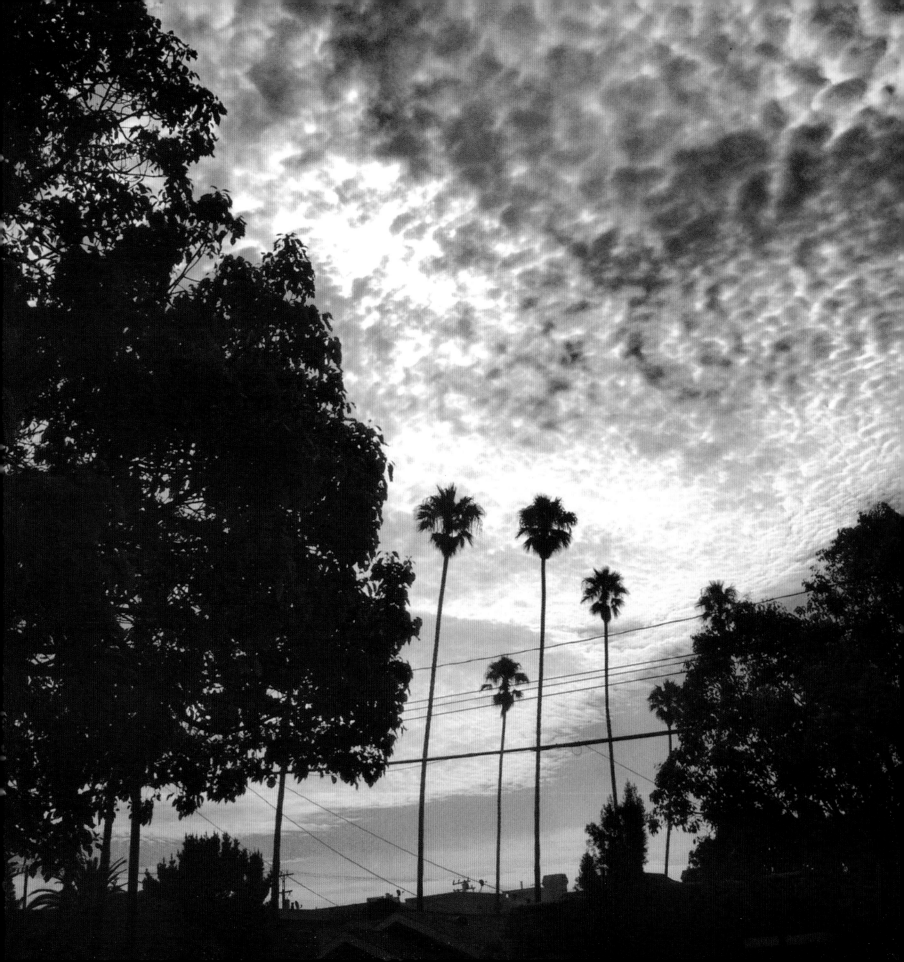

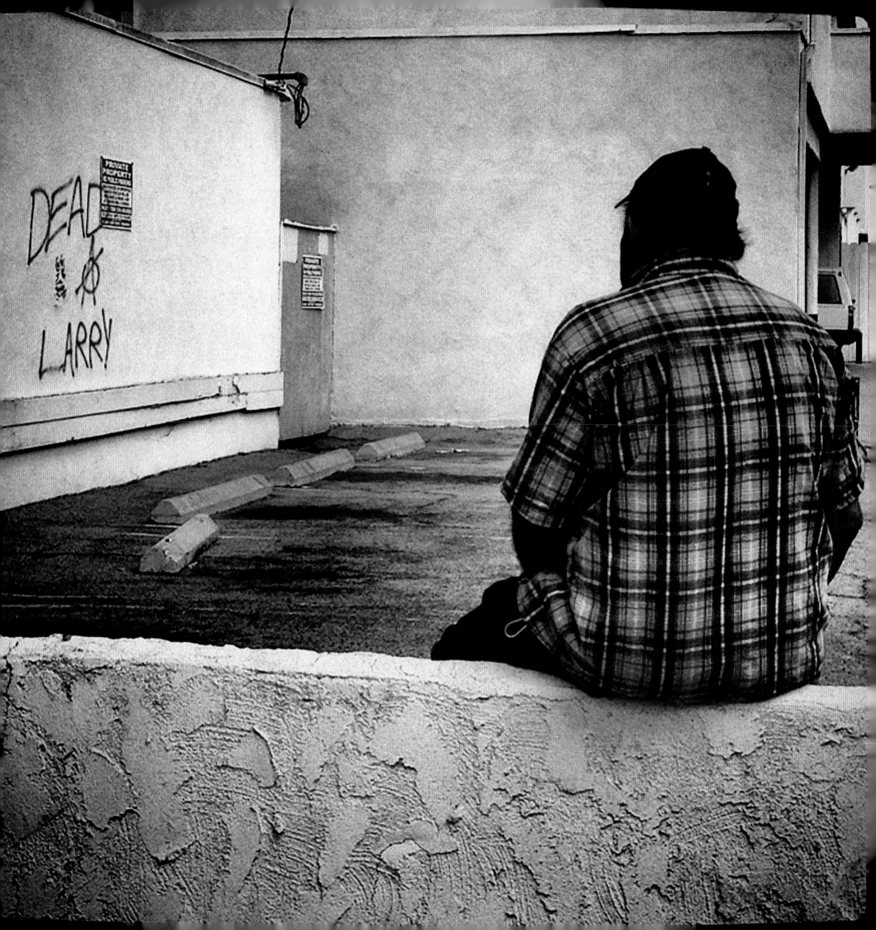

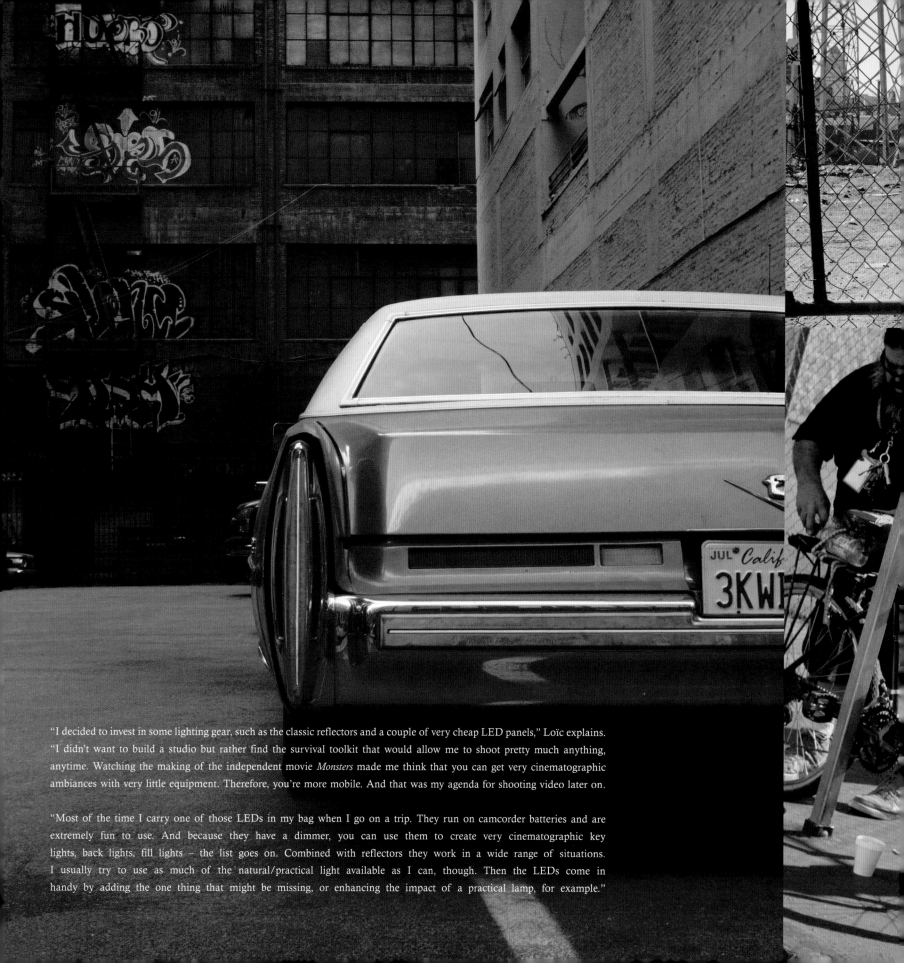

"I decided to invest in some lighting gear, such as the classic reflectors and a couple of very cheap LED panels," Loïc explains. "I didn't want to build a studio but rather find the survival toolkit that would allow me to shoot pretty much anything, anytime. Watching the making of the independent movie *Monsters* made me think that you can get very cinematographic ambiances with very little equipment. Therefore, you're more mobile. And that was my agenda for shooting video later on.

"Most of the time I carry one of those LEDs in my bag when I go on a trip. They run on camcorder batteries and are extremely fun to use. And because they have a dimmer, you can use them to create very cinematographic key lights, back lights, fill lights – the list goes on. Combined with reflectors they work in a wide range of situations. I usually try to use as much of the natural/practical light available as I can, though. Then the LEDs come in handy by adding the one thing that might be missing, or enhancing the impact of a practical lamp, for example."

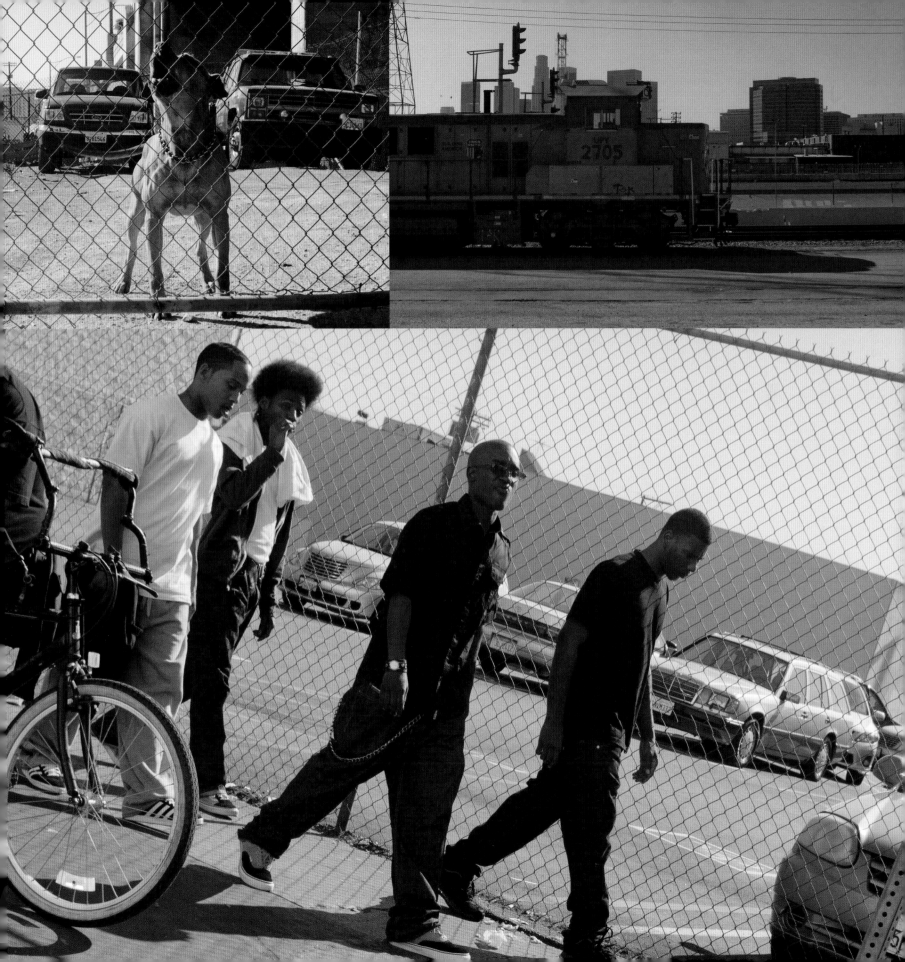

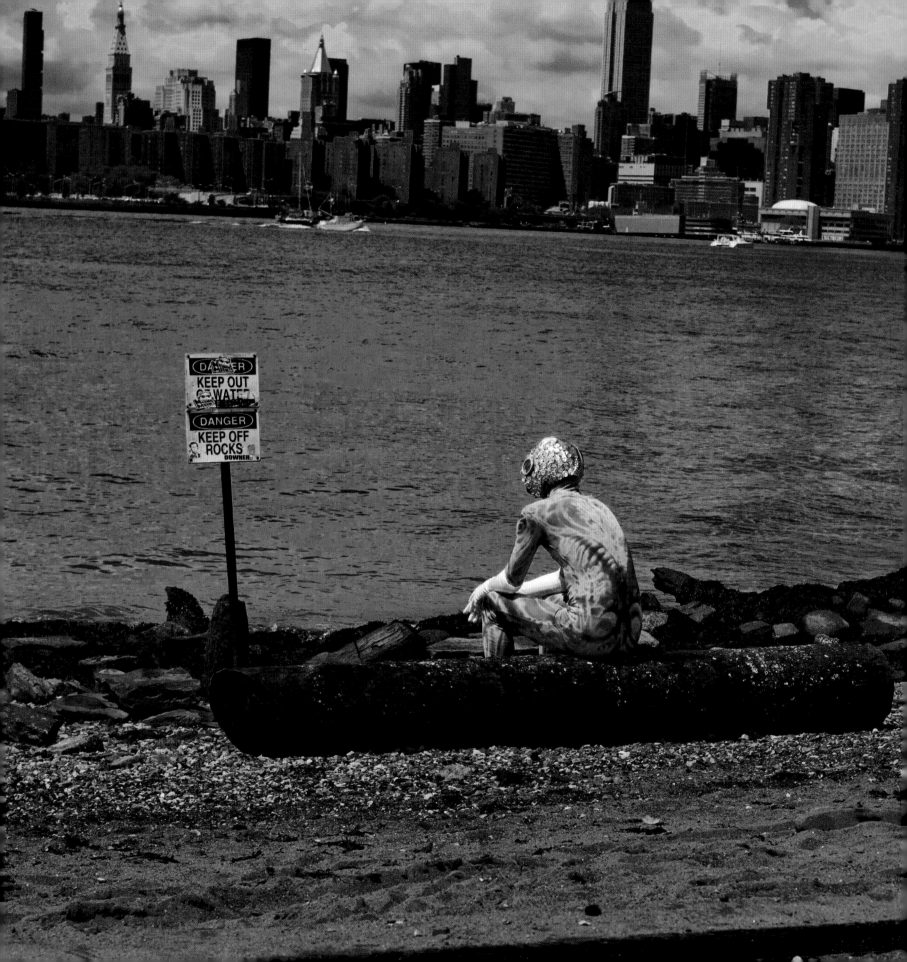

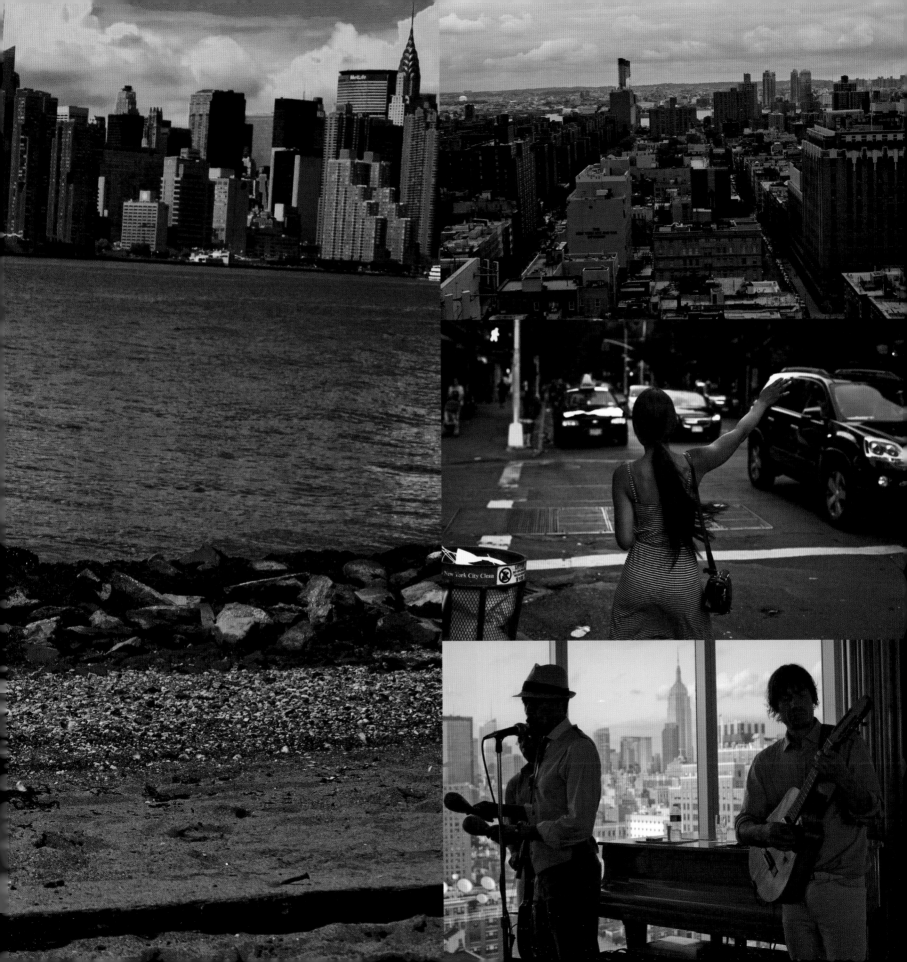

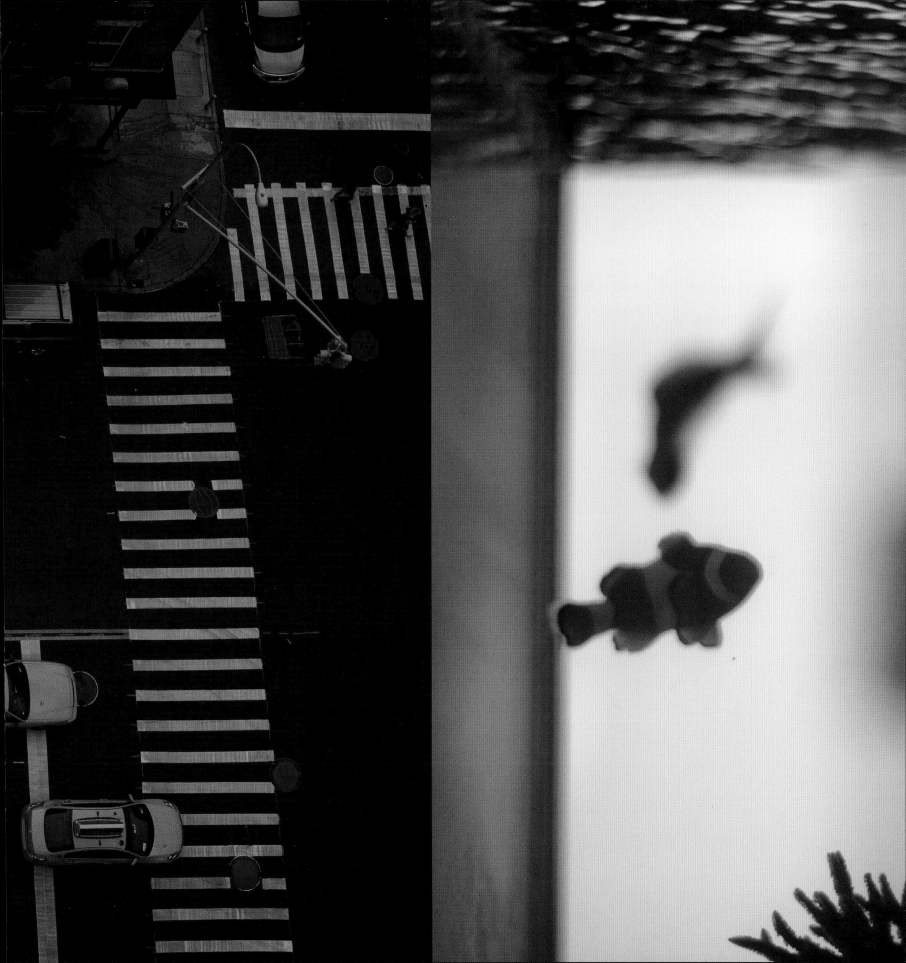

THE
BINAURAL
SERIES

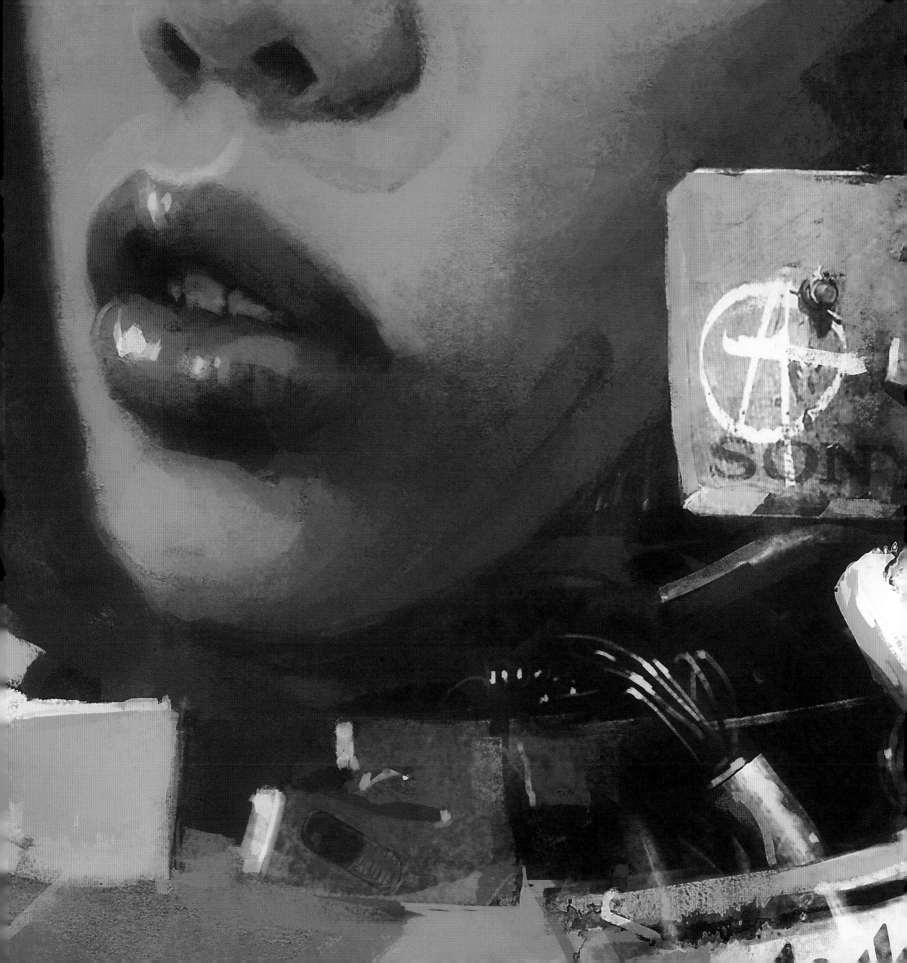

The first *BINAURAL* illustration was crafted several years ago. Back then, Loïc had no idea it would eventually form the foundations of an entire series of artworks...

"I worked on the second image during a very bad week of insomnia a couple of years later," Loïc explains. "Awake, in the middle of the night, I started to dive into my archives to check if any of my previous works would be worth pushing any further*.

"I wanted to explore similar ideas: partial symmetry, high-tech flirting with abstraction with a sci-fi flavor to it. As well as a square ratio common to all the images of the series.

"For the third illustration, I used a reference image from Kristeen (a follower of my work on Facebook) that had been sitting on my hard drive for too long.

After this, I had a model for every illustration and I kept on exploring that simple theme. Over time, the new images started to use fragments of their predecessors; more specifically the helmets that started to combine archive fragments of the existing images – a detail here becoming a broad design element there.

"The number of each *BINAURAL* illustration is present on each helmet, starting from number four."

*A series like *TAR* is also a good example of this process, sharing similar sources and textures, and contributing as sources themselves. See page 88.

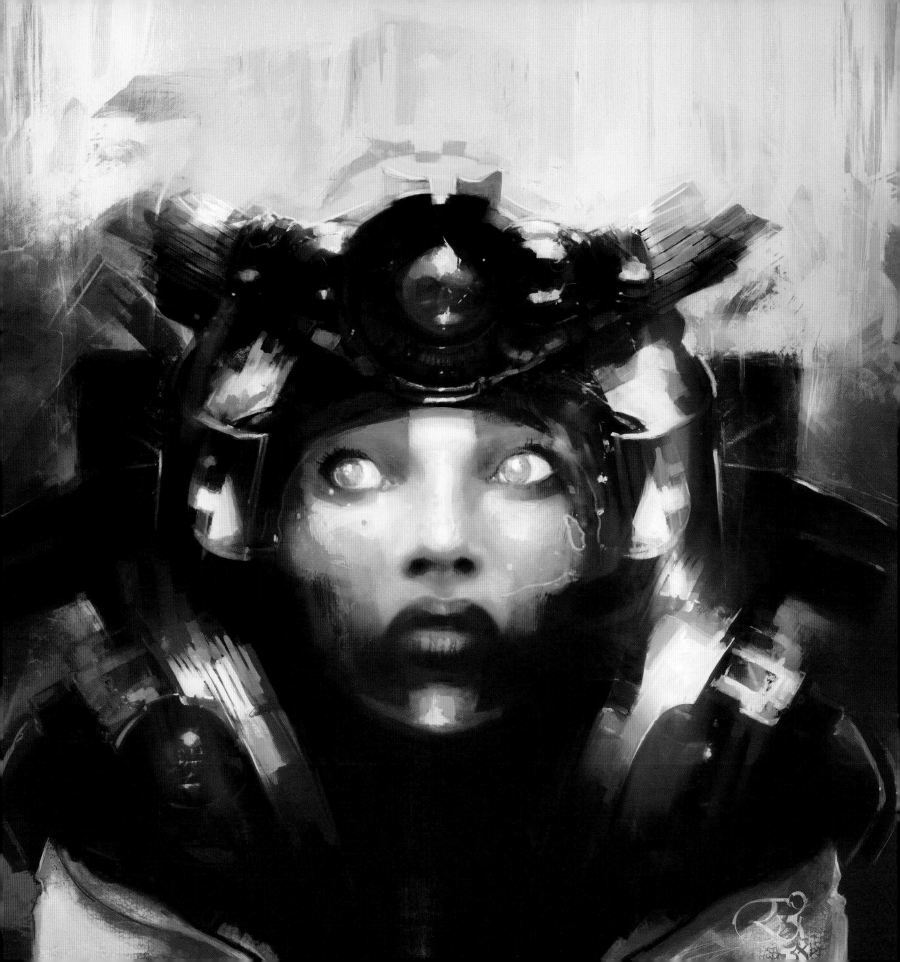

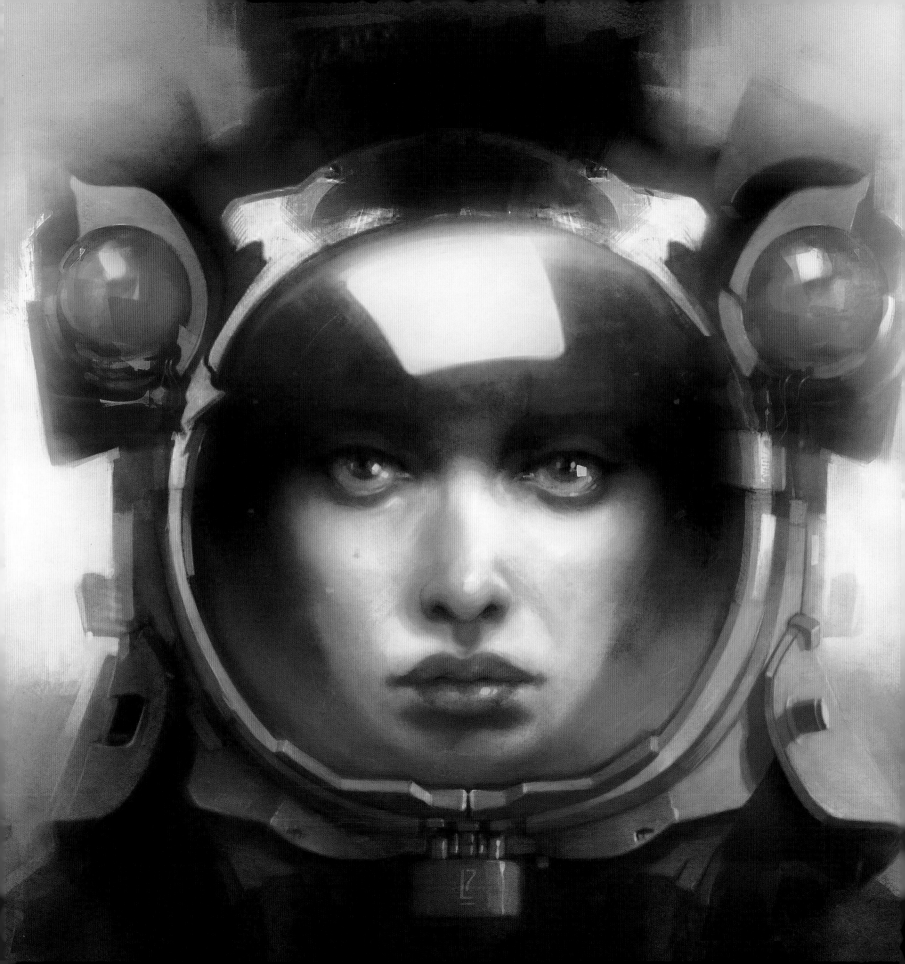

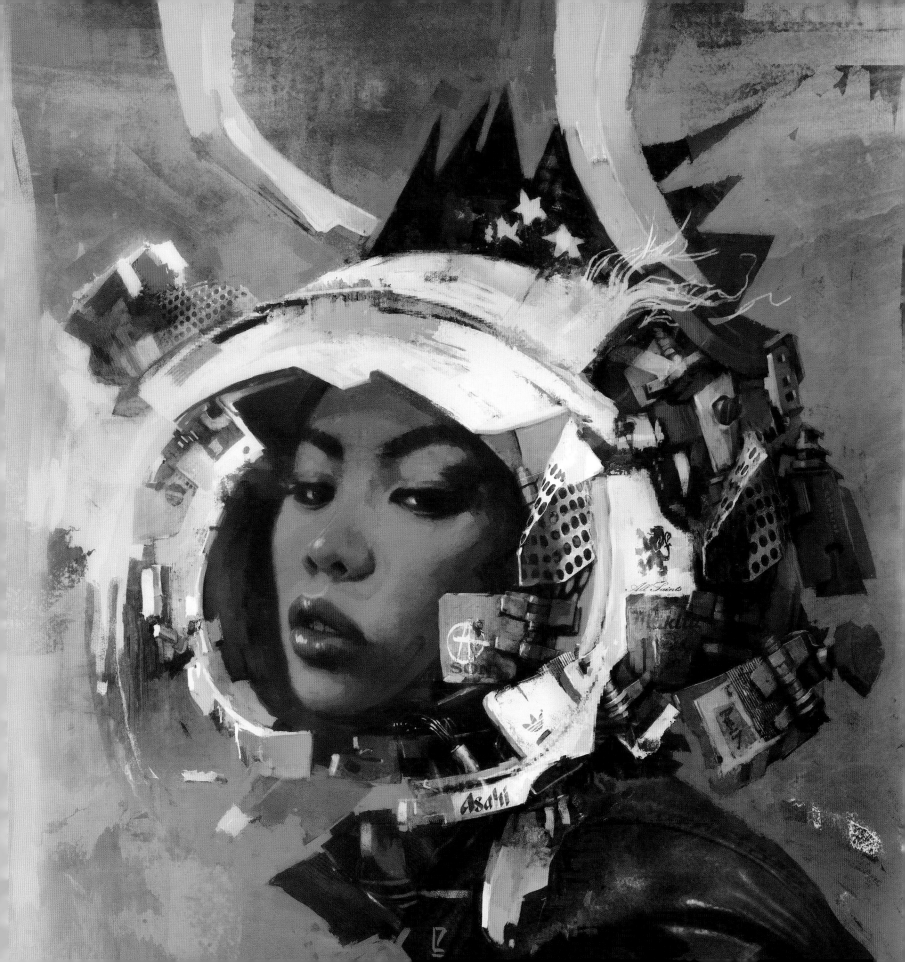

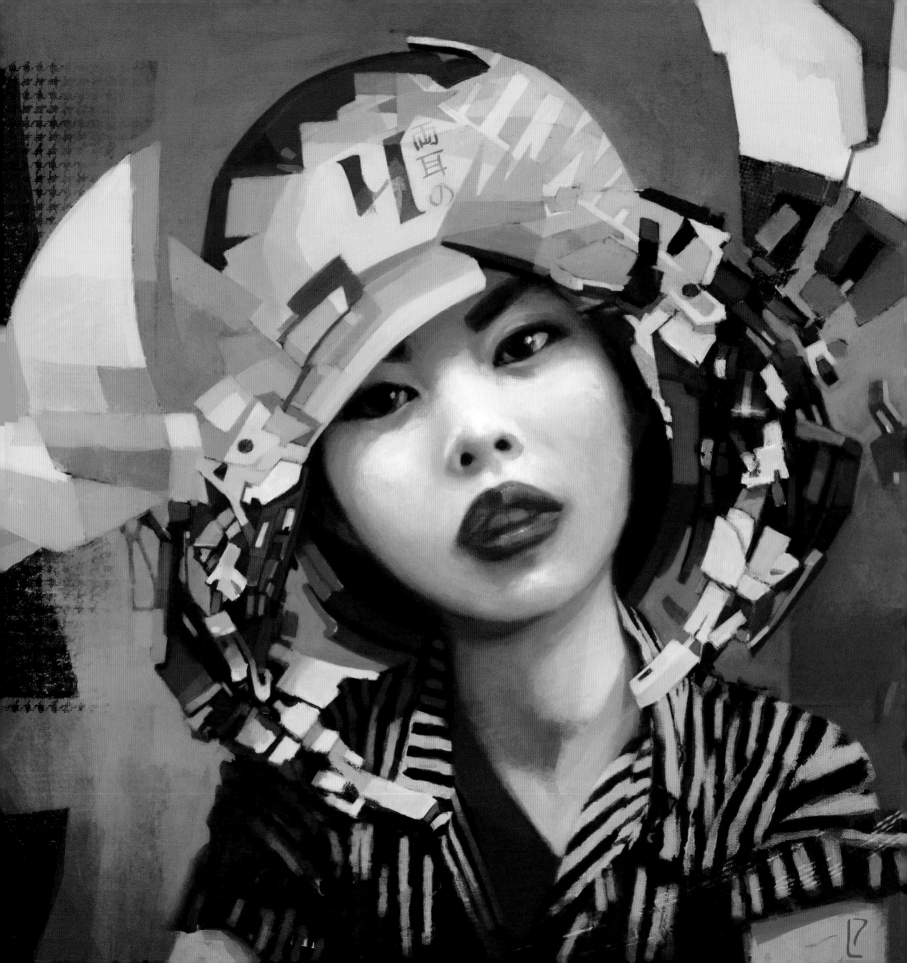

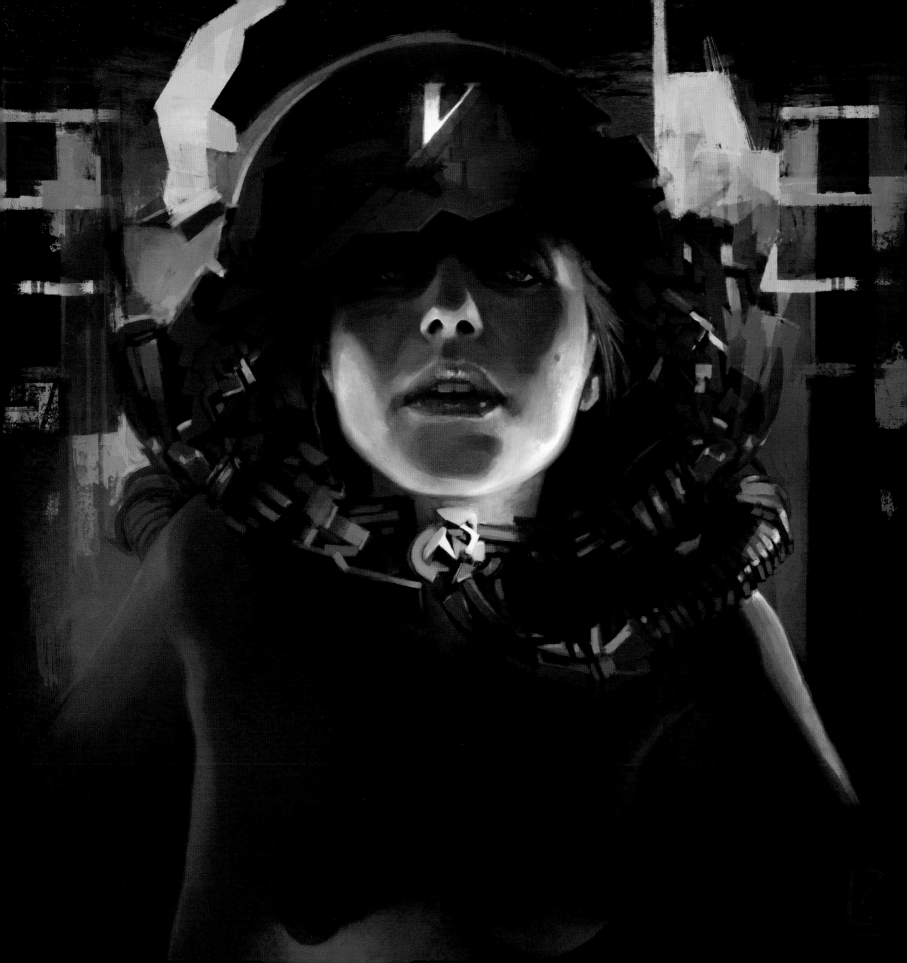

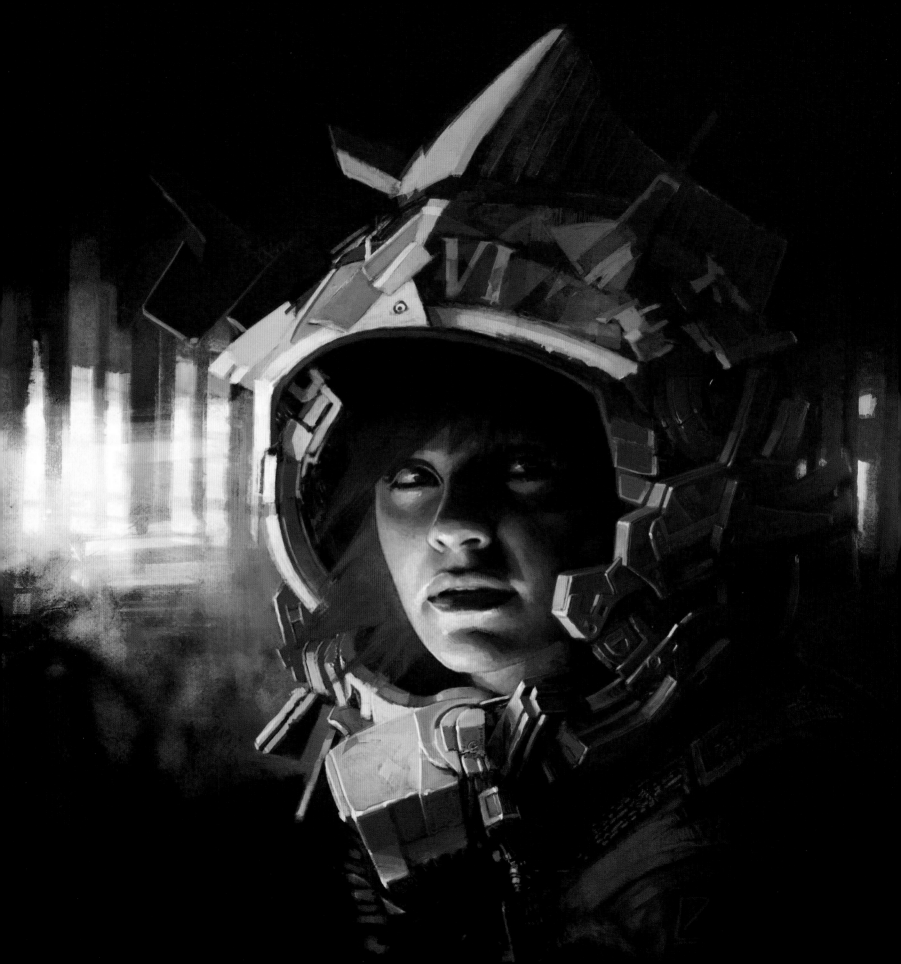

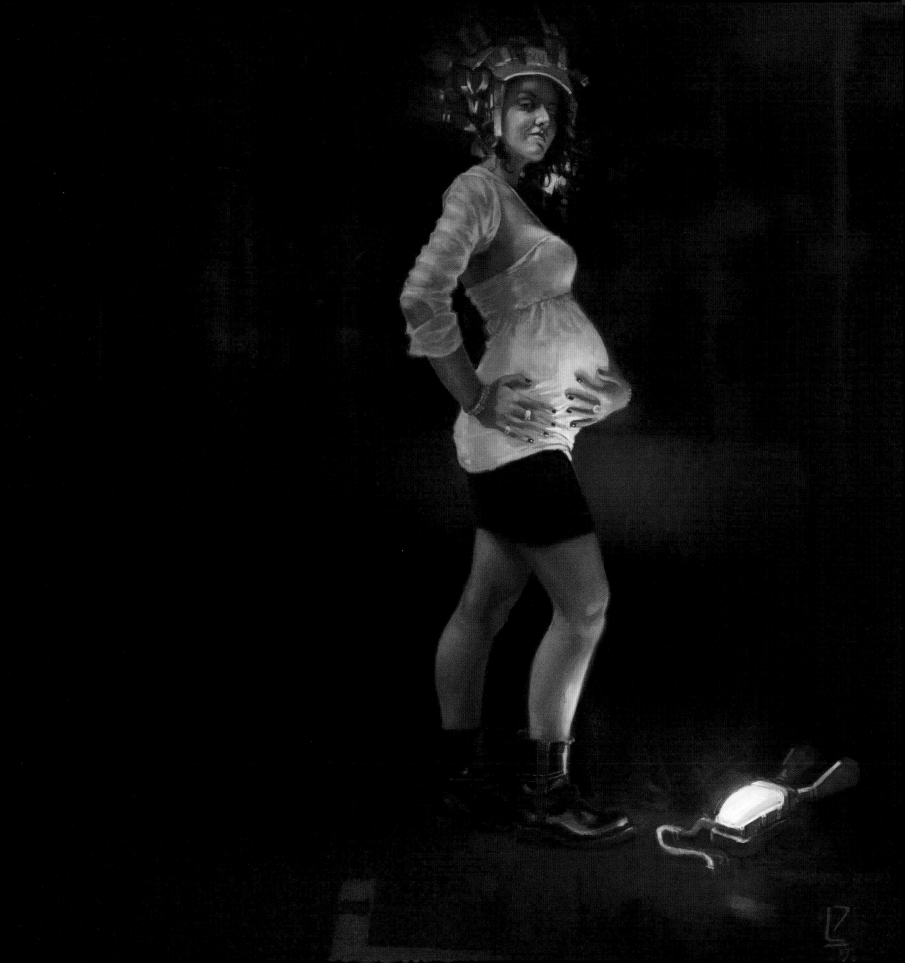

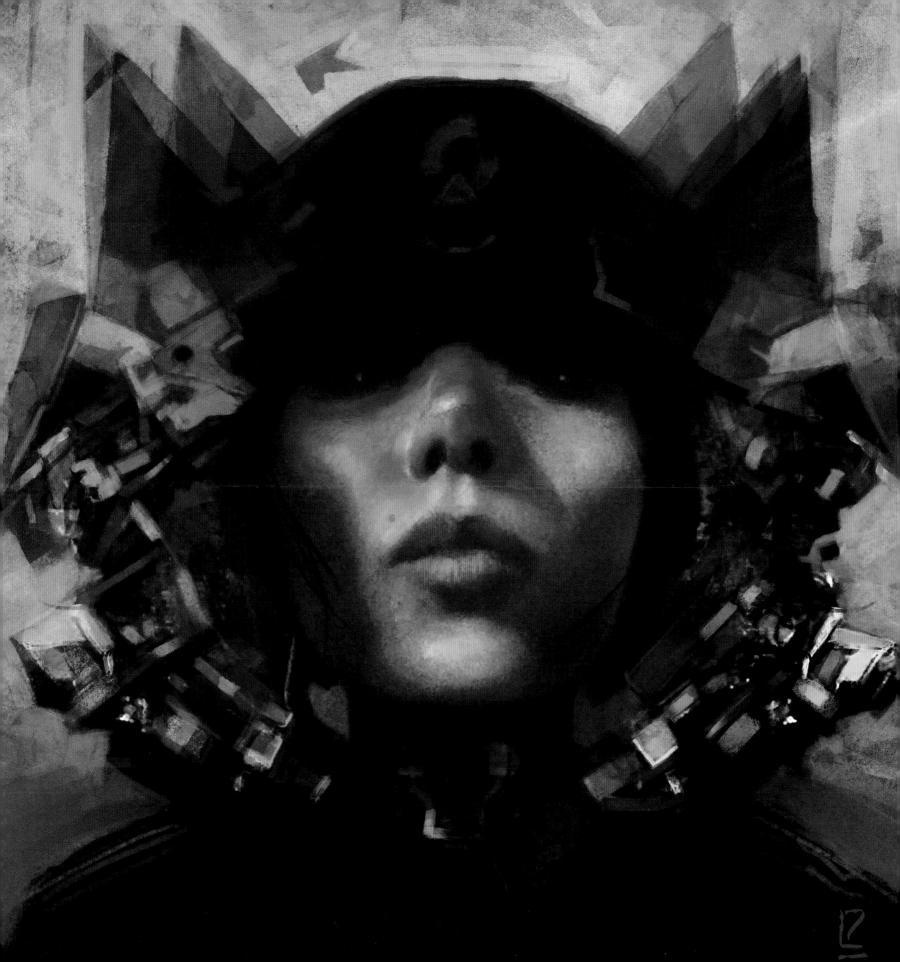

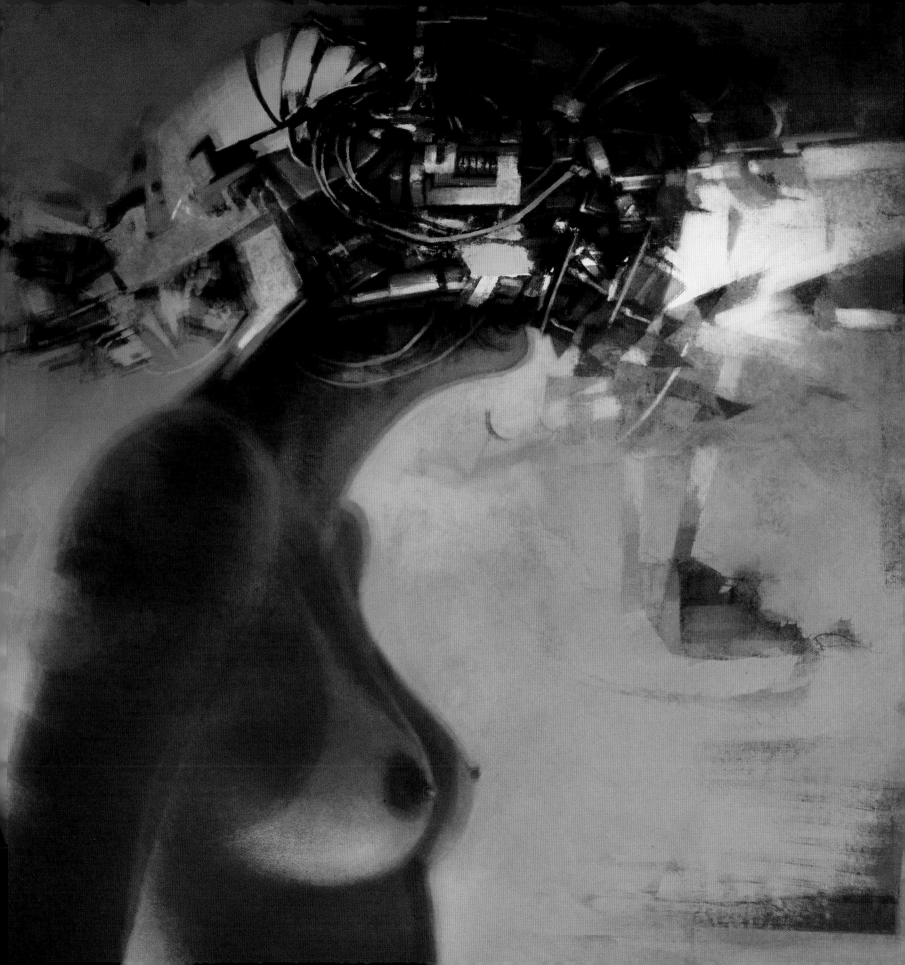

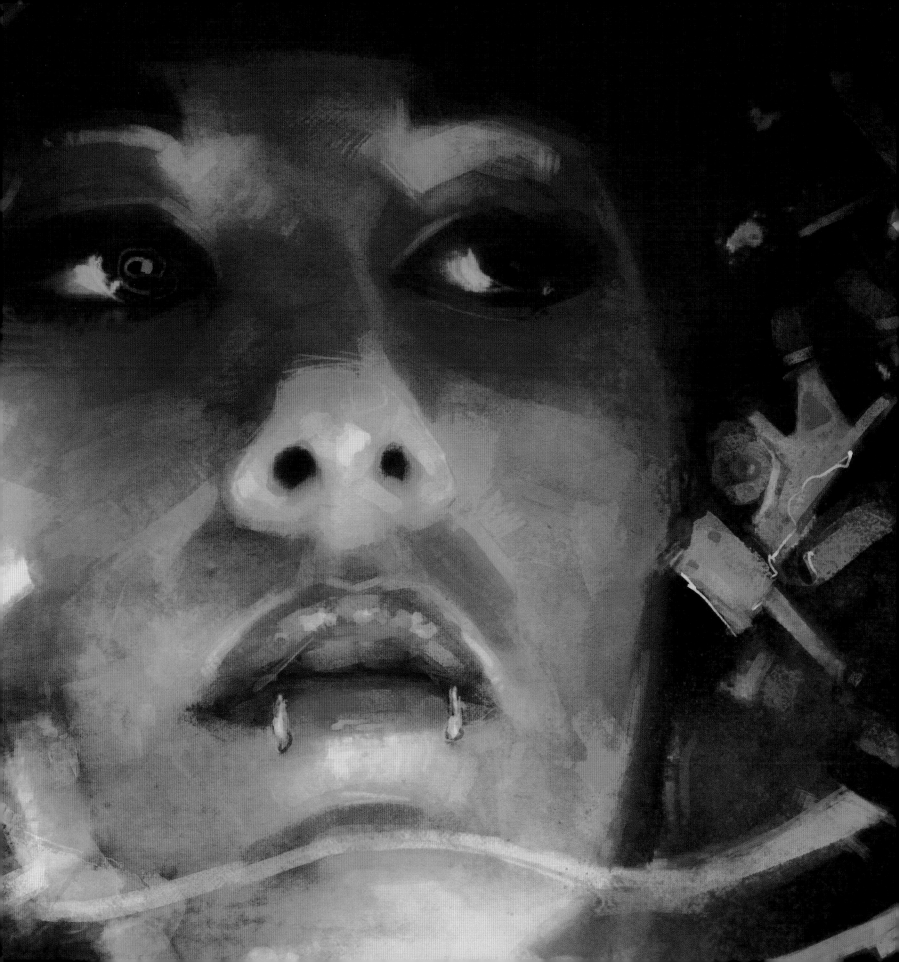

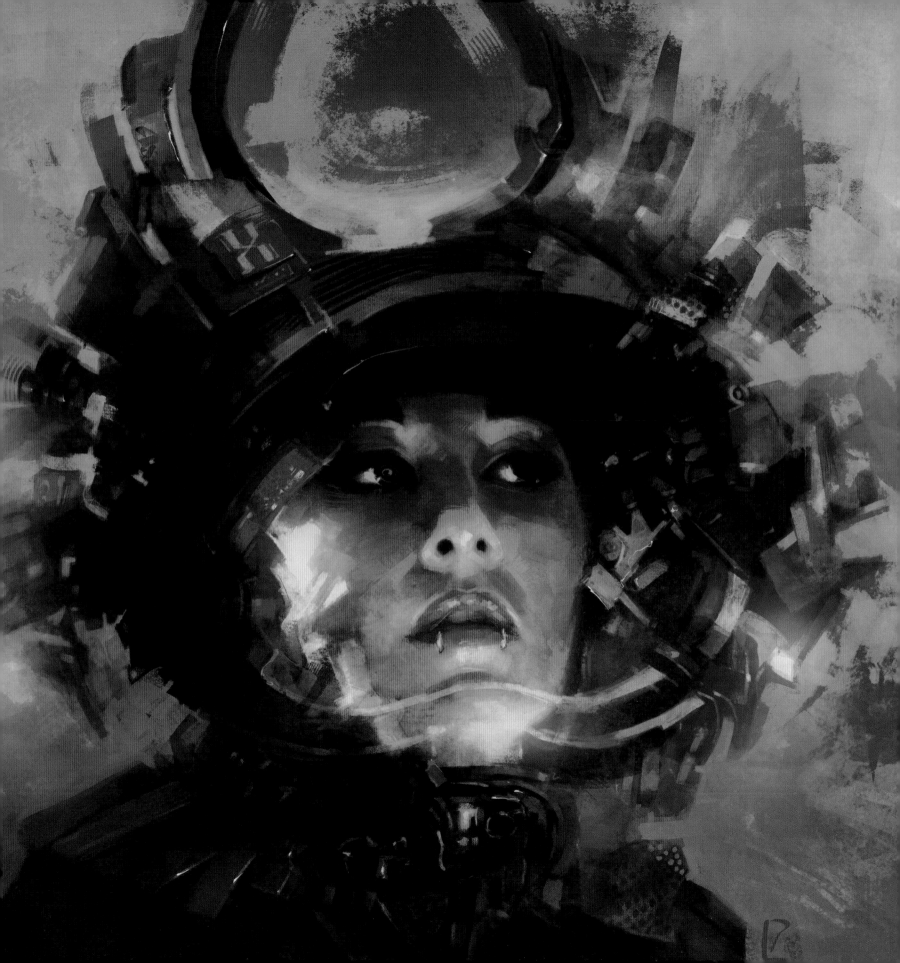

" Over time, the new images started to use fragments of their predecessors "

>> Go check how people in the rest of the studio
 work. Your task is not over until your work
 has gone through every step of the pipeline.
 This understanding of other people's jobs
 will get their attention and respect. You
 will be recognized as someone who facilitates
 the whole process.

 Don't try too hard to find your
 style; it will find you.

Adèle Sinigre • Alan Bligh • Albert Kiefer • Alexander Wilhelm • Alexandro Berto • Andre Doil • Andre Holzmeister • André Kishimoto • Andrea Masciadri • Andreas Böhler • Andrei Szasz • Andrew Baker • Andrew L Schmidt • Andrew Molyneaux • Anthony Grant • Anthony Partridge • Anthony Smith • Antoine Jarlegant • Anton Abela • Ashley Morgan • Barbara Beil • Barry Warner • Bart Holder • Beatrix Rossi • Benjamin Alcover • Bernard Caumes • Brent Hensarling • Bryan Gough • Buret Sébastien « A76 » • Camille Brasseur • Catherine Hughes • Cedric Nivoliez • Chaz Sutherland • Chen Yingnan • Chris Arnold • Chris Scobee • Christian Reichelt • Chung Liu • Cian-Grangé Benjamin • Ciel Bendall • Claire Chen • Clayton Mitchell • Courtland LaVallee • CPJ van der Velden • Crystal Murray • Dan Fairs • Dane Petersen • Daniel de la Calva • Daniel Riddle • Dave Lewis • David E Cordero • Devin Smith • Didier Levy • Donald Rowe • Dweller on the Threshold • Edward Yong • Elaine Wu • Eliot Jourdain • Enrico Toivinen

THANK YOU

Eric Hany • Eric Lloyd Brown • Ernst Krogtoft • Ethan Zlomke • Faisal Campwala • Florian • Franco Marini • Franklin Crosby • Fred Leggett • Fredi 'Haddedam' Tarenõmm • Garrett Clarke • George Asiedu • Gilles Beloeil • Glenn Morris • Grayson Soares • Grega Birsa • Griiot • Guillaume Cousin • Guilmain Rémy • H Haden Hammond • Hans Geyskens • Helen Peacock • Huhwn • Iain • Ignacio de la Calle • In-Ah Roediger • Jack • Jack M Gilson • Jaime Labelle • Jan Jinda • Jan Zirkel • Jani Jokinen • Jared Simeth • Jason • Jason Aaron Wong • Jenny Souza • Jess Madsen • Jessica DeCarlo • João Miguel Castanheira Jacinto • Joey Sila • John Ray Hazzard • John Sverre Stray • John Winocur • John Wyant • Jon Bunker • Jon Dunham • Jon Paul • Jonathan Felgate • Jorge Monreal Forcada • Jorge Montero • Jose Alberto Valente Ferreira dos Santos • Jose Alves da Silva • Joseph Drust • Julie Duchemin • Julien Alday • Julien Stara • Juuso Haimilahti • Katherine Heang • Ken Doyle • Kendrick J. Lepage • Keshia Nau-Dominique • Kevin Kabengele • Khasis Lieb • Lars Ivar Stranden • Lenny Gordon • Libor Mořkovský • Logan Feliciano • Louis Rodriguez • Luis Brigantty • Luis Yepez • Lynette Clee • Mamieyannick • Manuel Hofmann • Marc Gabbana • Mark Buzby • Mark Solloway • Markus Brackelmann • Martin Pham • Martin Silz • Mathieu Chardonnet • McSteed Inc • Mehran Mahinpour Tirooni • Metadsign • Michael Perdew • Michel Cavro • Miguel von Loehneysen • Mike McCain • Morgan Guillon • Naoki Terai • Nathan Rusch • Nikola Damjanov • Noxizmad • Olivier Bisson • Olivier Hero Dressen • Olivier Masson • Olivier Renouard • Oslo • Pablo Alonso • Patrice Mille • Paul Baguley • Pauli Nykänen • Pequelord • Peter Erik Hälldahl • Peter Mašek • Philip De Wandeleir • Philip Pendlebury • Pierre-Loïc Hamon • Quentin Chiché aka Kwen • Rafa Milfulles • Ralf Marczinczik • Remko Troost • Rich • Richard Sutherland • Roy Nottage • Russell Pacy • Ruy Delgado • Ryan Stevenson • S Dhillon • Samuel Dowse • Samuel Roberts • Scott Laughlin • Scott Ng • Sean Koudela • Sean Travis Flynt Dekle • Seth Duckens • Shawn Faherty • Silvia Cortellino • Simon "Gupta" Rees • Simon Gould-Thorpe • Simon Rudberg • Simonetti Marc • Sjoerd Adding • Sophie Manzetti • Stanford Charles Clanton • Stephen Mulhall • Stephen Pugh • Steve de Vriendt • Sven Fischer • Tayla Ealom • Taylor Nagle • thedarkinker • Thomas Bouquin • Tim Nicholls • Toke Jepsen • Tom Carter • Tom Greenway • Tom Krieger • Tomas Kral • Tomasz Wagel • Tony Kihlberg • Travis Pheil • Ufuk Mercan • Vincent Bertin • Vincent Cirelli • Vincent Percevault • Vincent Techer • Winston Worrell • Xavier C. Garand

Michael Kutsche: I mean, we forget about the way we work here, but the more entertaining part for me is what's outside of us, right? That's like the nutrition for our brains, right? To figure out how things work in general; how other artists work; how it's related to science and philosophy – it's always the best conversations when we forget about ourselves in them, right?

e338: It is. I love how all those things feed the subject you work on. And I think what you said earlier is that it's very dangerous when you try to keep them contained. Which again is a problem with this industry that feeds on the movies that have been released three years ago, as opposed to going to look for documentation from hundreds of years ago, or with dance, with music, with science, with sociology, with architecture – and just grabbing all those things, all that information, and I think it's going to give a better concept rather than doing a mash-up of all the video games you've been playing for five years. That industry is pushing towards that – and I'm glad that some people actually fight against it, and that they open the subjects up to a more random selection of media and visual answers.

And let's conclude on that beautiful sentence [laughs].

MK: [Laughs]

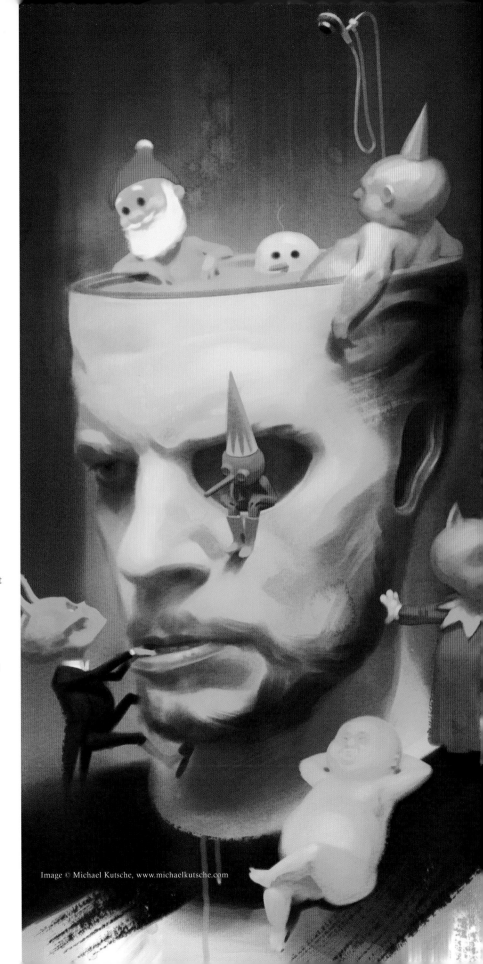

Image © Michael Kutsche, www.michaelkutsche.com

Discover more titles available from 3dtotal Publishing

If you've enjoyed this book and wish to expand your knowledge further, here are a few recommendations...

Sketching from the imagination

Whether scribbled in a sketchpad or on a napkin, concepts are a way for artists to develop their skills and discover interesting shapes and forms that can be developed into their next masterpiece. This bestselling book of 2013 explores the sketchbooks and concepts of 50 artists, providing a wealth of must-have inspiration.

"This book is an inspiring and informative look into the minds, and behind the scenes, of this highly skilled group of artists, as they break down what it takes to bring their amazing visions to life. It is the kind of book you can go through again and again, learning something new each time..."

Brom - Artist and Writer of All Things Rotten

Digital Painting Techniques: Volume 5

Celebrating its fifth year, *Digital Painting Techniques: Volume 5* presents the latest digital painting trends and techniques, courtesy of industry experts including Brian Sum (*Mass Effect* series), Shaddy Safadi (*Uncharted: Drake's Fortune*) and Levi Hopkins (*Guild Wars* series). It's an indispensable resource packed with advice.

"Not many art books offer such a detailed insight into other artists' workflows. You might be a beginner looking for a step-by-step tutorial, or a professional in search of a variety of tips and tricks to speed up your painting process; either way, you will not be disappointed."

Blaz Porenta - Freelance Illustrator

Digital Art Masters: Volume 8

This is not your typical digital art gallery book. While it does showcase stunning work from 50 of the best international artists, it also includes detailed tutorials explaining how each image was created. If you're looking to be inspired and learn something at the same time then *Digital Art Masters: Volume 8* ticks all of the boxes.

"An integral part of my own drive for self improvement has always been admiring and scrutinizing the work of others. Getting to see brilliant works of art broken down and explained step-by-step is always a pleasure, and a captivating glimpse into the minds and processes of the creative's behind them."

Charlie Bowater - Atomhawk Concept Artist

ZBrush Character Sculpting: Volume 1

ZBrush is an integral part of the 3D modeling industry. *ZBrush Character Sculpting: Volume 1* examines the tools on offer in this groundbreaking software, as well as presenting complete projects. Drawing on the traditional roots of classical sculpture, this book also investigates how these teachings can be successfully applied to 3D.

"This book offers a great gallery of work from today's best artists and an insightful look into the creature and character design process. It provides a helpful breakdown written by various artists, explaining the steps they took to create truly unique and eye-catching designs."

Aaron Sims – Art Director